RIVER OF WORDS

River of Words

PORTRAITS OF HUDSON VALLEY WRITERS

Nina Shengold

Photographs by
Jennifer May

Foreword by Dennis Stock

excelsior editions

State University of New York Press
Albany, New York

Published by State University of New York Press, Albany

Excelsior Editions is an imprint of State University of New York Press

For information, contact State University of New York Press, Albany, NY
www.sunypress.edu

Design by Cathleen Collins
Production by Dana Foote
Marketing by Fran Keneston

Library of Congress Cataloging-in-Publication Data

Shengold, Nina.
 River of words : portraits of Hudson Valley writers / Nina Shengold and
[photographs by] Jennifer May.
 p. cm.
 ISBN 978-1-4384-3425-4 (hardcover : alk. paper)
 1. Authors, American—Hudson River Valley (N.Y. and N.J.)—Biography.
2. Authors, American—Homes and haunts—Hudson River Valley (N.Y. and
N.J.) 3. Hudson River Valley (N.Y. and N.J.)—Biography. I. Title.
 PS253.N7S54 2010
 810.9'3587473—dc22
 [B]
 2010015305

10 9 8 7 6 5 4 3 2 1

To the memory of the unforgettable

Frank McCourt (1930–2009)
Dennis Stock (1928–2010)
Donald E. Westlake (1933–2009)

CONTENTS

FOREWORD

THE CHALLENGE IN TAKING PORTRAITS is that, typically, the photographer has never met the subject until the day of the shoot. So, in a short amount of time, the photographer must analyze the subject's physical appearance to the best of her ability in order to make a responsible photograph that gives insight into the subject's personality. By incorporating the environment in which the subject lives, the photographer can create a background that is both informative and complimentary. This is the craft of composition. The photographer is not only telling us what she sees, she is also telling us what she feels.

In *River of Words*, Jennifer May presents a collection of portraits that each tells a story. But a portrait is only fifty-one percent about the subject—the remaining forty-nine percent is about the photographer. A discerning eye can learn a great deal about both. We learn many different things about the group of distinguished writers May has photographed, but about May herself we also learn much. In this sublime and timeless collection, we see an empathic photographer who, with the highest mastery of craft, has presented us with her own love of books and the writers who write them. This is a celebration of something dear to May's heart and, time and again, we will eagerly look over May's shoulder to see what she sees and to celebrate what she celebrates. This is May's love letter to writers —a portrait of words in images.

DENNIS STOCK
Woodstock, New York
December 2009

INTRODUCTION

WHAT MAKES A LANDSCAPE MAGNETIC? For centuries, writers have drawn inspiration from the Hudson River and its surroundings. John Burroughs, James Fenimore Cooper, Washington Irving, Herman Melville, Edna St. Vincent Millay, and Edith Wharton all lived and worked in the region immortalized by the Hudson River School of painters.

River of Words is a group portrait of seventy-six contemporary authors who populate these storied hills—close enough to New York City to meet an editor for lunch, but a world away, filled with rambling Victorian farmhouses, Dutch barns, and Revolution-era stone houses. This book's subtitle should rightly be "Portraits of *Some* Hudson Valley Writers," since no book of any length, let alone one this modest, could begin to include the hundreds of talented writers who call this place home.

Artists of all genres gather in groups: think of Hollywood actors or Nashville musicians. Manhattan is publishing's company town, and the phrase "New York author" is firmly entrenched in the zeitgeist. But writing is essentially a solitary pursuit, whose practitioners may benefit from a certain meditative distance. In the breathtaking landscapes and quirky small towns up the river, working writers can find an artistic getaway that isn't *too* far away.

The colleges and universities lining both banks of the river—Sarah Lawrence, Vassar, Bard, Marist, Siena, SUNY Albany, and SUNY New Paltz—create literary hubs; so, too, do Albany's New York State Writers Institute, The Hudson Valley Writers' Center and Slapering Hol Press of Sleepy Hollow, the region's strong network of

independent booksellers, and the book festivals held annually in Albany, Millbrook, Spencertown, and Woodstock. It's a rich, lively mix, and fitting even a taste of it into one book is a daunting proposition.

First, we needed some definitions. Where does "the Hudson Valley" begin and end? The river flows 315 miles, from Lake Tear of the Clouds in the Adirondacks to the tip of Battery Park. The lower Hudson is an estuary, with tidal influences as far north as the junction of the Mohawk River at Troy; its Lenape name, Muhhakantuck, means "the river that flows both ways." This offered a natural northern boundary; we chose a man-made one, the Tappan Zee Bridge, to the south.

We also needed to define "Hudson Valley writer." Would we include only those authors who write *about* the region, or anyone who lives and works in it? What about second-homers, weekenders, and summer people? Expatriates with local roots? Would we limit ourselves to authors of books, or include those who write plays, screenplays, graphic novels, and songs? In the end, we decided to be as inclusive as possible—the Hudson Valley is that kind of place.

Many of the author profiles and photographs published here first appeared in the pages of *Chronogram* magazine; grateful thanks to editor Brian Mahoney, creative director David Perry, and publisher Jason Stern for giving this project their blessings. Many more were created exclusively for this book. I travel light (legal pad and Bic pen) and Jennifer May travels heavy, toting suitcases full of camera equipment. We made forays by Subaru wagon in all four seasons, traversing unpaved mountain roads, rambling through farmland, and visiting riverfront cities. We met writers at home, in favorite cafes, on college campuses, at historic estates, in parks—even, in the case of river crusader Pete Seeger, at a roadside peace vigil. We crossed the Hudson on seven different bridges—Castleton-on-Hudson, Rip Van Winkle, Kingston-Rhinecliff, FDR Mid-Hudson, Hamilton Fish Newburgh-Beacon, Bear Mountain, and Tappan Zee— and the vistas were stunning from every one.

In all, we logged thousands of miles. But that was just part of the treat of creating this book. The real joy was the thousands of pages we read, guided not by the

oddly Australian tones of Jen's GPS, but by the masterful voices of our chosen writers. Our backup list, dozens long to begin with, swelled to over two hundred names as we continued to read and do interviews. Every writer we spoke to knew many more; their recommendations were impassioned and quite overwhelming.

Perhaps this is what makes the Hudson Valley so magnetic to writers. It isn't the breathtaking scenery, the peace and quiet, or the proximity to New York City's publishing axis. It's all these, of course, but above and beyond that, the lure is community. We are proud to be part of this generous literary landscape, and to offer this tasting sampler from the laden banks of the River of Words.

—Nina Shengold and Jennifer May
October 2009

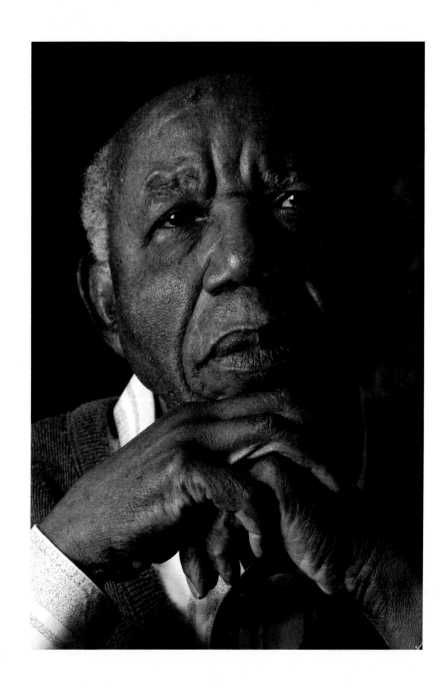

Chinua Achebe

FIVE DECADES AGO, an ambitious young man from a small Nigerian village put the handwritten manuscript of his first novel into a brown paper parcel and shipped it to a typing service in London. Months went by without word; the package, it seemed, had been lost. In desperation, the author begged an English colleague at the Nigerian Broadcasting company to stop by the typing service when she went to London on leave. She found the package languishing on a back shelf and got it typed posthaste. The book was called *Things Fall Apart.*

Since its first publication in 1958, Chinua Achebe's masterpiece has sold over twelve million copies worldwide; it's been translated into over fifty languages. Achebe, whose other novels include *No Longer at Ease*, *Arrow of God*, *A Man of the People*, and *Anthills of the Savannah*, has received over thirty honorary degrees and a cornucopia of literary awards, including the 2007 Man Booker International Prize. He is widely considered, in Lewis Nkosi's words, "Africa's greatest indigenous novelist."

Given this kind of acclaim, it's startling to visit Achebe's home on the Bard College campus in Annandale. The world-renowned novelist lives in a nondescript ranch house on a sleet-streaked back road, so easy to miss that Bard's publicity office offers a driving escort. Achebe answers the door himself. He has used a wheelchair since 1990, when a car accident left him paralyzed from the waist down; his presence imparts upon it the majesty of a throne. He moves to the dining room, turns, and says simply, "Here."

Achebe has a powerful face, with an unswerving gaze and deeply carved lines around a strong mouth. He's wearing a striped broadcloth shirt, a coffee-toned vest, and dark trousers, with a black beret at a rakish angle that recalls a resistance leader. He speaks with a quiet authority, sometimes so softly one needs to lean forward. His hands

are long-fingered and graceful; they dance as he talks, kneading the air. His dignity is palpable, but there's nothing austere or pompous in him—it's as easy to picture him grinning at his four grandchildren as mesmerizing an international audience.

The house is decorated in earth tones, with dark leather club chairs and vases of dried flowers. There's a sideboard covered with family photos, and numerous African carvings and masks collected by Achebe's wife, Christi, a psychology professor at Bard.

For years, the author turned down nearly every request for an interview. Then he changed his mind. "What is this business of writing?" he asks. "Obviously, there is something I want to communicate with people. That's what the writing is about, to hold conversations with people, with your culture, with yourself."

Achebe can't remember exactly when he last read *Things Fall Apart*, but his respect for his freshman effort remains intact. "I look at it now and again. It is still a marvel, it's still a surprise," he says, smiling. "I had no experience of that kind of thing. I had scribbled a few short stories in college." The stories, like his groundbreaking novel, were written in English.

Achebe explains, "English was the language of education in British colonies. The fact that it is a foreigner that arrived in my home and seized power struck me at a certain point. At other times, I've taken the view that this is a language with which I had no quarrel. A language doesn't really fight with you, unless you want it to." The language of Achebe's village, Ogidi, was Igbo—one of Nigeria's three principal tongues—but school was always in English.

Achebe's father, Ogidi's first convert to the Church Missionary Society, was a devout evangelical Protestant who baptized all six of his children. But young Albert Chinualumogu Achebe was also drawn to his "heathen" uncle's ancestral traditions. In his autobiographical essay, "Named for Victoria, Queen of England," Achebe (who dropped the "Albert" in college) writes that he was born "at a crossroads of cultures." His family "sang hymns and read the Bible night and day," while his uncle's family, "blinded by heathenism, offered food to idols. That is how it was supposed to be anyway. But I knew without knowing why that was too simple a way to describe what

was going on. Those idols and that food had a strange pull on me in spite of my being such a thorough little Christian."

Achebe loved books as a child, especially such "African romances" as *Mister Cary* and *Prester John*. Years later, he gained a different perspective on these colonial narratives. "You look at something you thought was fascinating and realize there was something more, that your people were put down very badly in these stories. These were some of the ideas floating around when I sat down to write *Things Fall Apart*. I had to write a different kind of book."

Things Fall Apart tells the story of Okonkwo, a villager whose unbending strength sets him at odds with his tribal culture and on a collision course with the first wave of white missionaries. Achebe wanted his book to bear witness, but knew it must also be pleasurable. "That was my task: how do you write good stories about your community, your people, and in what language? My education, my literary language, is English, but what I'm writing about is happening in Igbo."

His solution was capturing the flavor of Igbo speech. "As a child I knew a number of very eloquent people. That eloquence was what I had to convey. I attempted to convey the *spirit* of that language in English. I had to invent a language. It doesn't appear in any book before it," he says. In his essay, "The African Writer and the English Language," Achebe dubbed this creation "African English . . . a new voice coming out of Africa, speaking of African experience in a world-wide language."

As snow swirls past his window, Achebe continues. "The way I look at literature—it's something you do with a big community in your view. It's not a private concern. Especially an ex-colonial like me, who just managed to catch a glimpse of my past before it disappeared altogether."

Nigerians of his generation hold a unique place in history. "We are the last people who know what our past was," he notes, stressing the importance of "making sure the story does not disappear. The manuscript of *Things Fall Apart* very nearly disappeared. That shows you just how fragile, how tricky our situation in the world is. There are so many things we have to make sure are not gone forever."

Achebe gets letters from readers on every continent, including Native Americans who connect his work to westward expansion and the erasure of their traditional culture by European colonials. For him, literature is inextricably political. His widely read essay "An Image of Africa: Racism in Conrad's *Heart of Darkness*" confronts Conrad's vision of Africa as "the antithesis of Europe and therefore of civilization, a place where man's vaunted intelligence and refinement are finally mocked by triumphant bestiality." When he first presented this lecture as a visiting professor at the University of Massachusetts in the 1970s, many academics were scandalized; one huffed in his face, "How *dare* you?"

Multiculturalism has made some inroads—Achebe reports that his current Bard students are more conversant with non-Western authors than those he taught a generation ago—but much remains to be done. "The story of the world has not yet gained the momentum it needs. A different account in many instances needs to be created. The reason it's not there yet is that we tend to leave issues of justice and fair play to those who have been hurt," he asserts, noting that gender issues are usually left to women, and issues of race to minority writers. "When those who did the hurting see it as their responsibility . . . to find that injustice and expose it, even if it's late in the day, then we can take the steps necessary to live as one people."

The afternoon sky is darkening, and Achebe sounds tired. Perhaps his long exile is making him weary. When he was invited to teach at Bard in 1990, he assumed he would stay for a year or two; he's renewed his contract seventeen times.

"I am a resident but not a citizen, and there's a difference, especially because things are not working well in my country. That's one reason I feel my absence more acutely," he says. In 2004, Achebe turned down the honorary title of Commander of the Federal Republic in protest over the state of affairs in Nigeria. Would he do the same today? "Absolutely, without question. Though I don't think they would make the mistake of offering it to me again," he laughs.

In spite of political setbacks and healthcare issues, Achebe still dreams of moving back home. He wants to translate his novels from English into Igbo, "which I think would more or less round up my career." He's currently working with his son

Ikechukwu, the only one of his children who lives in Nigeria, on an Igbo dictionary. Achebe's other three children and all four grandchildren live in various parts of the United States, from Red Hook to Michigan. "We're all accidental exiles," he says ruefully.

Eight years ago, Chinua Achebe told a *New York Times* reporter, "There's a reason we were planted in a certain place. Our people have a saying: The whole essence of travel is to go back home." To that end, he's working long-distance with an architect to modify a house in Ogidi for wheelchair access. "I hope I'll be able to go home soon," he says, gazing out at the snowdrifts. "There's so much to do."

Susannah Appelbaum

"I've always been fascinated with poisoning. It's a hard thing to talk about at a dinner party," says Susannah Appelbaum. When she was four, she tasted an alluring blue flower in her aunt's garden and wound up in the hospital for three days. Several years later, she took to crossing an old railroad trestle near her New Paltz home. "This was in the pre-Rail Trail days, so there were ties missing, it felt very dangerous. I used to look down and think, what if there was a little man living under there?"

Appelbaum's debut novel *Poisons of Caux: The Hollow Bettle* features trestlemen, a trained crow, a wild boar, some exceedingly scurvy knaves, and a mysterious jewel. Her feisty young heroine, Ivy Manx, has a way with plants, both healing and lethal—a valuable skill in a land where the rule is "poison or be poisoned."

Tall, striking, and regally poised, the author resembles a fairy-tale princess whose basket of apples may not be entirely safe. She's the daughter of poet, philosophy professor, and Codhill Press publisher David Appelbaum; her mother died when she was eight. When her father taught at the Sorbonne during her high school years, Appelbaum learned French by the "sink or swim" method. She attended NYU, traveled abroad, and worked as a magazine editor, shunning New Paltz for thirteen years. "But like some twist of fate in a story, I guess I was destined to raise my kids on the same playground I played on," she says.

Though the *Poisons of Caux* trilogy targets young readers, its supple prose and award-winning artwork will also entice adult readers of fantasy. Book two, *The Poisoners' Guild*, releases in August 2010; Appelbaum is currently writing book three. The mother of two young children, she often wakes at 4:30 A.M. and writes until her husband leaves for work. She treasures the quiet intensity of predawn hours. "You're transferred from your dream world right to your desk," she avers. "The less time from bed to desk, the better."

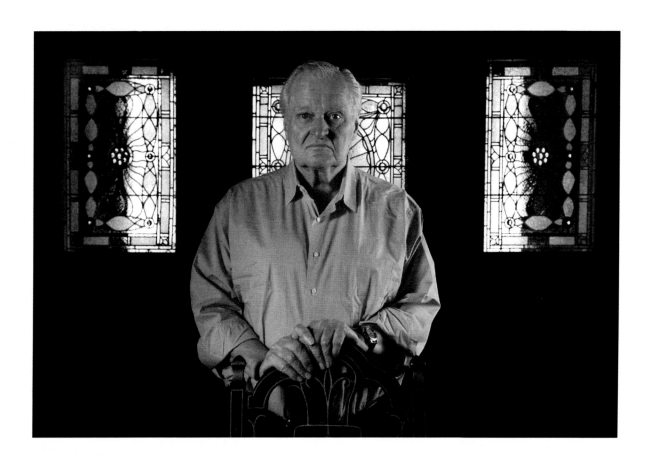

John Ashbery

"ATTENTION, SHOPPERS." This may not be the opening gambit most readers expect from a poet who's won every major award in the pantheon, but John Ashbery often defies expectations: These K-Mart–tinged words launch his poem "Wolf Ridge."

There are few laudatory adjectives critics haven't applied to Ashbery's twenty-six books of poetry; "dazzling," "sublime," and the like have become shopworn. His 1975 *Self Portrait in a Convex Mirror* won an unprecedented triple crown, garnering the National Book Award, the National Book Critics Circle Prize, and the Pulitzer. In September 2007, Bard College hosted a three-day celebration honoring the poet's eightieth birthday, drawing such overflow crowds that nearly every event was moved into some larger venue.

Ashbery divides his time between a Manhattan apartment and a magisterial Victorian home in Columbia County. His partner of thirty-seven years, David Kermani, a slight, dark-haired man with a seemingly permanent smile, opens the door to an alternate universe, ushering guests through the oak-paneled entryway, past a huge stained-glass window of striking amber and butterscotch hues, and into a formal dining room lined with deeply textured maroon wallpaper. Like the woodwork, beveled mirrors, and tile fireplaces, it's original to the house. The careful arrangements of porcelain geishas, trompe l'oeil plates, Little Orphan Annie teacups, and the like are pure Ashbery.

The eclectic mix of architectural classicism and vintage curios mirrors the juxtapositions of high and low diction in Ashbery's poems. The late Jim Ryan, curator of nearby Olana, once told Kermani, "Someday this house is going to be seen as a major work by John Ashbery." Kermani ran with the concept, publishing an essay called "In Context: 'Created Spaces' as a New Resource in Ashbery Studies" in *LIT* magazine, in which he described these live-in collages as "a kind of physical poetry."

"Of course, John won't say any of this is conscious, just the way he won't discuss the meaning of his poems," Kermani says, passing through a butler's pantry with a well-stocked bar and into the kitchen. The table is piled with junk mail and newspapers, and there's a microwave squatting on top of a coal stove. In front of it stands the poet, in his stocking feet. If he's surprised to be interrupted, he covers it gracefully.

Ashbery is a large man, with a handsome, square face and a corona of silky white hair. He's wearing a light blue shirt that brings out the tint of his eyes. He walks with some stiffness, but his gentle, mellifluous voice is that of a much younger man.

He settles into a favorite upholstered chair in the parlor, with antimacassars on both arms. Ashbery and Kermani bought some of the house's original furniture from the former owners when they took possession in 1978. "Just from having sat in the same place for eighty years, it has a kind of authority," he says, flashing a gap-toothed smile.

Born in Rochester, he studied at Harvard and Columbia, then spent a decade in Paris, where he worked as a translator and wrote about art for the *International Herald Tribune*. He also wrote poems, in fits and starts. In 1956, his collection *Some Trees* was selected by W. H. Auden for the Yale Younger Poets Series.

Ashbery and his peers, including Frank O'Hara, Kenneth Koch, and James Schuyler, were dubbed the New York School of poets. "We didn't think of ourselves as a school," he insists. "We were a group of friends who wrote largely for each other, since we didn't have any other audience and didn't expect to." Gallery owner and publisher John Myers chose the label, hoping the luster of New York School painters Jackson Pollock and Willem de Kooning would shine on "his poets."

Fifty years later, Ashbery remains on the cultural vanguard. He was MTV's first Poet Laureate, and has collaborated with experimental filmmaker Guy Maddin. Movie references abound in his poems, which also employ such cinematic devices as intercutting, montage, and flashbacks. He's equally conversant with music, favoring contemporary classical and avant-garde composers. John Cage's I Ching–based "Music of Changes" was "very influential when I heard it in my early twenties," he relates.

The musical influence is reciprocal: composers including Ned Rorem and Elliott Carter have composed settings for Ashbery's verse. There's a similar cross-pollination in visual art. Ashbery has provided texts for Robert Mapplethorpe, Joe Brainard, and Archie Rand; in 2008, he exhibited his collages at Manhattan's Tibor de Nagy Gallery. "Since I wanted to be a visual artist when I was a kid—I took art classes at the Museum of Rochester—I have a visual artist's take on how a poem should be, for instance, 'I should move a piece of this over there'; 'This needs a certain color,' rather than a certain word,'" he explains.

Larissa MacFarquhar's 2005 *New Yorker* profile details a day in the life of John Ashbery, full of the procrastinatory yet somehow essential practices most writers embrace: cups of coffee and tea, phone calls to friends, reading, playing significant music. "What he is trying to do is jump-start a poem by lowering a bucket down into a kind of underground stream flowing through his mind—a stream of continuously flowing poetry, or perhaps poetic stuff would be a better way to put it. Whatever the bucket brings up will be his poem," MacFarquhar reports.

This method has changed little over the years. "I suppose what's changed is that when I was young, I was more intimidated by the process of writing," says Ashbery. "I didn't try to do it very often—maybe I felt that I'd sort of use up my artistic capital. And I would revise endlessly. As the years go by, I've become much more casual about writing. If I'm not pleased with something, I tend to discard it rather than reworking it to death."

The contents of Ashbery's bucket may confound, even enrage, some readers. Adam Kirsch wrote in *The New Republic*, "Ashbery, like God, is most easily defined by negatives. His poems have no plot, narrative, or situation; no consistent emotional register or tone; no sustained mood or definite theme. They do not even have meaningful titles. So complete is Ashbery's abandonment of most of what we come to poetry for that his achievement seems, on first acquaintance, as though it must be similarly complete: a radical new extension of poetry's means and powers, or an audacious and wildly successful hoax."

Ashbery is aware of his reputation for inscrutability, but insists that the poems are their own explanation: "I don't know why I would want to analyze my own poetry. If I knew too much about it, I wouldn't be able to write it."

When he teaches, Ashbery says, "I try to figure out the way a young poet *wants* to write, and point him in ways that turn out to be helpful." He assigns students to write poems based on Italian rebus puzzles and Max Ernst collages, or "translate" from languages they don't speak, such as Finnish. "I try to disorient them, really—disorientation being a state of mind from which poetry emerges. It's for their own good." There's that smile again, cracked in the center, suggesting a mischievous schoolboy.

Ashbery spent his school years in two very different households. His father owned an orchard in western New York; Ashbery shudders, recalling his "terrible temper." He spent most of his early childhood with his maternal grandparents in Rochester. His grandfather was a physics professor, gentle, bookish, and "interested in whatever was new": X-rays, talking pictures.

Young John adored movies. "The RKO Palace was a real palace, sort of like the Eighth Wonder of the World, with grand chairs in the lobby, ornate decorations. I won a contest to be on the *Quiz Kids* radio program—the final quiz was held on the stage of the RKO," he recounts. "The first movie I ever saw was the 1933 *Alice in Wonderland*, with W. C. Fields as Humpty Dumpty and Gary Cooper as the White Knight. I was five. It was a double bill with Disney's *Three Little Pigs*—no, Frank Buck in *Bring 'Em Back Alive*. He was a sort of adventurer and animal explorer. They showed a python swallowing a live pig. It was amazing because it was a *movie*—anything on the screen would have been equally amazing."

When John turned seven, his grandfather retired and moved to a country house on Lake Ontario. "I always felt this as the end of paradise, a place I could never go back to," Ashbery says, turning his gaze out the window.

The Victorian house in Hudson, found after a long search which Kermani likens to "scouting for a film location," reminded the poet of his grandfather's house in Rochester. Kermani claims that Ashbery fell in love on the front porch, telling the realtor, "I'll take it," before he'd seen all of its rooms.

Ashbery describes moving into his home as a "way of reliving a pleasant childhood." He opens his eyes very wide, a characteristic expression which seems to suggest he sees more than most people. "Not everyone goes out and tries to *replicate* it. Most people would be content just to remember their childhood—I don't know what it says about me that I wanted to live there."

Like John Ashbery's poetry, it says many things at once, letting each listener find his own meaning. And though Ashbery must rank among the least autobiographical of contemporary poets, such musings may bring to mind the closing lines of "A Man of Words," from *Self-Portrait in a Convex Mirror*: "Just time to reread this / And the past slips through your fingers, wishing you were there."

Shalom Auslander

A NINE-YEAR-OLD BOY goes to a swimming pool Snack Shack and orders a Slim Jim. No biggie. Unless, of course, he's an Orthodox Jew.

In Shalom Auslander's furiously funny memoir, *Foreskin's Lament*, the non-kosher meat stick looms huge: "I was about to cross a line that nobody I knew had ever crossed, a line Rabbi Shimon bar Yochai said that God said could never be uncrossed.—*He who eats forbidden foods*, God said to Rabbi Shimon bar Yochai,—*can never be purified.* Once you go Snack Shack, you never go back."

Auslander grew up in Monsey, an ultra-Orthodox enclave in Rockland County. He's a frequent contributor to NPR's *This American Life*, reading short fiction from his collection *Beware of God* and essays about an upbringing he likens to that of a veal calf. From *Foreskin's Lament*: "The people of Monsey were terrified of God, and they taught me to be terrified of Him, too—they taught me about a woman named Sarah who would giggle, so He made her barren; about a man named Job who was sad and asked,—Why?, so God came down to Earth, grabbed Job by the collar, and howled,—Who the fuck do you think you are?"

If this raging authority figure was omnipresent, he also came in a scaled-down model for home use: Auslander's punitive, hot-tempered father. The family dynamic was also burdened by the mysterious death of a two-year-old son, whom young Shalom sometimes envied for getting out early.

Auslander got out too, at least physically; he still fears God's wrath so acutely that his preternaturally understanding wife Orli calls him a victim of "theological abuse." Though the poolside Slim Jim was a gateway drug to other rebellions (shoplifting, pornography, pot), he didn't escape Orthodox Judaism without a fight. Early in their marriage, he and Orli moved to a community in New Jersey where they kept kosher and observed Sabbath prohibitions against work or driving, once going so far

15

as to walk fourteen miles to a Rangers game at Madison Square Garden. They now live outside Woodstock with their two young sons, Paix and Lux, and two much-walked dogs.

It's easy to spot Auslander at Bread Alone cafe—he's bent over a notebook, frowning. He's just come from the writing office he rented on Tinker Street a few weeks after Paix was born, where he's been wrestling with a novel tentatively titled *Leopold Against the World.* "It's about a genocide, but funny," he says. "It's really about the family it's happening to. It's not the first genocide they've been through. They have terrible luck."

Today's wrestling match did not go well. "I've basically wasted two years," he says grimly. "I'm throwing it out." Asked if he's really abandoning the novel, or just in a cycle of beating himself up, he says without missing a beat, "That's a forty-year cycle."

Auslander's metaphors for his creative process are grueling. "I've spent the last year and a half wielding a scalpel, cutting through bone, wincing as I reach inside and fiddle around with the organs," he says. "It's Kafka's Hunger Artist—you lock yourself in a cage and starve to death. That's the job. You perform open-heart surgery on yourself."

What fun.

Auslander is wearing a dark shirt and jeans with motorcycle boots—he likes riding on racetracks. His hair is cut short and his brows knit over dark eyes with unusually long lashes—it's easy to picture him as a bright-eyed, bewildered boy in a yarmulke who learned to protect himself by being funny. He heads into an interview wielding a smart-ass, outrageous persona he gradually sheds, revealing a thoughtful, sensitive man who reveres Samuel Beckett and Voltaire's *Candide*, and who isn't afraid to say, "What makes me happy? My sons—seeing them together. And I couldn't go more than a few days without taking long walks with my wife, just talking together. Book tours are hell on me. I love solitude, but not from her."

Is Shalom Auslander getting, God forbid, *mellow?* Not quite. Asked how he feels when he sees Orthodox Jewish families at Thruway rest stops, he deadpans, "That's why I keep a handgun in my glove compartment. I try to stay as far away from

Rockland County as possible." When a *New York Times* reporter wanted to take him on a roots cruise to his old school and *shul* on Rosh Hashana, Auslander told him, "Okay, but we're taking your car, not mine. I know these people. They throw rocks through windshields."

This year's Rosh Hashana is two days away, and Auslander's young family will celebrate with a distinctly un-Orthodox annual ritual: picking apples at the Stone Ridge Orchard and inviting friends over to cook. "I often forget about holidays," Auslander reports. "My shrink reminded me. He said 'Happy New Year.' He's just trying to keep me crazy to drum up work for himself."

Therapy has been a lifesaver. Auslander calls it "my new religion" and says of his therapist, "He's wise and centered, two things I'm not." His therapist also urged him to start writing, at first in a journal, then for publication. "Before that I just ranted and raved, often aloud. Every job I ever worked in, I was asked to leave."

He does have a talent for burning his bridges. While writing *Foreskin's Lament*, Auslander severed all ties with his family, becoming a very black sheep to the faithful herd. He's often accused of being a "self-hating Jew," but that misses the point; his beef is not with Judaism but with fanaticism, and the notion that "God-fearing" should be a compliment.

"I get pegged as dark, angry, whatever—all I'm writing about is, why does it have to hurt?" Auslander says. In an interview with *Bookslut*, he observes: "It would be a much better religion—any of them—if it was '*We* shall not kill.' Including Himself in the commandment. The way we have it now, it's more like, 'You don't kill, I'll do whatever the fuck I need to.'"

Auslander is raising his sons to know that parental love doesn't depend on whether or not you eat cheeseburgers, but sometimes the "anything goes" spirit of his new hometown makes him squirm. "I have—no surprise here—a love/hate relationship with Woodstock. Tuesday I want to burn it to the ground. Then Wednesday we go to the Farmers Market and see lots of people we like, walking around, playing music. We go to the playground, my son is happy, contented, safe—I wouldn't trade it for anything."

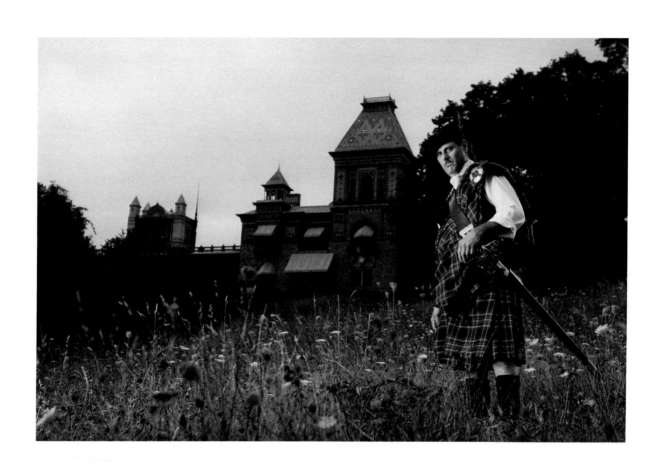

Scott Ian Barry

"HERE'S HOW YOU SUM UP MY LIFE: you can call me Wolf Man/Rob Roy," says Scott Ian Barry. The Woodstock author, wolf behaviorist, lecturer, photographer, and sword collector answers to both names. His Wolf Man guise began "organically and intrinsically" in early childhood. While other kids in his Flushing, Queens, neighborhood played cops and robbers, he'd drop down on all fours, becoming a wolf or dog. His mother remembers him plunking his arms on the table, demanding, "More meat!"

"The fact that I am from New York City made my need for wolves and wilderness that much greater," he writes in *Wolf Empire: An Intimate Portrait of a Species*. Alongside photographs praised by Ansel Adams, Barry observes pack behavior in Ontario's Quetico Provincial Wilderness and reminisces about his cross-country tours to present wolves at schools, museums, and other venues, including a concert at Carnegie Hall when he got a capacity crowd to howl along with a wolf named Slick.

In 1980, Barry was *Cosmopolitan*'s bachelor of the month, posing with Slick and receiving copious fan mail, though he had a girlfriend—and a pack. His first live-in wolf, Jalene, was donated by an Oklahoma zoo. He also raised a cub named Raven, buying her Huggies disposables. In the wild, a female wolf once turned her backside to him, swishing her tail in an invitation to mate. "Till the day I die, I will be given no greater compliment," he writes in *Wolf Empire*.

But wolves aren't his only love. For over a decade, he's been donning an eighteenth century "great kilt" to attend Scottish games, Celtic festivals, and lectures as "Rob Roy" MacGregor. He's also been taking photographs for his new book *Castles of New York*. Hudson Valley favorites include painter Frederic Edwin Church's Moorish-inflected Olana, Lyndhurst, Wing's Castle, and Troy's Emma Willard School— "perfect, a gem."

"Almost every one of these places was built as an expression of love," Barry notes. Besides, he says, "Photographing castles is like taking candy from a baby. They don't move."

19

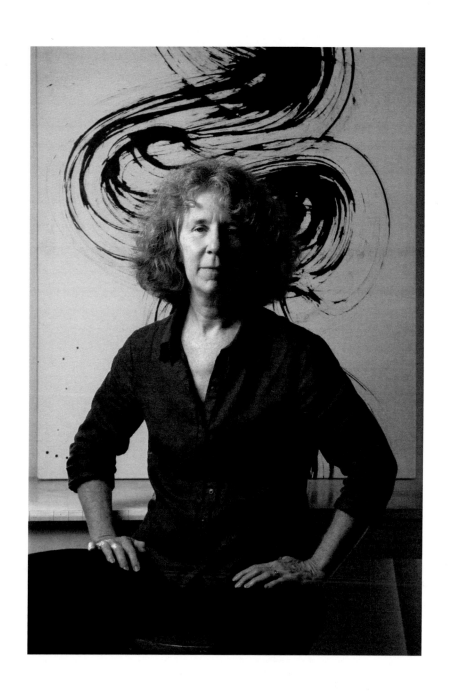

Barbara Bash

MUSIC FILLS Barbara Bash's airy, light-filled studio, high on a windswept knoll in Accord, with Tibetan prayer flags fluttering amid sere winter grass. She's married to Indian flute virtuoso Steve Gorn, whose workroom adjoins hers. Bash sits before a rack of enormous calligraphy brushes, their outsized handles and unruly hanks of black horsehair suggesting punk feather-dusters.

The giant brushes' output is displayed around the studio, in great, Asian-influenced swirls of calligraphy. There's a Balinese ceremonial umbrella furled in one corner, and the walls display many of Bash's illustrations, including a spread from *True Nature*, a lushly illustrated journal detailing four seasons of solo retreats in a remote Catskills cabin.

"In elementary school I loved to draw and write the name of the thing next to it. Words were always a part of it," says Bash, who grew up in suburban Chicago. After college, she worked as a calligrapher and botanical illustrator, merging these interests with *Tree Tales*, a Sierra Club series for children. "I was always on the lookout for something in the natural world that piqued my interest. Then I heard about giant saguaro cacti being pollinated in the middle of the night by long-nosed bats." From the southwestern desert, Bash traveled to India, Africa, and the Pacific Northwest to research banyan, baobab, and Douglas-fir trees.

Though her books are meticulously planned, Bash says neither words nor pictures come first. "I'm always working in both forms, verbal and visual. It's like two trains on parallel tracks that will pull into the station at the same time. First one pulls ahead, then the other. The text changes what I want to illustrate, and the final art changes what I'm going to say."

A practitioner of Tibetan Buddhism, Bash is accustomed to sitting meditation and contemplative rhythms; her handwritten text invites readers to move at a gentler pace. "All the books have a deeper message: you can go outside to sit and draw too."

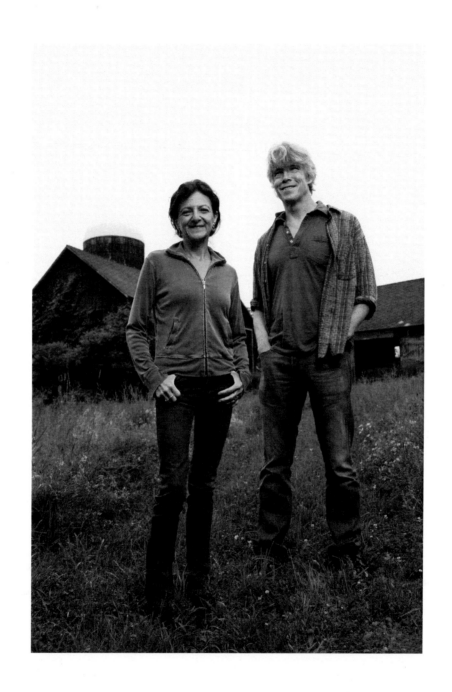

Helen Benedict
and Stephen O'Connor

YES, THERE REALLY IS a Medusa, New York. For the past ten years, the Albany County hamlet has been a second home to a literary couple who, while not at all monstrous, do seem a bit superhuman.

A professor of journalism at Columbia University, Helen Benedict has written five novels and five books of nonfiction. In April 2009, Beacon published her wrenching expose *The Lonely Soldier: The Private War of Women Serving in Iraq*; seven months later, SoHo Press released *The Edge of Eden*, an elegant, often wickedly funny novel about a British family's disintegration in the last-gasp colonial outpost of the Seychelles islands in 1960. Each is a marvel on its own terms; that they come from the same writer's hand smacks of sorcery.

Benedict's husband, Stephen O'Connor, is equally protean, publishing short fiction and poetry (*Rescue*), memoir (*Will My Name Be Shouted Out?*), and nonfiction (*Orphan Trains: The Story of Charles Loring Brace and the Children He Saved and Failed*) between teaching gigs at Columbia and Sarah Lawrence. He also writes a hilarious set of driving directions, guiding the uninitiated through T- and Y-shaped intersections, a misleading road sign ("IGNORE IT"), past Camp Medusa ("An Adventure in Christian Living"), and onto a series of winding back roads. Just as the thought dawns that he recently published a story in the *New Yorker* about the Minotaur, and might have a thing for insoluble mazes, the couple's pristine Victorian farmhouse comes into view, surrounded by thirty-nine acres of meadows, rambling barns, and outbuildings.

They're a striking pair. Benedict is petite and whippet-thin, with enormous green eyes and a piquant face; born in London to American parents, she has a distinct British

accent. O'Connor, broad-shouldered and handsome, grew up in New Jersey, the son of an Irish immigrant father and a French mother. They met as graduate students in a Berkeley writing class taught by Leonard Michaels. Their bond was immediate. "I looked at Steve and thought 'Wow!'" says Benedict. "And we were each other's favorite writers in the class."

Benedict had just come to America, fresh from a job at "a really crappy paper" in England. The pull between fiction and journalism has always been with her. "Fiction was my first love, ever since I was eight, but I wanted to make a living," she says. "I also have this really political, burning side. Writing nonfiction is more of an activist impulse than anything else."

The Lonely Soldier came out of anti–Iraq War protests at which she heard soldiers and veterans speak out against war. Realizing that "women soldiers had their own stories to tell," she started to interview them. Initially, she wanted to find out why women would enlist in the military, and what it was like to be a woman active in combat. What she uncovered—from deceitful recruiting techniques to relentless sexual harassment and frequently unreported assaults by male colleagues—makes for gut-twisting reading. *The Nation*'s Katha Pollitt wrote, "*The Lonely Soldier* will shock you and enrage you and bring you to tears."

Benedict structures her narrative around five women who fought in Iraq between 2003 and 2006. She interviewed around forty female soldiers, eventually weaving an Off-Broadway play, *The Lonely Soldier Monologues*, from the women's own words. (Specialist Mickiela Montoya: "There are only three things the guys let you be if you're a girl in the military—a bitch, a ho, or a dyke.")

"It was very important to me that it be a documentary play and that I not mess around with their words," she says. "It's not my story, it's *their* story. I wanted to step out of the way, be a vehicle." When director William Electric Black staged the play at Theatre for the New City, several interviewees came to see it. "It was surreal and hard and traumatizing for a lot of them, but also cathartic and amazing," reports Benedict. "They went out for drinks afterwards with the actresses, they were like sisters." Nevertheless, she called afterwards to make sure they were all right.

While researching her 1985 book *Recovery: How to Survive Sexual Assault*, Benedict trained for ten weeks as a rape crisis counselor at St. Vincent's Hospital. Another book, *Virgin or Vamp: How the Press Covers Sex Crimes*, applies a different lens to the same topic. "From a very early time, I've been infuriated by injustice of all kinds, and especially this," she asserts. "Rape itself is such a ghastly act, and its victims are treated so badly by society—they're *blamed* for it. That double injustice—I just can't stand it, it gets me inflamed. It stands in for all kinds of injustice: race, class. It's always one on top of another and another."

She's currently writing a new novel set in Iraq. "There were whole inner layers that I came to understand that were more intuitive," she says. "What do you *feel* when a prisoner throws excrement on you, when your sergeant is making passes at you all day long, when someone you thought was a friend assaults you?" About half the novel is narrated by an Iraqi woman. It's a nervy choice, but Benedict, who conjured the voices of a Dominican teen mother in *Bad Angel* and Greek islanders in *Sailor's Wife*, is unfazed. "Writers have been crossing cultures and genders and ages and times *forever*," she says. "I think we've gotten narrow about that, maybe because of all this P.C. business."

The Edge of Eden's third-person narrative dips freely into the minds of a wide range of characters. "I didn't want only the British point of view," Benedict says. "In old-fashioned novels, the 'natives,' quote unquote, are never full human beings." Here, Sechellois Marguerite Savy assesses her British employer: "At times Penelope reminded her of the local cattle egrets, stalking around on spindly yellow legs, eyes wide and empty, with no clue as to what they were really seeing." (Marguerite may be short-changing Penelope, who can look at her onetime lover and his wife and notice "his hand resting on her plump shoulder with the casual possessiveness of a man holding his bicycle.") Benedict's prose glints with such deft observations, along with vivid evocations of a landscape where even the plants appear oversexed.

In 1960, when Benedict was eight, her family moved to Seychelles. "My father was an anthropologist and my mother became a de facto one, helping him with his fieldwork," she says. "I had this whole rich experience and many memories and had

never used them in my writing in my whole life, partly because I shy away from anything autobiographical."

Though Zara, the older daughter whose dark fixations precipitate some of the novel's most wrenching twists, is the same age Benedict was during her family's stay in Seychelles, her fictional family is based on London classmates whose parents were sent away during the Blitz, raised by nannies, or farmed out to boarding schools. "How do people learn to be parents if they were exiled from their homes and basically grew up without a family?" she asks. "That began to fuse with the kind of decadent way European adults behave when they're in the tropics. Even at age eight, I was definitely aware of that with the British adults in Seychelles."

Benedict's approach to fiction is largely intuitive: "I never think out novels in that much detail. The imagination that's at work when you're actually writing is so much more intelligent than the brain that plots and plots. I tend to just pour out a novel and see what happens, do it really fast, then spend years rewriting."

O'Connor and Columbia County novelist Rebecca Stowe are always her first readers. Benedict shares her work "when I get blind to it—when I know it needs work, but don't know *what.*" Her husband concurs, adding, "We literally started our relationship showing each other our work, and we've been doing it ever since."

Several years ago, on vacation in France, O'Connor set himself a challenge. "I decided to write fourteen lines of verse every day. My only requirement was that it could not make sense," he says. "I was sick of the way I'd been writing. I wanted to explode out of my voice, smash my voice. I'd sit down to write poems and I had to surprise myself with every line. I found I was getting at material I've never gotten at in my life. It completely changed the way I wrote." O'Connor just sold a story collection to Free Press for publication in June 2010. He'd published many stories in magazines, but found little interest in a new collection until "Ziggurat" appeared in the *New Yorker.* His agent sold the book that weekend.

Accomplishment seems to run in the family: O'Connor and Benedict's son, Simon, plays lead guitar in rising alt-rock band Amazing Baby, and college-bound

Emma has won scholarships for her writing. When they were younger, their parents made charts, dividing the days so they'd each have time to write. "It sounds awfully mechanical, but I think it was a good idea," says Benedict. "You knew exactly when you were going to write, and the non-writer would handle all phone calls, chores, et cetera. It's very good for not messing about. If you only have three or four hours, they become sacrosanct."

O'Connor agrees. "Before we had kids, I could only write when I was inspired. Then it became, my god, if I've got five minutes, I'll write for five minutes. If I've got ten hours, I'll write for ten hours. Otherwise, I wouldn't be writing at all." He shakes his head. "It's hard to do all this *and* be a husband and father."

Benedict snuggles next to him on the couch. "Are you a husband and father as well?" she asks teasingly.

"Sometimes," smiles O'Connor. "We're maniacs."

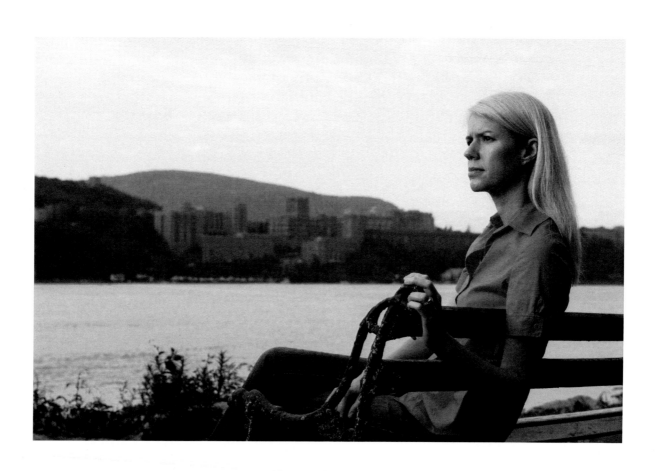

Gwendolyn Bounds

GARRISON'S LANDING is a sleepy cluster of houses, some sporting American flags for the Fourth of July. Just beyond the old train station, across from West Point, rests the former Guinan's Pub and Country Store, the nonpareil gathering place immortalized in Gwendolyn Bounds's *Little Chapel on the River*.

"What's been amazing and surprising is not only how many people took it to heart locally, but nationally and internationally," Bounds says. Three years after publication, she still receives daily emails from readers who have similar places in their lives.

A fast-track *Wall Street Journal* reporter, Bounds lived across the street from her office in Lower Manhattan. It was an ideal arrangement, until the morning of September 11, 2001. When the planes hit, she and her girlfriend fled their apartment in the clothes they were wearing. After six weeks of temporary housing arrangements, fate led them into the family-run Irish pub that would change Bounds's life. Her book's subtitle, *A Pub, a Town, and the Search for What Matters Most*, says it all.

"When you truly fall in love, whether with a person or a place, you make everything else fit around it. The last eight years of my life have been a love affair with this place," she asserts. Within days, they'd moved to Garrison, and soon Bounds was bartending, part of the network of "human duct tape" that kept Guinan's open through its founder's twilight years.

Jim Guinan died in 2009, soon after St. Patrick's Day. The pub's doors are padlocked and knee-high weeds sprout where picnic tables once housed the spillover crowd on Irish Nights. But its spirit endures. In May 2008, Bounds and entertainment reporter Lisa Bernhard exchanged vows at nearby Boscobel estate, with a reception in the rose garden overlooking the Hudson. "It felt like all the different pieces of my life were coming together," says Bounds, delighted that so many Little Chapel regulars came to celebrate her wedding. "Red staters and blue staters all came together at Guinan's."

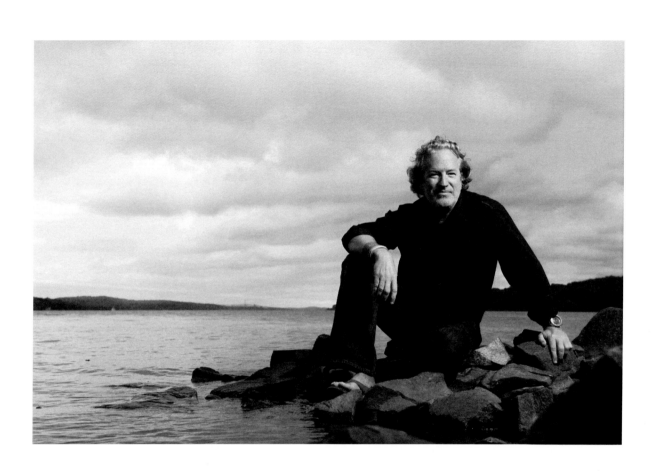

Jon Bowermaster

THERE ARE SOME WRITERS you don't interview in a coffee shop. Since *National Geographic* explorer Jon Bowermaster's ten books and eight documentaries recount such adventures as dog-sledding both Poles, making first-ever rafting descents of wild rivers in Chile and China, and kayaking eight hundred miles of Vietnamese coastline, it seems only right to propose a small expedition: a photo shoot at the Saugerties lighthouse.

On the morning of our proposed trek, the sky is awash with rain and crackling thunder. Bowermaster answers his phone cheerfully at 7:15 A.M. and reschedules for late afternoon. When we meet at the trailhead, he's pulling two extra rain jackets from the back of his Land Cruiser, "just in case."

Bowermaster has been to the lighthouse many times, but not overland: he usually kayaks across from the Tivoli Bays. He starts telling travel stories as soon as his feet hit the trail. Last year, he completed his decade-long Oceans 8 project, which he describes as "sea kayaking around the world, one continent at a time, studying the health of the seas and the lives of people who depend on them." The final voyage is the subject of his latest film, *Terra Antarctica*, which offers sobering evidence of global warming, with shrinking glaciers and rain-soaked penguin chicks dying in unfamiliar mud. After a sneak preview to benefit the Stone Ridge Library, the documentary premiered at the Blue Ocean Film Festival in Savannah, Georgia, where it was nominated for Best in Festival and won Best Ocean Issues. Bowermaster's other Oceans 8 films detail expeditions to the Aleutian Islands, coastal Vietnam, French Polynesia, Gabon, Croatia's Dalmatian Coast, the Andean Altiplano, and Tasmania.

The logistics were fearsome. Each expedition's crew, including videographers and photographers, had to be expert kayakers. International shipments of gear sometimes went wildly awry: kayaks bound for Hanoi wound up in Ho Chi Minh City

("like dropping them in Miami when you need them in Boston"), and the Antarctic-bound kayaks were held up in a container strike in Peru, arriving just hours before their polar vessel went south. The six-man crew traveled heavy as well, bringing fifty bags filled with "at least two of everything. If something breaks, you have to have backup," notes Bowermaster; repair shops do not dot the pack ice.

On some trips, the logistical nightmares were more bureaucratic in nature. The Vietnamese government met Bowermaster's proposal with a terse "That will be quite impossible." The journey, described in his 2008 book *Descending the Dragon*, was memorably accompanied by a karaoke-loving, ocean-phobic factotum named Linh.

During Oceans 8's ten-year span, its film gear advanced from unwieldy VHS to HD digital. Add computers, portable satellite phones, and beacons, and, Bowermaster says, "you can be in touch from *anywhere.*" In November 2008, when the tourist ship *Explorer* hit an iceberg and sank in the Antarctic Ocean, he and his crew were the first responders. Within ninety minutes, Bowermaster had been interviewed by the *New York Times* and was doing a live feed on *Good Morning America.* He's posted internet dispatches, filed magazine stories, and uploaded photos from around the globe.

But whatever equipment may be available, one ritual remains stubbornly low-tech: Bowermaster writes for an hour every night with a notebook and pen. "Everywhere we go, I'm resolute in sticking with that pen," he says. Since it's impossible to take notes while paddling, he's learned to store up his impressions and let them unfurl in his tent at the end of the day, recreating sounds, smells, and weather with evocative strokes.

Nothing in Bowermaster's upbringing suggested the life he now lives. He grew up in a suburb outside of Chicago; both parents were teachers. "We weren't a traveling family," he says. "I've never been on a plane with my siblings or parents." Trained as a journalist, with a graduate degree in government and politics, his first book was a biography of five-term Iowa governor Robert D. Ray. His second changed everything.

Bowermaster's introduction to adventure travel was collaborating with polar explorer Will Steger on his 1989 book *Crossing Antarctica.* As a shakedown cruise,

Steger brought the young journalist on a New Year's Eve hike in the thigh-high snow of his northern Minnesota homestead. "I guess he figured if I could keep up—which I did, barely—I'd be all right," says Bowermaster. He joined the international team on training trips in Greenland and Canada, and accompanied them on several stretches of their historic journey by dogsled across the seventh continent.

"I started writing about expeditions, then going on them," he explains. In the introduction to his anthology *Alone Against the Sea and Other True Adventures*, he states, "I am a writer, first and foremost. Which makes these stories, and their sharing, the most valuable part of my wanderings."

Bowermaster's latest book, *Wildebeest in a Rainstorm*, is subtitled *Profiles of Our Most Intriguing Adventurers, Conservationists, Shagbags, and Wanderers*. His profiling technique is simple: Spend as much time as possible with your subject. For a *Harper's* profile of Native American activist Winona LaDuke, Bowermaster slept on her couch for three days. He learned this approach from legendary rock photographer Jim Marshall. "I asked him how he got that intimacy with people who'd been photographed so often, and he said, 'It's about *time.*' We've moved into an era where if you get thirty minutes with someone, you're lucky. Marshall went on the road with [rock stars], lived with them, changed their kids' diapers. When you have that kind of access, people get comfortable, they forget they're being recorded."

Indeed. Bowermaster's long profiles are sometimes so frank that friendships have suffered. "People are more unguarded when they're being interviewed by someone they know, they feel like you're just hanging out," he says, adding ruefully, "Even if the piece is 95 percent positive, that other 5 percent is what they'll remember. It's just how it is."

Bowermaster met his partner, naturalist and photographer Fiona Stewart, on a kayaking trip to an island near Tasmania. "We were there for a big bird migration of short-tailed shearwaters, also called muttonbirds. They're incredibly noisy and really bad fliers—they'll use you as a way to stop," he says. Flinders Island is populated by eight hundred people and two-and-a-half million muttonbirds. Bowermaster had

contacted a local abalone diver and kayaker about using his house as a base. When the expedition arrived, the diver sent his friend Fiona to check them out. Clearly, she liked what she saw. "It's really great to be with someone who comes *with* you," says Bowermaster, citing the heavy relationship toll of the itinerant life. "Most adventurers have been married and divorced three or four times. The issue's impossible to avoid, it comes with the territory."

He admits to spending more time on the road than at home—in his busiest year, he stayed in Stone Ridge only seventy-seven days. His travel essentials include "a comfortable pillow and Tabasco sauce," the latter because expedition food can be tasteless; some polar explorers subsist on a diet of seal meat and butter sticks. Bowermaster's favorite expedition meal was smoked fish and a smuggled flask of plum brandy; the worst, "some kind of pig-knuckle thing at an end-of-the-road in Nicaragua."

Between adventures, he gives lectures and slide shows all over the country. "In places that are far from the ocean, say in the Midwest, I remind audiences that we're all connected. I'll ask, 'Have you ever been for a holiday on the beach?' A bunch of hands go up. 'Do you ever eat fish?' More hands go up. Even if you're not one of the three billion people within sixty miles of the coastline, you're involved with the ocean," he says. "We're a pretty rapacious species, and we've really damaged the ocean. . . . Everywhere we go, we see overfishing, plastic pollution, the impact of climate change—not just rising seas, but more serious storms. We see it everywhere. *Everywhere.*"

Bowermaster shades his eyes with one hand, squinting up at a northbound line of Canada geese. He wears two silver bracelets over a wristband tattoo, which he got after spending a month on a cargo boat in French Polynesia with a heavily tattooed local crew; the design symbolizes land, sea, and sky. He notes that some tourists get tattoos as souvenirs. "I've seen people sell trips to Antarctica to get a tattoo," he says, shaking his head. "There is no tradition of tattooage in Antarctica. Nor bared skin."

Though he's currently working on a collection of profiles of environmental and ocean activists, including Jacques Cousteau's heirs and Obama's energy czar Carol

Browner, Bowermaster's also mulling a radical concept for a new book: staying home. The adventurer would spend 365 days without going anywhere, making an exploration of his home base. "There are small towns around the world I know better than my own—I've spent more time there," he says, gazing out at the Hudson as if he's comparing its slate-blue waves to some of the wild seas he's seen. "For me, this place says calm. I've lived here for twenty-one years. I come home to recharge."

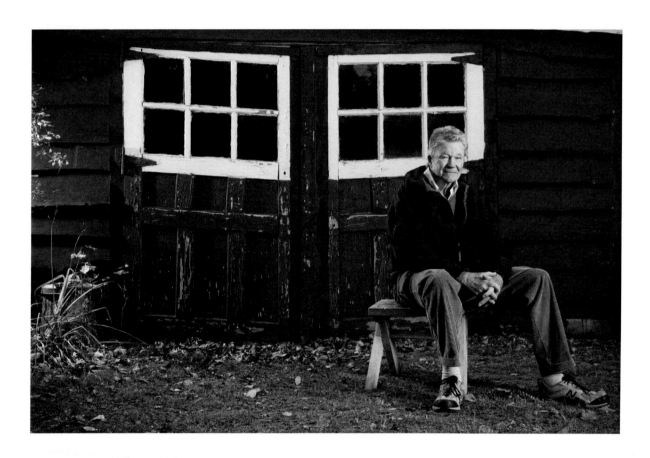

John Bowers

AMERICAN LITERATURE has its own railroad map, with tracks that meander from Sherwood Anderson's Winesburg, Ohio, through Willa Cather's Nebraska to Jack London's Alaska. Readers can add a new whistle-stop: John Bowers's Tennessee.

It's no accident that the railroad looms large in *Love in Tennessee*: the narrator's father, like Bowers's own, is a night telegrapher at a small-city depot in east Tennessee; his young son carries his dinner down the tracks in an old Christmas fruitcake tin. But *Love in Tennessee*, overflowing with idiosyncratic town characters whose lives and loves feel authentic as denim, is billed as a novel, not a memoir.

"Well, sure. I didn't want to be sued or killed," Bowers grins. He's sprawled in his comfortably funky Phoenicia cabin, wearing a sweater that brings out the blue of his crinkly eyes. His folksy cadences and Smoky Mountains lilt seem tailor-made for the radio; he'd be a natural on *This American Life*. Bowers often closes his eyes as he speaks, as if the rich world of words inside his head requires his undivided attention.

He calls *Love in Tennessee* "a fictionalized memoir. It's written about real people, but in some cases they've been changed quite a bit, or made into composites, including the love of my life—of the *narrator's* life," he amends with a glance at his second wife, architect Leslie Armstrong. "All those figures in the book have been in my head since I was twenty-two or twenty-three. They never left my mind. It was an unbidden collection."

Bowers turned eighty last year, so it's been a long marination. That may be why the stories seem perfectly pitched, both nostalgic and fresh. There's the overripe teacher who gives her male students flying lessons, the lustful fat man who looks like Clark Gable from the neck up, the cocky star athlete whose leg amputation changes his fortunes forever. Most of all, there's the never-named narrator, who moves as a small

boy among ladies' rustling nylons, gets his sexual education in the backseats of buggies parked inside a barn, and finally meets his soul mate, the hometown girl he must leave behind to enter the wider world.

It's not the first time he's examined this theme. Bowers's breakthrough novel, *The Colony*, is a *roman à clef* about leaving his Tennessee sweetheart for a wildly eccentric midwestern writers colony run by Lowney Handy and her protégé, James Jones of *From Here to Eternity* fame. For a year and a half, Bowers joined other young men in a monastic apprenticeship, living in tents and motel rooms furnished only with cots, desks, and typewriters.

"Lowney Handy wouldn't tolerate any female that came on the premises," Bowers recalls. "She wanted to keep Jones on the reservation." Her teaching method was unorthodox: her "boys" were instructed to retype great novels. ("Let it seep into your brain and it'll stay there.") Though Bowers, who's taught at Columbia and Wilkes University, doesn't recommend the copying method, he's grateful for his hands-on literary education. "I discovered Edith Wharton at the colony. I read *Middlemarch*, which is as topical as anything written today about a small town." He met Norman Mailer and Montgomery Clift, both of whom blast through *The Colony*.

Bowers's Pygmalion was a rakish journalist named Chandler Brossard. After a colorful series of blue-collar jobs, Bowers moved to Washington, D.C. He was languishing in a bureaucratic job at the State Department—"I was not a diplomat, by far"—when he asked out a co-worker Brossard was tailing for a *Look* magazine piece on "the typical Washington girl." As Bowers remembers, Brossard got "immediately drunk" and advised him, "John, you're wasting your time in D.C. You'll be among the living dead." If he was serious about becoming a writer, New York was the place. Brossard even offered a place to stay, at his *pied-à-terre* on the Lower East Side.

Burning all bridges, Bowers moved to New York in 1962. Brossard had neglected to leave him a key; when Bowers finally got in, his apartment was trashed. But Brossard took him under his wing, introducing him around at Magazine Management—"the last of the pulps," Bowers says—where a staff of ambitious young men including Bruce

Jay Friedman, Mario Puzo, and Joseph Heller ground out questionably factual but well-turned copy for lurid magazines like *For Men Only* and *Male.* "We'd write stories like 'Rockaround Dolls of New Orleans,' 'Wild Women of Moscow,' expose hotbeds of prostitution on Wall Street," Bowers laughs, recalling the audacity of their inventions. "Puzo would write about World War II tank battles that never happened."

But, Bowers says, "At the back of my mind, I still thought of myself as a serious artist. My idols were Hemingway, Fitzgerald, Thomas Wolfe; I was steeped in great literature. My idea of being a writer wasn't to churn out 'Hotsy-Totsy Girls of Tijuana.'"

He started freelancing for more legitimate magazines—*Playboy*, *New York*, *The Saturday Evening Post*—and developed a knack for catching careers on the updraft. The 1971 anthology *The Golden Bowers* includes profiles of a pre-Broadway Joe Willie Namath, just signed by the Giants but still enrolled at the University of Alabama; rising starlet Sharon Tate; Andy Warhol during the filming of *Trash*; Dionne Warwick appearing on *Hullaballoo.* This was the era of long-form magazine pieces and bottomless expense accounts, when an eager young man with a portable Olivetti could spend a year flying cross-country with a rising young singer named Janis, whose outrageous outfits and loud mouth could still get her tossed out of restaurants mid-interview.

Bowers loved Greenwich Village. "If you're from the boondocks, it's really an exotic land," he exults. When *New Yorker* writer Lis Harris reviewed his 1973 novel *No More Reunions*, he invited her out. She demurred, but when he called again, one month later to the minute, she agreed to meet for coffee at the Lion's Head, the "more civilized" of his Village hangouts (the other, the 55 Bar & Grill, was given to brawls). Both had the advantage of being right around the corner. "You could get as drunk as you liked and still make it home," he recalls. "It was a giant dating scene, a rotating door."

He married Harris and they had two sons. Bowers started writing nonfiction, including *In the Land of Nyx*, a study of urban night workers whose title so thoroughly confused booksellers that he once found it shelved under Gardening, and two books about the Civil War. His fact-based books show a novelist's flair. "I couldn't

have Stonewall Jackson become a parachutist," he says. "But even those who do biographies need to make up dialogue, to recreate scenes on the battlefield they couldn't have experienced, so there is an element that's fictionalized."

Bowers gets up to poke the recalcitrant woodstove. Since marrying Armstrong last year, he's become a less frequent Phoenician. "We have five houses and five kids between us," he grins. "We rent 'em out and try to juggle. This place is not San Simeon."

Maybe not, but it fits him as comfortably as an old slipper. There's an oversize office desk in the kitchen and bookshelves in every conceivable nook. The snug living room features a spiral staircase with tennis balls over exposed corners that might bump an unwary head (Bowers, a rangy six foot two, has taken a few in the temple over the years).

He's owned the cabin since 1969. After reading Alistair Cooke's descriptions of an idyllic Woodstock, he took the bus up from the city. "In the back of my mind, I think I missed Tennessee—I wanted trees, a fire, all the things I grew up with. But I was really taken over by New York. New York was my fantasy, and it was coming true." Bowers couldn't afford Woodstock, but bought the first cabin he saw in Phoenicia, writing a check for eleven thousand dollars on the spot. He did not own a car. "I bought a house, then needed a car to go with it," he says, ruefully recalling the rusty VW Bug whose floor sprayed his feet every time he drove over a puddle. "I remember just lying on the couch, thinking, 'What the hell have I done?'" He moved into the cabin and wrote *The Colony*.

Bowers is currently writing a novel with thrillerish genes, *Dead Girls Dancing*. The story seed was a grisly murder in Tennessee; he got intrigued with the case when it turned out several participants had been his classmates. He seems richly amused by the irony of struggling so hard to escape Tennessee and then returning to it again and again in his writing.

Perhaps it goes back to his first published story. Bowers was fourteen years old, and his mother, a literary enthusiast, had just bought him his first typewriter. "I took the advice 'Write what you know' to heart," he explains. "I wanted a dog, so I made it

into a story, with a conflict with the mother and father over the dog." He mailed it off to a magazine he'd found in *Writers Marketplace*, went out to play basketball with a neighborhood boy and forgot all about it. Six months later, a slender envelope came from Philadelphia. "'Dear Mr. Bowers, we're happy to accept your story for publication.' They paid me five dollars. And the editor said, 'We want to compliment you for getting into the mind of a fourteen-year-old boy.'" Bowers's eyes crinkle up as he laughs. "That was something."

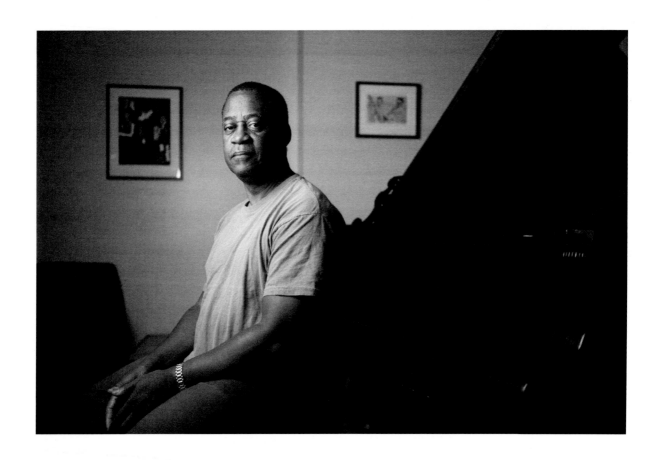

Wesley Brown

THE TURNOFF TO Wesley Brown's home outside Spencertown is marked by a few rusting tractors. An unpaved road meanders alongside a tumbling stream till it reaches a single house, airy and pleasingly spare, standing alone amid a stand of hemlocks. No one appears to be home, though there's a huge crockery bowl of chopped collards on the kitchen counter and cat food in dishes on the floor. After several knocks, the novelist answers the door in bare feet, surprised to see visitors; he's forgotten the interview he called to confirm two days earlier. "See, this is what happens when you come up to the country," he laughs. "There's all this incoming effervescence and you lose track of time."

Brown is compact and burly, with a mobile, intelligent face and a soft voice; he chooses words thoughtfully. He has lived on the same plot of land since 2002, but the old house he bought back then burned to the ground two years later. Brown lost all his books and manuscripts—about forty years worth of work. "A lot of only copies—hundreds of poems, short stories, journals, family photos. Irreplaceable things," he says, shaking his head. Luckily, he had loaned a new draft of his manuscript *Push Comes to Shove* to an editor friend before the fire, "or the book wouldn't exist."

Push Comes to Shove was published in 2009 by the Concord Free Press, an independent press with a genuinely radical business model. A limited print run is available free, with each person who orders one pledging "to give away money to a local charity, someone who needs it, or a stranger on the street," and to pass the book along after reading to someone who'll do the same. Its first two publications—Stona Fitch's *Give+Take* and *Push Comes to Shove*—have raised more than eighty-five thousand dollars to date, with donations logged by readers on five continents; a new novel by Gregory Maguire, *The Next Queen of Heaven*, is forthcoming.

The author's work is also donated; there are no advance or royalty payments. This didn't faze Brown, a literature professor at Simon's Rock whose first two novels were published by Random House and University of Massachusetts Press. "Very few writers earn their way through writing and publication of their books," he says with a shrug. "For most writers, you want to be *read*. I never assumed or expected I was going to make money—it's not some great sacrifice. I felt quite honored to be published by a group that's innovative and very progressive. It's a new way of seeing how a book could find its way in the world, the effect it can have."

This revolutionary publishing concept seems an apt choice for a novel about sixties radicals. It's 1969, Jimi Hendrix is about to play his legendary New Year's concert at the Fillmore East, and Muriel Pointer's lover is shot in a police raid on the black radical group Push Comes to Shove. Brown narrates his tale in alternating first-person voices—shell-shocked Muriel, still "horny with idealism" and groping for answers; and Raymond, the even-keeled history professor who fathers her child but ultimately can't quiet her troubled waters—and occasional spurts of third-person narration, unfurling a broad panorama of social history, from the Patty Hearst kidnapping to the Vietnam Veterans Memorial.

"Culturally and politically, everything seemed to be crossing and connecting: sexual identity, racial identity, the role of women," says Brown. "I tried to capture as much as possible of that era. I don't think, at least in our lifetime, we'll ever see that moment reproduced."

The author's own history echoes his characters'. Brown was a civil rights volunteer for the Mississippi Freedom Party in 1965 and joined the Black Panthers in 1968. He started writing poetry while in Mississippi. "It became clear to me that there was this story, these events taking place—a narrative that included Southern blacks and the young people, black and white, coming from different parts of the country," he says. "Why were these people putting their aspirations on hold? Something more important than a career was drawing them to make common cause with people who, as Ella Baker

of SNCC said, had even more to give, but didn't have the means to summon that up. We had more opportunities than they had, but they had *experience.* There was a story with currents, tributaries, moving in different directions that intertwined. And the news version often bore little resemblance to what I felt going on."

Vehemently opposed to America's involvement in Vietnam, Brown applied for conscientious objector status in 1965, but was never approved. When he got out of college in 1968, his draft notice arrived. He didn't show up for induction. Prison "wasn't one of the things I was looking forward to," he says with a rueful smile, "but there was no question of joining that war. As much as jail was not what I wanted to do, at least it was finite. Leaving, taking flight, is forever. It would have been even more difficult for my folks, because being in touch with me would have meant breaking the law. I couldn't put them into that position."

Paroled after eighteen months of a three-year sentence at Lewisburg Federal Penitentiary, he was accepted into the masters program at City College. The former political prisoner was mentored by Donald Barthelme, took classes with Susan Sontag and Joseph Heller, and wrote a quasi-autobiographical novel called *Tragic Magic*, which Barthelme's agent sold to a Random House editor named Toni Morrison.

Tragic Magic's protagonist, Melvin "Mouth" Ellington, has just been released from prison for dodging the draft. His first night "outside" frames a series of flashbacks to his family life in Queens, radicalization in college ("We called it the 'No Vietnamese Ever Called Me a Nigger' Caucus"), and prison education at the hands of such inmates as Hardknocks ("Once you make up your mind, you your own majority"). Brown's loping, skittering, jazz-infused prose drew praise from such luminaries as Ishmael Reed and James Baldwin.

Brown became a professor at Rutgers, where his writing students included a young Junot Diaz. His next novel was *Darktown Strutters*, a historical fantasia on the apocryphal tale of Jim Crow, a slave who performed a virtuoso jig in a stable—some say in Cincinnati, some say Louisville—which a white man appropriated as a minstrel

dance sensation. "The figure of Jim Crow vanishes into the ether. What about this anonymous slave? Who was he?" Brown muses. "I was free to invent the life of a figure about whom nothing is known except that he's part of some mythology."

He also had three plays produced: *Boogie Woogie & Booker T*, about a turn-of-the-century reporter discovering the eloquence of New Orleans piano; *Life During Wartime*, a *Rashomon*-like reconstruction of the death of graffiti artist Michael Stewart; and *A Prophet Among Them*, about James Baldwin. Brown says his writing "always seems to have a historical context. I'm looking at the fates of individuals who are being pressed by events."

He still has an activist streak, though its focus has gotten distinctly more local. In Columbia County's Democratic party, he says, "zoning becomes the Antichrist. Local people see these carpetbaggers from New York City with their money and mini-mansions, trying to dictate to them what they should do, when all they have is their land. Folks can come in with a kind of arrogance that can be quite patronizing. But I feel really strongly that the fact that somebody comes from someplace else doesn't make them a pariah."

Brown's parents moved from Harlem to the predominantly Italian neighborhood of Elmhurst, Queens, in 1952. His father worked in a tool-and-die factory and his mother was an office worker. "We were perceived with fear and suspicion," he recalls. "Even though we were similar working-class people with similar aspirations, trying to better their lives, that was trumped by the fear of outsiders."

Theirs wasn't a literary household. "Basically, it was newspapers and the Bible," Brown says. "My fascination as a child was with movies." He still remembers seeing *The Thing* in a theatre on 116th Street in 1951, and is well-known among friends for his encyclopedic knowledge of actors and vintage films, mostly from watching them day after day on *Million Dollar Movie*. "I think I caught the bug from my father. He had watched silent movies in segregated theatres in North Carolina. During the Depression, movies were an elixir, an escape. Once they entered me, they never left."

Brown is equally smitten with music, and his living room features a baby grand piano covered with sheet music, mostly jazz standards and Rodgers and Hart. He took piano lessons as a boy, and started studying again twelve years ago, "after a gap of about forty years." The CDs on display are an eclectic mix—Ornette Coleman, Joni Mitchell, Cassandra Wilson—as is the artwork adorning his walls, including a Glenn Ligon print of the opening paragraph of Ralph Ellison's classic *Invisible Man.*

For the past four years, Brown has been organizing author events at the Spencertown Academy's annual Book Festival, featuring such notables as Russell Banks, Mary Gaitskill, and Sharon Olds. The collard greens he's preparing tonight are a side dish for the Academy's "blues barbecue" fundraiser. Brown's recipe includes "olive oil, red wine vinegar, sweet onion, scallions, and a Tabasco/chili/garlic sauce for that sharp boost. And of course bacon." He smiles, aware that he's crossing the bounds of political correctness. "For the vegetarians in our midst, I say eat coleslaw."

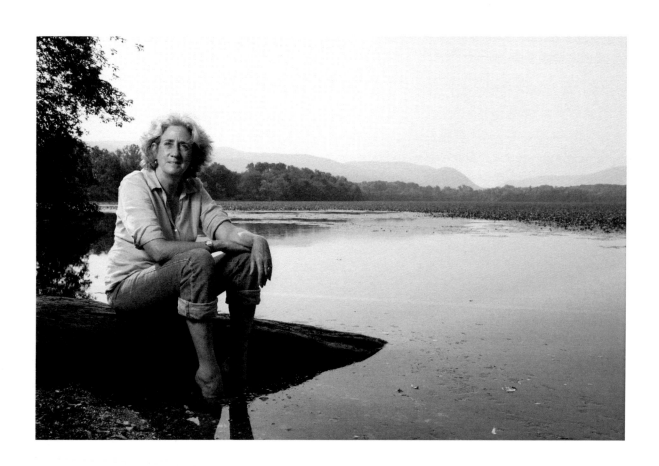

Akiko Busch

AKIKO BUSCH HAS A different perspective on the Hudson River than most writers who live on its banks. "You mean the immersion factor?" asks the author of *Nine Ways to Cross a River: Midstream Reflections on Swimming and Getting There from Here.*

Though she grew up in Millbrook, Busch never swam in the Hudson. "Well, back then, you wouldn't," she says. In 2001, after decades of cleanup efforts by Clear water, Riverkeeper, and other grassroots organizations, she took the plunge with four friends. Thirteen days later, the World Trade Center towers fell. Busch mailed her friend Onni a photo of their group on the riverbank; it arrived in Manhattan weeks later, smudged with ash. They vowed to mark every summer with a river crossing.

"Two years and three rivers later," Busch knew she'd embarked on a book. "As I realized how different each river was—different taste, texture, feel—I realized it went beyond personal restoration, that there was a larger story of river renewal."

Busch has nonfiction bloodlines: both parents were magazine writers. In 1981, she became a contributing editor for *Metropolis*, covering design "from spoons to skyscrapers." Her essay collections *Geography of Home* and *The Uncommon Life of Common Objects* are meditations on design and culture. "For me, design was always about a sense of fit: how the spoon fits the hand, how the building fits the landscape," she says. "When I jumped into the river, I took the idea of fit into a different realm: how we can fit in the natural world."

As Akiko Busch sits on the revitalized Beacon pier, gazing over the Hudson, she seems to fit perfectly. The river is glassine, with a hint of estuarial riptide. A great blue heron preens amid water chestnuts, just beyond Busch's pet project, the River Pool. A floating ring of rainbow-colored benches with a net bottom, the community pool aims to "get a new generation into the water—into *river* water," says Busch, quoting River Pool founder Pete Seeger: "Changing the world, one teaspoon at a time."

Kris Carr

A LOVELY YOUNG WOMAN is framed in the window of Woodstock's Garden Café. Her name is Kris Carr, she has cancer, and she wants to rock your world.

The former actress got an out-of-nowhere diagnosis in 2003, after a strenuous yoga class left her with abdominal pains and doctors found twenty-four tumors of a rare, inoperable cancer called epithelioid hemangioendothelioma. Two weeks later, she started a video diary, which became the TLC documentary *Crazy Sexy Cancer.* Carr explored every form of alternative healing she could find and bonded with other "survivor-babes." Along the way, she married her cameraman, wrote a bestseller called *Crazy Sexy Cancer Tips*, and wound up on *Oprah*.

"It usually takes a trauma for people to wake up. When you wake up, you look around. That's what happened with me," Carr says, stirring her chai. A vegan and raw-foods enthusiast, she calls health food stores and farmer's markets "my pharmacy."

Though she'd been an "obsessive" journal-keeper since age sixteen, Carr didn't envision herself as a writer. But healing opened the floodgates. "Crazy sexy cancer" was her subject line on emails to friends. "I wanted to prove I still had my sense of humor; I'm still the same girl," she says. "I didn't want to be safe about it."

Carr grew up in Pawling and moved to Manhattan at nineteen, but "after the diagnosis, I wanted to be back in nature." So she and her husband Brian Fassett moved their production company upstate. Carr published *Crazy Sexy Cancer Survivor* in 2008; *Crazy Sexy Diet*, a lifestyle and diet book, is forthcoming. She's also developing a TV series based on her motto "Live Like You Mean It." Being Kris Carr is a cottage industry, and she does it with irrepressible style. "I broke up with hijiki," she says of her macrobiotic period. "Hijiki and I are ex-lovers."

Seven years later, her tumors remain stable. "I could wake up tomorrow and it's worse, I could wake up tomorrow and I'm cured, but I don't think about either of those things," Carr asserts. "It's the same old, same old: gotta change the world."

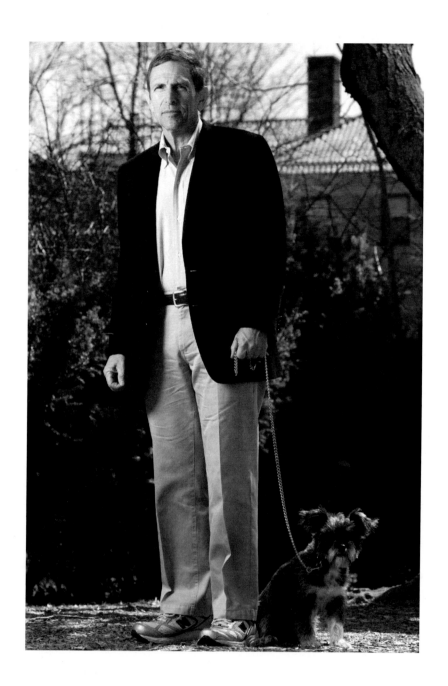

Benjamin Cheever

WHEN BENJAMIN CHEEVER set his sights on the Boston Marathon, an elite event requiring a qualification time of under three hours in another accredited marathon, he finished the New York Marathon in 2:59:33. "My father celebrated my acceptance by taking the whole family to spend the eve of the Boston Marathon at the Ritz Carlton," Cheever writes in *Strides: Running Through History With an Unlikely Athlete.*

The year was 1979. After conquering the notoriously hilly Boston course in 3:02:02, an exuberant Cheever returned to an empty hotel room. The phone rang and rang: first the Associated Press, then UPI, asking to speak to John Cheever. Benjamin Cheever writes, "I drew a bath. My father came into the hotel room and then into the bathroom. 'You finished the marathon?' he asked. I nodded. 'And you won the Pulitzer Prize.'"

The novelist son of John Cheever may have some big shoes to fill, but he's certainly fleeter of foot. Though the elder Cheever was an ardent walker and bicyclist—"We share an interest in rudimentary forms of transportation," he once told his son—he never ran 26.2 miles with a number pinned to his chest. After their shared win in Boston, John Cheever wrote to a friend, "Ben came in gallantly under three hours which is considered winning and when I returned to the hotel he was sitting in the bathtub, holding in his teeth a wire from the Pulitzer Prize Committee."

"He'd chopped 3 minutes off my time," Cheever notes with amusement. (He'd also added the telegram between the teeth; the Pulitzer prizewinner couldn't resist a good fictional detail.)

Running and writing might seem like entirely different endeavors, one making extreme demands on the body and one on the mind, but Cheever sees them as kindred pursuits. "Writing and long-distance running both respond to stamina and

application," he asserts. "If you write two hours a day for ten years, you're a writer." And if you log fifteen hundred miles a year, as Cheever has done for over three decades, you're definitely a runner. With *Strides*, he has brought these two passions together. The result is a joy to read.

Cheever has chosen Pleasantville's Dragonfly Cafe for an interview, partly because its sidewalk tables allow him to bring his beloved dog, The Schnoodle. Clearly the man and his schnoodle are regulars—everyone from the Moroccan barista to a local designer stops by to tell stories about them. Cheever, who seems at once pleased and abashed by the flow of attention, is dressed in a navy blazer, blue button-down shirt, tan chinos, and New Balance sneakers: Westchester classic with a bit of extra bounce. Articulate and gracious, with a frequent laugh that crinkles his eyes to inverted half-moons, he's clearly a man who relishes good conversation. For several years, he's hosted *On Writing*, a literary talk show on cable station PCTV, with on-camera guests including Alan Furst, Da Chen, Laura Shaine Cunningham, Rafael Yglesias—"my friends, my sister, my mom . . ." There's that laugh again.

And there's that family. Cheever's sister, Susan, is a prolific memoirist and novelist; their mother Mary, a poet. The third Cheever sibling, law professor Fred, is also a skilled writer. "I grew up in a household in which writing was revered, which is both good and bad," Cheever says. Though he worked as a journalist and magazine editor for many years, he didn't feel ready to think of himself as an author. (He still prefers "writer," noting wryly that "author" adds nothing but grandiosity, "like calling yourself an attorney instead of a lawyer.") His first book project was editing his father's letters for publication, a task many sons would find daunting. Though John Cheever had always been uncommonly frank about many things, including his alcoholism and many affairs with women, his journals and letters also recorded his secret life as an active bisexual.

"The experience of reading them was revelatory, and often uncomfortable," says Cheever, whose introduction to *The Letters of John Cheever* is titled "The Man I Thought I Knew." Though he'd told his family he wanted his journals published

posthumously, John Cheever urged them to throw his letters away, saying that "Saving a letter is like trying to preserve a kiss." Describing himself as an obedient son, Benjamin Cheever nonetheless felt his father's letters deserved publication, and that "his duality was essential to who he was as a man, as a writer. And as a father."

Cheever pauses to stroke his dog's head. "He thought of himself as very different, extraordinary, simultaneously blessed and cursed, both by being a writer and by his bisexuality. He put on a mask every day." John Cheever's letters and journals (over a million words) also revealed how hard he'd struggled to become a writer, and that even after achieving critical and popular acclaim, he continued to face rejection and financial hardship. For his son, who'd grown up thinking of literary achievement as a god-given gift, this was a revelation. "I realized that success as a writer is more about desire and stamina than what you're given," he says.

So the editor started to write. He published his first novel, *The Plagiarist*, in 1992, following up with *The Partisan*. Both won glowing reviews for their wit and acuity. "I thought I was made," Cheever says dryly. But as he'd learned from his father's journals, literary stardom is fickle. When he finished his third novel, the mordantly funny social satire *Famous After Death*, nobody wanted to publish it.

Cheever found himself at loose ends. His wife, *New York Times* critic Janet Maslin, earned a good living, but being a stay-at-home husband and father to two teenage sons made him feel idle and gnawed at his self-esteem. This being the crash-and-burn nineties, he started to see his reflection in downsized executives, middle-aged men who were forced to reenter the workforce in any way they could manage. He decided to write about downsizing—from the inside.

"Instead of interviewing people about their troubles, I thought I'd share theirs with them and see what they said to a colleague," he writes in the introduction to *Selling Ben Cheever: Back to Square One in a Service Economy*, in which he describes his five years in the entry-level workplace. Cheever took jobs as a sidewalk Santa and Halloween spook; as a salesman at CompUSA, Nobody Beats the Wiz, and a car dealership; as a fast-food sandwichmaker nicknamed by colleagues "Slow G" (for grandpa);

and a fearful security guard. Like everything he writes, the book is extraordinarily funny, but also sounds deeper notes. In chronicling the indignities of the workplace, Cheever somehow extols the dignity of work itself. It's telling that even after he landed a publisher for *Famous After Death*—and for *Selling Ben Cheever*—he kept showing up for day jobs.

After publishing his fourth novel, *The Good Nanny*, Cheever turned to a subject close to his heart. He'd started jogging as a senior editor at the *Readers' Digest* (gleefully skewered in *The Plagiarist*) and eventually started writing for *Runners World.* "I was in the awkward spot of a man starting to observe a sport he'd been participating in on an almost-daily basis since 1978. I felt a little like a trout who has taken up fly-fishing," he writes in *Strides.*

The book is an exuberant blend of memoir, sports reportage, and history. Cheever details the marathon's origins in ancient Greece and some of its exotic offshoots, like the Medoc Marathon in Bordeaux, where fine wines are offered at water stations. He goes on training runs with world champions in Kenya and ground troops in Baghdad. John Cheever makes several appearances, exhorting his clumsy son, "For Christ's sake, stop apologizing," when he drops a softball. ("I'm sorry," poor Ben replies automatically.) Adult Benjamin observes, "Walking is safe. Running is more satisfying. This is a vast oversimplification, but I would argue that I get from running what my father got from walking *and* gin."

Cheever also describes running with his own sons, and calls his wife getting her shoes out to run on his fifty-ninth birthday, "my best present." Running, he writes, is a literal cut to the chase: "It's a family axiom that while running, the brain doesn't get enough oxygen to sustain a falsehood."

"Running and conversation are a twofer—you're getting the exercise, but you're also getting an amazing level of intimacy. People tell me things on long runs," he reports with a knowing smile. "Mile five is the equivalent of three A.M. at a bar."

Cheever looks at his watch, a high-tech runners' gadget. For some time after John Cheever's death in 1987, Benjamin took to wearing his father's gold Rolex. "It's

a motion watch, and he didn't know how to set it when it stopped—he would take the train into New York and go to the Rolex company—so he wore it all the time. He used to sleep naked in what had been my sister's bedroom, so sometimes at night you'd see this naked man with a gold Rolex darting across the hall to the bathroom." He smiles with affection, recalling the image, then adds that he now keeps the gold watch in a safety deposit box. Benjamin Cheever, it seems, has made peace with a heritage that is both weighty and precious, and he's got his own race to run. In *Strides*, he describes the post-marathon high:

> I noticed that the mass of humanity has a post-race murmur very like recordings I've heard of whale songs. It's as if we're a single organism, not a sophisticated one either, maybe a giant sponge. We seemed more tide than crowd. . . . These were my people. I adored them all. I caught the sharp smell of excrement in the air. We were packed so tightly that if I'd died, my corpse would have been carried for yards, like a cork in the ocean. I crushed a paper cup under my shoe. We gimped along in our silvery capes. "Good race," we told each other. The air was thick and had substance to it, as if the runners had been set in aspic. I was hurting. I was ecstatic. I was serene. I was wide, wide awake, but also deep in the folds of an ancient dream.

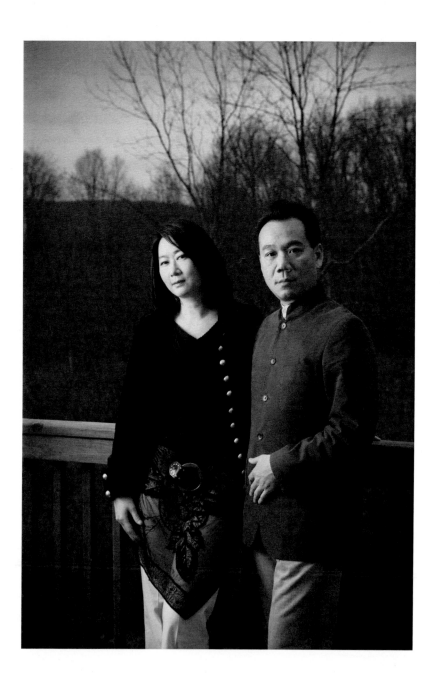

Da Chen and Sunny

DA CHEN RUSHES into the New Paltz Village Tearoom with enough energy to light several villages. He's not drinking caffeine these days, but he scans the tea menu with visible yearning. He chooses a Calming Blend herbal and urges me to try the Oolong, grown in the Fujian province of China, where he grew up. Soon he's painting a picture of tea pickers' earthen ovens and miles of tea leaves drying on bamboo racks. "You go to the mountain and see this, then you turn to the sea and see miles of salt flats, the farmers spreading it out so the miracle happens, a sparkling white gold is born."

Anybody who's ever met Chen is accustomed to such bursts of poetry. Several years ago, when he joined my writers' group, he charmed us all by fortune-telling our faces in the ancient Chinese manner he learned from his father, finding fame in this eyebrow, long life in the bow of that lip. He's never shown up without armloads of gifts, from towers of Asian delicacies to two dozen Dunkin' Donuts. The opening lines of Chen's bestselling memoir *Colors of the Mountain* shed some light on this largesse: "I was born in southern China in 1962, in the tiny town of Yellow Stone. They called it the Year of Great Starvation." Like his "brothers from another mother" Frank and Malachy McCourt of *Angela's Ashes* fame, Da Chen will never take food for granted.

Chen cuts an elegant figure in a white collarless shirt with silk-lined cuffs, tailored black slacks, and Prada ankle boots. In the past decade, he's published three memoirs (*Colors of the Mountain*, *Sounds of the River*, and *China's Son*), two young adult adventures (*The Wandering Warrior* and *Sword*) and the novel *Brothers*, a sweeping 430–page saga which garnered a starred review from *Publishers Weekly* and sent Chen, with his bamboo flute and calligraphy brushes, on three national book tours.

It's a wild ride by anyone's lights, but for someone who grew up in a farming village with more water buffalo than lightbulbs, unable to pay for tuition and

textbooks even when Communist cadres permitted him to attend school, it is nothing short of a fairy tale.

The Year of Great Starvation was also the dawn of the Cultural Revolution, when intellectuals and landowners were reviled. Chen's forebears were both. His paternal great-grandfather scored so well on a national exam for civil servants that China's ill-fated Last Emperor granted him the honorific title *Jin-shi*, the governorship of Pu-Tien, and a lot of land.

Chen's poetic grandfather inherited this wealth, raising his two sons in luxury. When they reached adulthood, the brothers decided to start their own business in underdeveloped Taiwan, first returning to Yellow Stone for a double wedding to their village sweethearts. Chen's uncle returned to Taiwan with his bride, while his father stayed home for a month to oversee some family business. During that fateful month, the Communists came into power. Overnight, the Chens were branded as "filthy landlords" and pariahs. Chen's father and uncle would not see each other again for forty years.

The uncle became a successful Taiwanese banker, while Chen's father struggled to care for a family of nine between stints of hard labor in reeducation camps. Though Chen's fictional brothers follow a different arc, it is no surprise that he dedicated his novel "to my baba and my uncle," or that the dizzying shifts of Chinese political history would provide the huge canvas for this epic tale, narrated in alternating chapters by two young men with the same father and wildly different fates.

Shento is a poor village boy with near-mythological origins: his unwed mother gave birth in mid-air of her suicide leap from a mountain cliff. The newborn was caught in the branch of a tea tree, snapping the umbilical cord as his mother plunged to her death. An ancient medicine man climbed to save him, raising Shento with his childless wife. Years later, Shento will learn that he's the illegitimate son of a general.

General Ding Long has another son, Tan, raised in opulent Party privilege. Inevitably, the brothers' paths cross, with many twists of fate along the way. When they fall in love with the same woman, the headstrong and beautiful author Sumi Wo,

the stage is set for a fraternal conflict of Cain and Abel proportions. Chen combines these timeless archetypes with acute observations of China's recent upheavals: his larger-than-life plot unravels against a very real backdrop of Vietnamese border wars, Tiananmen Square, and the emergence of rampaging capitalism.

"How did we get to where China is making eighty percent of the things for sale at Wal-Mart, and making billionaires? In Las Vegas, all the big players are Chinese guys. What does it feel like to be in the throes of such a huge and dramatic change?" Born when his family's gifts were despised, Chen reached young adulthood as the wheel of history turned yet again, allowing the promising student to escape the rice fields for an English major at far-off Beijing University, the first from his village to do so.

"Fate is fickle," Chen says, spearing a forkful of cherry pie. "What's most important is how you face it. My father suffered behind the Iron Curtain, but he survived, and could face anything with a smile. He was a great inspiration to me."

Chen passes along that inspiration—he's been a motivational speaker at corporations like Microsoft and Starbucks, and *Sounds of the River* has been assigned reading for incoming freshmen at SUNY New Paltz, Vassar, Seton Hall, and other colleges. It comes as a shock, then, to learn he had no intention of telling his tale.

"I was too ashamed to visit my childhood. Poverty and political persecution took a toll on my spirit, soul, and body," says Chen. "Now I'm mature enough to see that nothing was wrong with *me*, the society was wrong, but when I was younger, I just felt shame." Chen came to America at twenty-three, for a teaching exchange in Nebraska. He attended law school at Columbia University on a full scholarship, and met his wife Sunny, a Chinese-American doctor. She watched the young lawyer struggling to write his first novel, an international thriller, and quietly urged him to write down the stories he told her about his childhood.

Chen resisted at first. He'd carefully hidden his poverty from trust-fund classmates at Columbia. "It's easy to pretend to be a yuppie," he says. "All you need is a nice tie and shirt." (He admits that this too took some coaching—new in New York,

he was thrilled to find bargain-priced ties in Chinatown. Unable to choose between colors, he gleefully bought thirteen for three dollars apiece, only to have a blue-blooded classmate sneer at his "cheap, shiny ties.")

When he finally sat down to write about Yellow Stone, it was like a dam burst. "I would literally write thousands of words every night after work, no matter what," Chen says. "The more I wrote, the more I began to feel. It jabs me to think of what happened, how I was picked on and ostracized. I think I became a different person. I learned to hold my temper in check. It made me stronger, but it changed me, damaged me."

It also made him a writer. Chen always composes in English, and it's a jolt for the reader to realize that his fluid, vigorous prose issues forth in a language that isn't his native tongue. "I can't imagine writing in Chinese," he asserts. "My entire college education was in English. The literary seeds were planted then and there. I was reading books like crazy, gulping them down." His favorite authors were Dickens, Jack London, and James Michener. "I fell in love with *Chesapeake* at seventeen, the locality, the history. I learned so much about America from that book, from the oyster-digging Indians right up through Nixon. It was meaningful to me to write fictions like that. I hope to do that for China with *Brothers.*"

Chen still speaks Chinese with his mother, who lives with his family in Highland. The Chens are an overachieving clan: their children Victoria and Michael have appeared on *Saturday Night Live*, *Sesame Street*, and *Flight of the Conchords*; at ten, Michael starred in the 2009 Sundance hit *Children of Invention.* Sunny, a Vassar graduate who'd given up her medical practice to raise a family, recently reinvented herself as a best-selling author of paranormal erotic fiction. Dropping the surname that went with her doctor-and-mom persona, she churned out ten titles in quick succession, including the Monère series launched by *Mona Lisa Awakening*, and the *Demon Princess Chronicles.* Sunny's books have won PRISM Awards in three different categories (erotic/romantica, fantasy, and best novella), among other honors. Her husband reports, "Once she shut the door and started pounding that keyboard, she got that look on her face, very intense, beginning to live in the book."

It's a look Chen knows well. He's already at work on another big novel, a ghost story featuring China's last eunuch. It's hard to imagine he'll ever slow down. "When I talk at schools and libraries, I always talk about the idea of books, what they mean to people. There are millions of kids who don't have books, who have to walk miles to see any kind of entertainment." He pauses, perhaps recalling the days when he perched in a lychee tree, spinning stories for classmates in trade for foot rubs. Does his life's journey ever seem hard to believe?

"I'm the same person," Chen says, flashing one of his trademark grins. "I might be wearing Prada shoes, but inside are the same stinky feet."

Laura Shaine Cunningham

NO ONE WILL EVER GO HUNGRY at Laura Shaine Cunningham's table. The author's summer suppers are the stuff of local legend: cocktails and appetizers by the pool (reclaimed from a cistern, as described in her second memoir, *A Place in the Country*) and entrees on the porch. While her writers'-group colleagues may settle for putting out bagels and coffee, a meeting at Cunningham's house is a three-course affair.

The preternaturally energetic novelist/memoirist/playwright divides her time between city and country homes. Her eponymous place in the country is a former Victorian inn, tucked away in a quiet corner of Ulster County. Cunningham makes her entrance in a cloche hat, a white linen jacket and skirt, and jaunty pink sandals. She gives off the warmth of a six-burner cookstove, with an infectious smile and occasional bursts of wild laughter. She's prepared sole almondine and a Mediterranean tart of feta, heirloom tomatoes, and herbs—an elegant menu from a woman whose childhood meals, detailed in her first memoir *Sleeping Arrangements*, included popcorn for breakfast and kosher beef hotdogs kept warm in a thermos.

Sleeping Arrangements has been continuously in print for nineteen years. In 2008, it was the "One Book, One New Paltz" reading selection, the first time a local author's book was so honored. In irresistible prose, Cunningham chronicles a nomadic city childhood, made romantic by a loving single mother who could look at the underside of a relative's dining table, where she and her daughter squeezed in for the night, and convert its dangling tablecloth into a canopy bed. Rosie had an equally fanciful touch with her personal history, giving young "Lily" (Laura's childhood nickname) a war hero father with his own fighting dog, a boxer named Butch.

"It was a red-white-and-blue story, told to the accompaniment of bugles," Cunningham writes. "There was only one flaw: while we waited for my hero father to return from battle, this country was not at war."

Rosie's fiction frayed quickly. Eventually, she and her daughter found an apartment in the Bronx, so close to Yankee Stadium that the walls were bathed with the glow of twi-nite floodlights and shouts of "It's a homer!" Lily ran wild with her streetwise playmates, and all was bliss until Rosie's untimely death. But even in tragedy, family love triumphed: into the breach came two wildly eccentric bachelor uncles: six-foot-six private investigator Len, and Gabe, a dreamer who wrote Jewish gospel songs.

Sleeping Arrangements was a hit even before publication. The *New Yorker* published an excerpt, and book jacket quotes arrived from Cunningham's idols "like fairy dust": Harper Lee, Anne Tyler, Chaim Potok, Muriel Spark.

But the book's impact went deeper than praise. A magazine writer who'd already published two novels (*Sweet Nothings* and *Third Parties*), Cunningham finished most of her manuscript, then set it aside for nearly a decade because she couldn't bear to write about her mother's death. "Finally I sort of dove at it, and wrote it very quickly. I felt the weight of the world lift off my shoulders," she recounts. "I remember it was three in the morning, and I walked out onto this porch, feeling literally lighter. This is what memoir can accomplish: you can write your way out, you can write for your life."

Both of Cunningham's uncles were writers, as was their mother (and Lily's eventual roommate), the unforgettable Etka from Minsk. After Rosie's death, Lily clung to the family tradition. "It was a healing device—write, write, write, read, read, read. I read the way people drink. I would stagger out of the library with seventy pounds of books," the author recalls. "I quickly got lost in a fantasy world. I'm very lucky that it also became a way to make a living."

Cunningham's first paycheck came at fifteen, when she won a nationwide Youth Writers contest sponsored by ABC television. The prize included a check for two hundred dollars, a huge sum for an illicit fifteen-year-old (the contest was for sixteen- to eighteen-year-olds; terrified she'd be found out, the winner received her award "dressed like I was forty.") After the contest, she landed a column in *Seventeen*, and wrote for magazines ranging from true-detective pulps to *The Atlantic Monthly*. She

also wrote plays. One of these, *Beautiful Bodies*, is currently leading a rich double life: as source material for a 2002 novel with the same title, and as a runaway box office smash in the former Soviet bloc.

Cunningham was researching a historical novel about the ill-fated Romanovs when she got a three A.M. email from a Russian producer who wanted to translate and produce *Beautiful Bodies.* She leapt at the chance. "It felt like a very heavy hand of fate, mysterious and magical."

Beautiful Bodies premiered in thousand-seat theatres in Moscow and Leningrad. ("It was a terrible production, but a *successful* terrible production.") More productions followed, and Cunningham found herself "Aerofloting around" to premieres in Siberia, war-torn Chechnya ("a beautiful production, very moving"), Bulgaria, Estonia, Romania, and Lithuania. At one premiere, diners washed their hands with vodka between courses of a backstage banquet. "I've never had such pure adventure," Cunningham says. "When you go as a playwright, you're not a tourist—you're in back rooms, off the beaten track."

Not all back room dealings were savory; Cunningham soon realized royalties were not forthcoming. When all else failed, she brought suit, becoming the first English-language writer ever to win a Theft of Intellectual Property claim in Russian court. "I'm not a litigious person. Why did I do it?" she muses. She did win some rubles, but "it was for justice. My family lost everything in Russia in 1905. I was damned if I was going to let it go under again." She's currently writing a third memoir, *Playing in the Forbidden Zone*, about her multilayered connection to Russia.

Memoir is a booming genre, and Cunningham, who's appeared at Troy's Memoir Project and the Woodstock Writers Festival, has mentored both promising first-timers and accomplished writers as writer-in-residence at the Memoir Institute. "More and more people are turning to memoir, not just to have a book, but to understand their lives," she says. "You're able to retrieve so many memories, and when they're in written form, the patterns are so much clearer. It's kind of like psychotherapy. Plus you get a book advance."

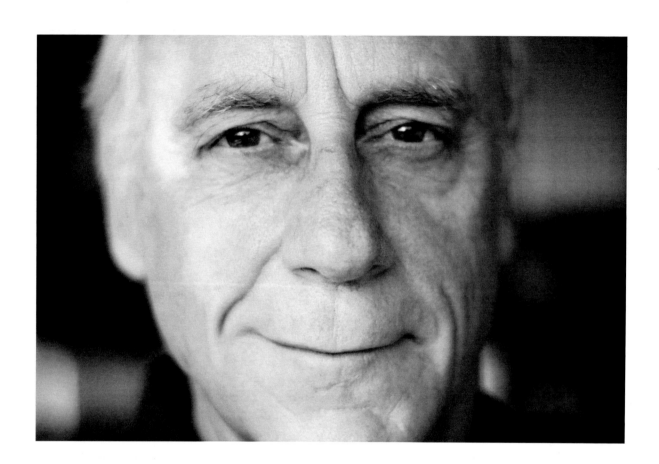

John Darnton

Talk about front-page news. In the opening pages of John Darnton's *Black & White and Dead All Over*, merciless editor Theodore S. Ratnoff turns up dead in the newsroom, a note in his trademark purple ink pinned to his chest with the spike he used to impale cancelled stories. The journalistic saw "If it bleeds, it leads" has rarely been taken so literally.

Ratnoff was the scourge of a fictional newspaper that bears more than a passing resemblance to Darnton's day job. In a waggish press release, the Pulitzer Prize–winning reporter and editor writes, "Some have suggested that *Black & White and Dead All Over*, which is set in a major New York City metropolitan daily of international repute, may be a *roman à clef*. Such a rumor may have come from the fact that I have worked over four decades at the *New York Times* and that I have never worked at any other newspaper." Could this be why the *Times Book Review* headlined its rave, "Anybody We Know?"

From the aerie-like deck of his New Paltz retreat, the author insists, "The characters are not always one-for-one. I put pieces together." After a pause, he adds wryly, "Some pieces are bigger than others." Most of the novel's wittily encoded cables were lifted verbatim from legendary reporter Homer Bigart; a fatefully bad lede is based on an actual one by a now-deceased colleague.

"You can't make this stuff up," the semi-retired Darnton shrugs, though *Black & White* provides ample proof that he not only can make it up, but can make it hilarious. *Kirkus Reviews* called the satirical mystery a "multifaceted, gloriously entertaining thriller." The *L.A. Times* weighed in with "deliciously sharp, wise, and hilarious . . . a love letter to an endangered species."

That species, of course, is print journalism. Darnton's insider view of a news industry threatened by rising costs, diminishing profits, corporate greed, and a vanishing readership gives his novel additional bite. So does his undiluted affection for the hard-drinking, work-driven newsmen of past generations.

"When I was in college, I didn't know anybody who wanted to be a reporter. It didn't seem like a profession," says Darnton. This may sound a bit disingenuous—his father, a *New York Times* war correspondent, was killed on the job when John was an infant; his mother later became the *Times*'s first Women's Editor—but he explains that in those days, reporting "was a craft, not a profession for experts. Papers hired reporters off the street, sometimes literally. They didn't recruit from the Ivy League."

Darnton was not strictly Ivy League either. Accepted by Harvard, he was expelled from Andover during his final semester for signing into his dorm and then sneaking out to a bar (a background he gave to a character in his fourth novel, *The Darwin Conspiracy*). Harvard rescinded its offer, and Darnton attended the University of Wisconsin, where he met his future wife Nina on the first day of school.

Meanwhile, his older brother Robert graduated from Oxford and went to work for the *Times*, landing a police beat in Little Italy. "Here's this accomplished academic, covering grisly murders," Darnton says, shaking his head. "It was a bad fit."

But Robert's kid brother fell hard for the romance of hard-bitten newsmen playing cards on a hot night, occasionally glancing up at different colored lights in the window ("so you'd know at a glance which paper was phoning") and eating calamari on Mulberry Street between two-alarm fires. In 1966, John was hired as a *New York Times* copy boy, running a mimeo machine. ("My hands were purple to the wrists.")

Copy boys were expected to write on the side and move up through the ranks. "I'd never written a story, not even for the college paper," Darnton recalls. He pored over the daily edition, following certain bylines, and soon became a general assignment reporter. As Connecticut correspondent, he covered the Black Panther trials in New Haven. Next came a high-pressure stint on Night Rewrite. Once Darnton and a

colleague were assigned Man in the News features on two Supreme Court nominees, to be announced by President Johnson in a televised speech at 8:00. The *Times's* first edition deadline was 7:30. The National Editor told them breezily, "We'll hold the paper for you."

"And we *did* it," Darnton marvels. "That was a lesson. The copy will come from somewhere. There won't be a black hole underneath your name."

He covered City Hall during the mayoral transition from John Lindsay to Abe Beame. "I was rescued by the fiscal crisis," he says, with the skewed logic of a true newshound. "I've had great luck in that wherever I go, mayhem and chaos follow." The possible bankruptcy of New York City was a huge international story, and Darnton was right on its pulse.

When the *Times* planned to open a new bureau in West Africa, Darnton was sent to select a location. A hotel clerk in Accra told him on Tuesday that he could "probably" place a phone call to New York by Saturday, so Ghana was out. But one of the hotel's other guests was the High Commissioner of Nigeria, who knew Darnton's byline and got him a visa to Lagos.

After a one-hour flight that stretched into six and a close call with a haughty customs official, Darnton took a late cab to the house he'd share with an Australian reporter. They awoke to martial music and a radio announcement that the government had been overthrown in a coup d'etat.

"Coup d'etat?" Darnton remembers thinking, "I didn't know where I *was.*" He wandered onto the street, somehow finding his way to the Reuters bureau. British reporter Colin Fox scooped him into his sports car, and off they went. "The streets were deserted except for tanks. Guys were yelling at us from gun turrets," Darnton recalls. They found the bloodstained car of the head of state, abandoned where he'd been gunned down. Darnton managed to file a story on Reuters' telex machine—a rare commodity in the Third World—and slept on the office floor. The next morning, while he was out interviewing American officials, government forces trashed Reuters' office, arresting Fox and throwing him out of the country.

The coup was abortive. Darnton set up his bureau, sending for Nina and their two young daughters. The night they arrived, the American diplomat living next door dropped off a cold six-pack of beer, saying, "You're going to need this."

From the new Lagos bureau, Darnton covered a third of the continent. It was the era of Kissinger's "shuttle diplomacy," and "Africa was the newest chessboard for the Cold War," Darnton observes. His byline, once buried, inched steadily towards the front page. Some of his stories were critical of the Nigerian government, including an exposé on infant mortality rates and a story about local pirates preying on international freighters from dugout canoes. Darnton also befriended the revolutionary cult singer Fela Anikulapo-Kuti. It was this last offense that finally got him arrested, strip-searched, and deported with his whole family. They wound up in Kenya, where he covered the Rhodesian Civil War and the fall of Idi Amin, earning the prestigious George Polk Award.

Darnton's instinct for arriving at a historical moment continued with his next assignment in Warsaw. The rise of Solidarity brought "an incredible roller coaster ride of stories." Filing a late-breaking dispatch in December 1981, he discovered his telex and phone were both dead. It was the beginning of martial law, and Poland was under a news blackout. The remaining American journalists were forced to settle for filing a joint news report, subject to official approval. "We called it 'the camel,'" scoffs Darnton, who smuggled his own stories out via "pigeons"—departing Westerners whom he approached in hotel lobbies and airports. The *New York Times's* Pulitzer Prize–winning coverage of Poland's crisis left Warsaw in Marlboro cartons and boot linings, and on rolls of film surreptitiously shot by a German photographer in a hotel bathroom.

The Darntons moved on to Spain, where their son Jaime was born, then returned to New York. Nina wrote for *Newsweek* and the *New York Post*, and John became the *Times's* Culture Editor. "Editing uses a different part of the brain," he asserts. "But the real change was fiction."

Darnton's first novel was based on—what else?—a newspaper article. After reading that Neanderthals lived at a time overlapping our own *Homo Sapiens* ancestors, he found himself musing, "What if there was a small band remaining somewhere?" He wrote a hundred pages and shelved it, until he heard someone else had made a movie deal on a similar concept. He put his unfinished novel up for immediate auction, and Steven Spielberg bought movie rights.

The movie was never made, but Darnton's *Neanderthal* was an overnight bestseller. He followed it up with three more science-based thrillers, *The Experiment*, *Mind Catcher*, and *The Darwin Conspiracy*. Then he started researching a family memoir about his father's death in the remote World War II theater of Papua New Guinea. *Black & White and Dead All Over* "was an avoidance book," he admits. The opening scene came to him, and he wrote it down "just for fun." Then he started plotting the rest, and got hooked.

Does the veteran newsman and novelist prefer truth or fiction? John Darnton sits back in his cedar deck chair, surveying the Shawangunk Ridge. "It's much more satisfying to create something out of whole cloth," he replies. "And you don't have to check your quotes."

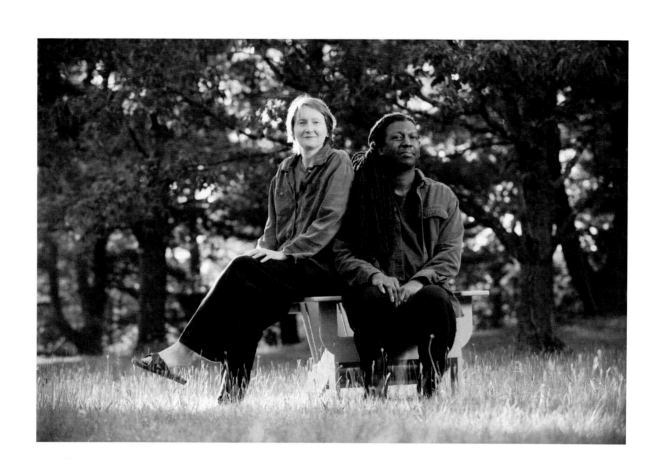

Cornelius Eady
and Sarah Micklem

CORNELIUS EADY AND SARAH MICKLEM have a busy address book. There's their tiny apartment in New York's West Village; South Bend, Indiana, where Eady commutes to run Notre Dame's creative writing program; and twin cottages on a hilltop in Greene County. Side by side, compatible but self-contained, the cottages offer an apt metaphor for the marriage of two working writers.

Eady's seven books of poetry include Lamont Prize–winner *Victims of the Latest Dance Craze*, *Brutal Imagination*, and Pulitzer finalist *The Gathering of My Name*; he's also an Obie Award–winning playwright. His 2008 book, *Hardheaded Weather*, opens with epigraphs from Ezra Pound ("Make it new.") and James Brown ("Make it funky"). Eady does both, and he makes it his own.

Micklem is a fantasy novelist whose earthy, remarkable debut, *Firethorn*, earned glowing reviews and a Locus Award nomination. *Wildfire*, the second volume of her trilogy about a headstrong woman amid warring clans, followed in 2009.

Today is the couple's thirty-first anniversary, and they're unwinding at their upstate getaway. "When we get up here, we immediately slow down," Eady says. "It's the porch effect." After a realtor showed them the vacant cottages in 2001, they returned several times before making a bid. "We'd bring coffee and sit on the porch," says Micklem. Eady adds, "We were afraid the sheriff would show up and say, 'Who are *you?*'" There's a subcutaneous tension in his laughter, recalling his poem "Recycling," in which "a middle-aged black and white couple" get the once-over at a Catskill dump: "Anyone with eyes can tell / We're a story that couldn't have / Originated around these parts."

A big man with a world-warming smile, Eady sports waist-length braids bundled into a ponytail, elegantly long nails, and horn-rimmed glasses. He's wearing a blue work shirt, dark trousers, and slippers. Micklem is dressed almost identically—a fact which amuses them both when they notice—but her sandy hair is a foot shorter than her husband's. She's clear-eyed, quick and light, self-effacing but quietly confident. In conversation, they listen respectfully, trading licks back and forth like a jazz duet.

They met in a seventies-era free school in Rochester, Eady's hometown. Micklem was born in Virginia; her family moved several times before settling in upstate New York. A restless student who "hated high school," she savored the chance to mainline sci-fi novels in place of conventional classes. Eady transferred midyear and spent his time writing poems and songs, playing drums and guitar with a short-lived rock band. Micklem also wrote songs; Eady calls her the group's "hidden genius."

After high school, Micklem started a science fiction novel which opened, like *Firethorn*, with a young woman living alone in the woods. Having assayed a three-day vision quest in the Adirondacks at sixteen, she rented a cabin ten miles from the nearest town, with no car. Eady would visit, bringing groceries and Stevie Wonder tapes. "He was my lifeline," she says. "That was probably when I fell in love with him—I just didn't realize it at the time." (Eady was dating someone else, which "helped put up the wall in my mind.")

The summer after her first year at Princeton, Micklem's former bandmate came for a visit and, she says simply, "It shifted." They married soon after. Eady's writing career was the first to take off, though he's also supported himself with teaching jobs. Micklem found full-time work as a graphic designer, but even when she wasn't actively writing, *Firethorn*'s world was marinating inside her head. "For a long time, this was a hobby, a world-building hobby," she says. "I'd think of weird things on long drives— what are their books like? I want them to have writing, but not like ours."

At a writers' conference, Eady met workshop leader Abigail Thomas and knew he'd found the right midwife for his wife's book. "The big reason I finished was Abby," Micklem concurs. "I learned to go in, go deeper, look around."

Though she's always her husband's first reader, Micklem doesn't always share her work in progress. "I don't read everything Sarah's doing, but I hear about it all the time," Eady says, and she laughs, "Mostly whining." She admires his equanimity. "Cornelius doesn't agonize over process, he doesn't complain when he's not writing, it's all fine. He doesn't seem to envy other people." But, Micklem says, "He's a binge writer. He goes at it and stays at it, he forgets to eat."

Eady sees many parallels between writing and music, and often references jazz, blues, and dance in his poems. "Poetry is a mysterious, slightly threatening thing for many people. Like opera, they think of it as a foreign language, something that's only for a few people who have the training to understand it." His unfussy voice goes a long way to defuse such worries. "I made a conscious choice to write clearly, to be intelligent but also accessible," he says.

Strikingly varied in format, Eady's poems often invoke personal experience, from befuddled home ownership (*Lucky House*) to mourning a difficult father (*You Don't Miss Your Water*). "It's autobiography, but it's also fiction. What happened is a jumping off point," he says. "I use my parents and neighbors a lot as source material— they're stories you don't often hear about African Americans. My language comes from them."

Eady was named after his father and grandfather. "Cornelius is a name you grow into. When I was a kid, I hated it," he says, imitating a schoolteacher calling roll: "Bob, Jim, *Cornelius.* Now I love it. It sounds like a poet's name."

Thirteen years ago, Eady and Toi Derricotte founded Cave Canem, an annual retreat for African American poets. The week-long workshops foment a sense of community and an exploration of "African American voice" that embraces everything from hip-hop to MFA programs. Eady says, "People can get in each other's hair— 'You're not political enough!' They're eating each other's young. At Cave Canem, it's a seven-day truce."

The workshop's logo, an unchained black dog, appears on a license plate over the door of the cottage where Eady writes and they share living space. Micklem works

in the smaller cottage, surrounded by forties board games, vintage prints, and research books. Though her trilogy takes place in an imagined world, it has taproots in numerous cultures. Micklem's website describes *Firethorn*'s society: "It's a patriarchy in which the role of the warrior is exalted, and it has a rigid caste system maintained by violence and the threat of violence. Firethorn is a woman among soldiers, a camp follower. She's at the bottom of the heap, being female and low caste."

Micklem sees caste as a metaphor for race ("It's another way to write about how we divide ourselves"), basing her Mud/Blood distinctions on Jim Crow laws. *Wildfire* invents an even more stratified culture, with an Untouchable caste who must cover their faces in public. "It was actually very hard for me, from my privileged background as a modern American, to write the correct amount of deference," she says. Firethorn frequently chafes in her role as "sheath" (wartime lover) to highborn Sire Galan, whose behavior towards her is likewise complex. "I think being inconsistent is important," says Micklem. "He's not a great romantic hero. He's very self-centered. I tried to make him accurate to what a man raised in that period, as a warrior, would be."

What period? Micklem smiles. "There's a lot of Middle Ages, but it's *so* not Christian."

Indeed. She's created a fascinatingly intricate cosmology of twelve gods, each with three avatars (male, female, and elemental) arrayed in a circular compass. Firethorn consults the gods by throwing a pair of fingerbones, I Ching style, and interpreting where they land. Micklem fashioned a model Divining Compass on a circle of suede, buying two human fingerbones online and coloring them in the manner of Firethorn's two mentors. Whenever her heroine casts the bones in the story, the author cast too. She was struck by the patterns. "I expected more random results, but certain signs really would recur. I can see how divination is powerful. I really don't believe in God—I'm an atheist—but I do believe in belief."

Though Micklem describes her purview as "no dragons, no elves," Firethorn does leave her body in a memorable battle scene. "I wanted to write a pretty realistic book, except for magic. What is true in our real world is so bizarre, and so totally

underestimated by those of us who grew up in science-based cultures," she says. "People *can* fly, in shamanic traditions. What is a trance, is it really happening? Does a curse really work? It's a matter of how you see cause and effect. Magic is a way of giving agency to ourselves."

Along with magic and shamanism, Micklem has researched anthropology, childbirth, warfare in all eras, tournaments, armor and weaponry, textiles, prostitution, herbalism, hallucinogens, aphasia, brain damage, and lightning. "I'm afraid of writing historical novels because you have to get everything *right*," she says, deadpanning, "I'm not writing about what I know."

Eady says one of his joys in reading Micklem's manuscripts is discovering why she's been reading the books that pile up in their various homes. Micklem radiates pride as she recalls hearing him read his poem "Gratitude" for the first time; their writers' retreat for two seems just as supportive as Cave Canem. As they stand in the driveway between their two cottages, discussing which restaurant to choose for an anniversary dinner en route to New York, it's tempting to conjure the last lines of Eady's poem "The White Couch":

> All this moving, he says.
> Ah! He says.
> This is living.
> This is life."

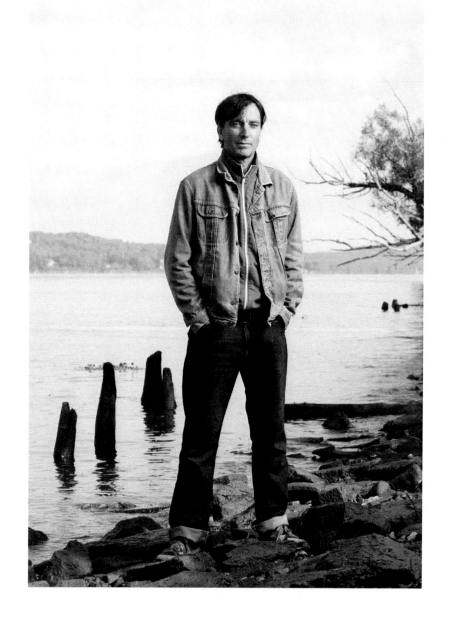

Nick Flynn

POET NICK FLYNN exudes a battered glamour, with pale blue eyes, a nose that looks like it's seen a few fights, and a scruffy goatee; it's a face that seems to invite a dangling Gauloises. With Ray-Bans perched on his tousled hair, he would look like the consummate hipster if he didn't smile quite so freely and often.

The author of two acclaimed books of poetry (*Some Ether* and *Blind Huber*) and two memoirs (*Another Bullshit Night in Suck City* and *The Ticking Is the Bomb*) is happy to be at the water's edge, on a rocky strand north of the Tivoli Bays where he and his partner, actress Lili Taylor, bring their two-year-old daughter to watch local fireworks.

The Hudson's at low tide, exposing slick patches of eelgrass and the spiked water chestnut seeds Flynn calls "demonic." The river is calm, its surface a scroll for small brushstrokes of color: a man rowing a scull, a distant flotilla of swans, a bright red barge pushed by a tugboat. An occasional train rockets past with a blast of sound. Flynn sits on a rock, leaning back on his elbows and watching the river flow. "It's not the ocean, but it's something else. It's tidal, it does have sort of the rhythm of the ocean," he says appreciatively. "I grew up on the water. I've lived in Boston, Provincetown, New York City. It was hard to leave the coast, but the Hudson's so wide there's a view across the water."

Flynn was born on Cape Cod and spent most of his unsettled childhood in Scituate. When he was six months old, his mother left his father, a larger-than-life alcoholic, con man, and self-styled great American novelist. She struggled to support her two sons, often working two jobs, bouncing in and out of relationships, and battling depression. From *Another Bullshit Night in Suck City*: "There'd always been books around our house—my mother and brother were voracious, compulsive readers.

Henry Miller's *Sexus* was hidden in my mother's lingerie drawer, alongside her gun and painkillers. She bought the gun the year before to protect herself, but she never said from what." When Flynn was in college, she used it, leaving a four-page suicide note.

Flynn was laid low. His absentee father, who'd done time in prison for passing bad checks, started to send his son grandiose letters ("I shall—soon—win the Nobel Prize for both Storytelling and Poetry—no fear"); one included the chilling line "Whether you like it or not—you are me. I know."

As Flynn relates in his miraculously compassionate first memoir, he did walk in his father's footsteps for a time, shoplifting, drinking, and drugging. He clung to the margins, living for stints on a derelict boat and working part-time at a homeless shelter in Boston. Eventually, perhaps inevitably, his father showed up there as a client. Flynn writes: "I drive slowly past a blanket shaped like a man—here is a man, shaped like a blanket, shaped like a box, shaped like a bench. Easy to miss. If this is my father, if I leave a sandwich beside his sleeping body, is it a family meal?"

Norton gave Flynn no flak about his edgy title—"they were totally into it"—but some bookstores got letters from irate customers. The *New York Times* listed the book as *"Another Bull**** Night . . ."* "It was down to two-and-a-half words," Flynn marvels. He was invited to speak at a luncheon for the annual conference of the St. Vincent DePaul Society, but "once the Archbishop heard the book's title, he said, 'No way is he coming.' I was disinvited," Flynn laughs. "There are only two cuss words in the book, and they're right on the cover." But he has no regrets. "Once I found that, it was just the right title. There's a sense of inevitability. You look at certain things, and once they're done, that's what it is. Our job as writers is to find that."

Another Bullshit Night in Suck City won the PEN/Albright Award; a film adaptation is set to star Robert DeNiro and Casey Affleck. Though director and screenwriter Paul Weitz has been sending Flynn drafts throughout, the author's main concern is that the homeless characters don't come off stereotyped. "I don't give a shit how *I* come off," he claims. Still, the first table reading "was pretty surreal. There's this guy playing *me.*"

Flynn's new memoir, *The Ticking Is the Bomb*, is a searching exploration of new fatherhood in an era of terrorism and torture. "I became sort of obsessed, deeply troubled by the Abu Ghraib photos. I began this sort of investigation with it, from looking at the photos to being in a room with the people in those photos." Flynn was invited to Istanbul by the lawyer collecting testimony from Iraqi detainees.

It was a time of "a lot of turmoil in my life, and the Abu Ghraib photos sort of took over. Why that hooked onto my subconscious in that way . . ." Flynn shakes his head. "That's the question of every memoir: why are you writing about this piece of your life, why this moment?" He'd hoped "to finish writing about torture before the baby was born, but it didn't work out that way." In an excerpt published in *Esquire*, he writes about seeing sonogram photos of his unborn daughter. "I was there when each shot was taken, yet in some ways, still, it is all deeply unreal—it's as if I were holding a photograph of a dream, a dream sleeping inside the body of the woman I love, this woman now walking through the world with two hearts beating inside her. At this same moment, or outside of this moment, outside of us, somewhere out there in the world, exists another set of photographs, photographs of prisoners and smiles and shadows."

The title came to Flynn after a meditation retreat with Thich Nhat Hanh (one of many he's attended during the past twenty years, starting with the Vietnamese Zen master's first trip to America to teach at Rhinebeck's Omega Institute). "He asked, 'What is the wind if it is not blowing? What is the rain if it is not falling? The blowing is the wind, the falling is the rain.' I came up with 'the ticking is the bomb.' It's the same koan: the action of the thing is the thing."

The memoir originally included a series of poems, which Flynn took out at the last minute. Instead, they'll appear in an upcoming book tentatively titled *The Captain Asks for a Show of Hands.* He's currently planning a third memoir about the making of the Oscar-nominated documentary *Darwin's Nightmare* in Tanzania (he is billed in screen credits as "field poet") with director Hubert Sauper, whom he describes as "a very Werner Herzog type of character. He might come with me on my next Istanbul

trip, maybe stopping in Paris on the way." (Flynn describes traveling from country to country with the casualness of somebody dropping by local farm stands.)

Flynn came to the Hudson Valley for the first time in 2003, to read with Paul Muldoon at the Woodstock Poetry Festival. As he drove down the Thruway from Albany to Woodstock, he passed a road sign for Coxsackie, where an old friend was living. Flynn decided to visit. "Within an hour, I had put a hundred dollars down on the house next door," he says. "It was an amazing old brick mansion with a view of the Hudson, huge rooms—*ballrooms*—and it was two hundred thousand dollars. I felt totally uncomfortable in it." He wound up buying a rundown Victorian in Athens for half the price.

Flynn says the Hudson Valley feels "different from Manhattan or Province-town—there's *room* here. In Provincetown, you get to the end and that's *it*." He and Taylor share a New York apartment and a farmhouse in Red Hook, but since the arrival of Maeve Lulu Taylor Flynn, he mostly writes in cafes. The couple met in 2004, and plan to get married "sooner or later," Flynn says with a smile. "We'll get hitched, yeah. But the baby's a bigger bond than the wedding."

The sense of stability is still new and wondrous. "I felt like everyplace I'd lived was a precarious perch, like I couldn't get a purchase," Flynn says. "I'm somewhat more of the air and water—I wasn't fully integrated with being on this earth." A friend once told him that buying a house would make him feel more grounded, that he'd own a piece of the earth.

"I had no experience like that," he says, paraphrasing a speech from his play *Alice Invents a Little Game and Alice Always Wins.* "I go away for months at a time and I don't even think about it. The boat took up much more psychic territory. Fully half the dreams I have are set there." But where the *Alice* character balks at becoming a father, fearing he'll be unable to connect to his child, Flynn is unambivalent. "The house didn't ground me at all, writing some books didn't ground me, but having a baby did."

From his poem "Father Outside":

> I want to believe
> that if I get the story right
> we will rise, newly formed,
> that I will stand over him again
> as he sleeps outside under the church halogen
> only this time I will know
> what to say.

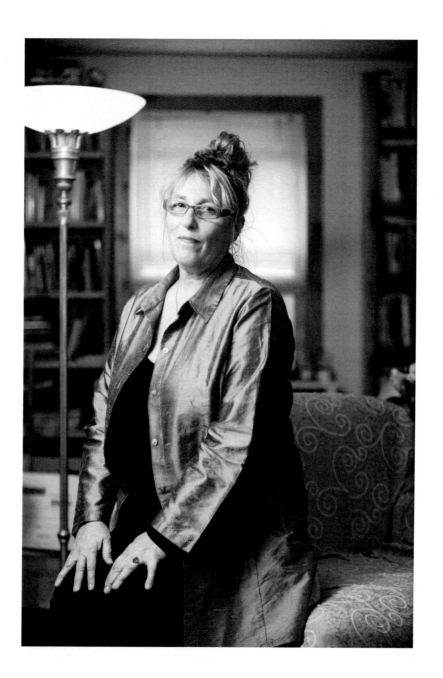

Martha Frankel

THERE'S A STORY BEHIND every object in Martha Frankel's office, from Anthony Hopkins's director chair to the Girls Pro Baseball League poster from *A League of Their Own*. Even her glasses have celebrity provenance: she won the DKNY frames in a Rachael Ray makeover contest.

A hands-on interviewer for *Details* and other magazines, Frankel has walked the red carpet with Janet Jackson, dodged paparazzi with Sean Penn, and zipped J.Lo into her wedding dress. She has also run up a five-figure debt playing internet poker, an addiction she managed to hide even from her husband, sculptor Steve Heller.

Frankel's memoir *Hats and Eyeglasses* puts her high-low cards on the table with candor and full-throttle warmth. She was a loved child, precocious with numbers, cheeks pinched by a houseful of *haimishe* cardsharps. Her father's death threw her into an adolescent tailspin. Decades later, her mother's unswerving love helped her beat her gambling jones. "My mother gets posthumous fan mail now," Frankel says. "Having a secret can kill you. You wake up in the middle of the night with it laying on your chest. You look at yourself in the mirror and think, who the fuck *are* you? It feels good to admit it, finally."

Frankel just coauthored *Brazilian Sexy* with bikini-waxer-to-the-stars Janea Padilha and is writing a second memoir, set in sixties-era Woodstock, about her choice to be child-free. Its title? *No Kidding.*

She may not have children, but Martha Frankel is raising a village. Her office overlooks a streamside gathering spot for teen dropouts. She helps them fill out job applications and offers no-questions-asked rides to anyone under the influence. "I tell these kids, tattoo my phone number on your arm. If you get drunk at a party, roll up your shirt and call me," she says. "That's what I want to be known for. That's even better than *Hats and Eyeglasses.*"

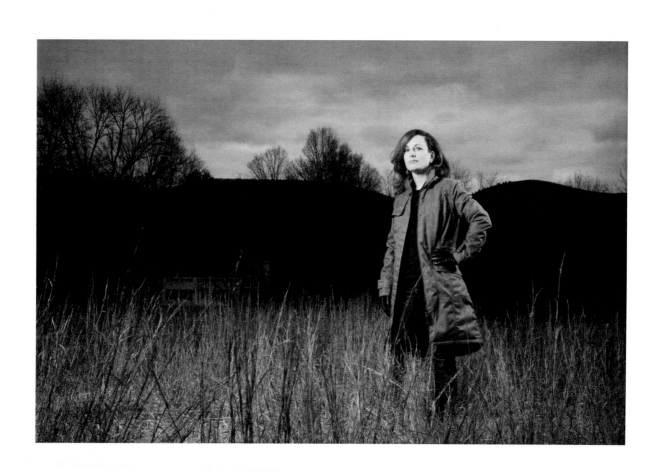

Alison Gaylin

HOW MANY EDGAR AWARD NOMINEES can say they've been thrown out of David Hasselhoff's wedding? "There are not many more embarrassing things that can happen to you," laughs Alison Gaylin. Fresh from a theatre major at Northwestern University, she was hired by the L.A. bureau of *The Star*, where her beat included going undercover as an extra on TV sets and crashing Fred Savage's bar mitzvah.

At Columbia journalism school, the former tabloid reporter was richly amused by the required course on journalistic ethics. "For everything I did at *The Star*, I never falsely reported there were weapons of mass destruction," she maintains.

A lifelong reader of mysteries, true crime classics, and "darker fiction" by authors like Joyce Carol Oates, Gaylin loves an adrenaline rush. "I never minded having nightmares," she says. "I *liked* the feeling of being scared." So she started writing a crime novel called *Hide Your Eyes*.

Her first draft didn't sell. "I had great characters, but not the suspense," she says. Gaylin taught herself structure by reading a hundred mysteries, rewrote "top to bottom," and sold her manuscript to Signet—ten years after she'd started it. Then her career hit the fast track with an Edgar nod. In short order, she turned out a sequel (*You Kill Me*) and two hardcover stand-alones (*Trashed* and *Heartless*). "My work process involves lots of Red Bull and Rock Star," she deadpans. Living in Woodstock with her filmmaker husband Mike Gaylin and their young daughter may help to counterbalance the energy drinks.

Or not. Gaylin's about to launch a new series about a missing persons investigator with a rare form of total recall. Like her previous books, they'll feature smart, feisty women and plenty of blood. "I write crime fiction with a fair amount of humor, but also some grisly murders," she says, grinning. Bring on the nightmares.

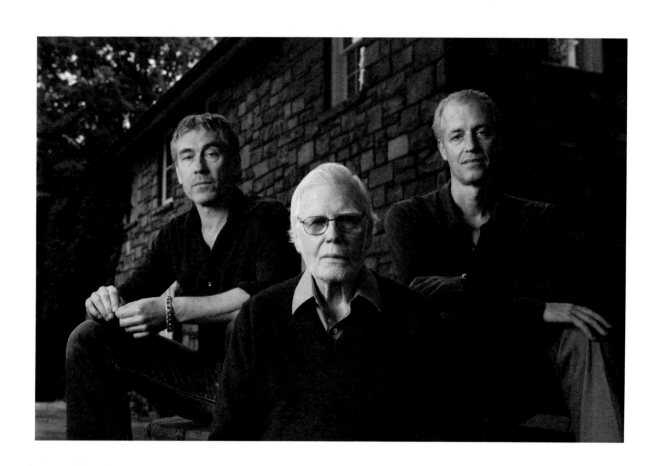

Frank D. Gilroy, Tony Gilroy, and Dan Gilroy

There's a thumb-shaped hole in the space bar of Frank D. Gilroy's typewriter, where the metal's succumbed to six decades of use. The black Royal manual, which Gilroy bought with his winnings from a crap game on a World War II troop ship, rests in its case in the Pulitzer Prize–winning playwright's home office. The hardest-working keyboard in show business now has an understudy—not some upstart Mac or PC, but an identical vintage Royal, bought by a friend.

Gilroy's credentials are legion, but he's a canny enough storyteller to know that the view from the top doesn't play half as well as the scramble to get there. His 2007 memoir, *Writing for Love and/or Money*, begins:

> As the man introducing me at the local community college goes on about my loftier achievements and awards, the audience (kids from families straining so they can get a higher education) openly yawns.
>
> Scrapping prepared remarks, I tell them 90 percent of my career has been failure.
>
> "I've been dead broke six times and if I don't sell something soon it'll be seven."
>
> I have their attention.

He has ours as well. Gilroy's tales of scraping together a paycheck from live TV shows like *Playhouse 90* and *Omnibus*, and of Hollywood during its studio heyday, are

short and salty, addictive as popcorn. We see him pitching to Jackie Gleason while The Great One gets a haircut and manicure. Telling Walt Disney he's quitting the studio. Scouting locations with Dick Powell in Havana as Castro's rebels attack. We also hear jazz trumpet riffs, gambling sagas, and grueling war stories etched in a few unforgettable sentences.

"I like concision," Gilroy says, leaning into a comfortable chair in his Orange County living room. He and his wife, Ruth Gaydos, have lived in the same house for forty-five years, and its wood-paneled rooms and stone walls have a reassuring solidity. The framed photos on the grand piano mix family snapshots with theatre and movie premieres. The Gilroys' oldest son Tony received two Academy Award nominations as writer/director of *Michael Clayton*, which was edited by his younger brother John and featured his wife and son in small roles. John's twin brother Dan is a screenwriter whose credits include *The Fall* and *Two for the Money*, starring his wife Rene Russo and Al Pacino.

Ruth seems to be the only show business refusenik—the house is full of her striking bronze and clay sculptures—but she wields a quiet authority. Besides retyping her husband's scripts on a computer, she serves as a valued first reader. "She's very honest, a very tough critic," Gilroy admits. *Writing for Love and/or Money* describes Ruth's first response to the play he wrote during the 1960 Writers Guild strike, *The Subject Was Roses.* After saying she liked it, she commented, "I think you shortchanged the mother." Gilroy flew into a rage, but soon realized she was right; the mother's big scene is one of the play's emotional high points.

The new memoir evolved from a housecleaning project, Gilroy explains. "Ruth and I thought we'd do our heirs a favor and start weeding out some of my papers." The family house came with a walk-in vault, which he commandeered for his backlist. "There were piles of old scripts: jobs for hire, spec projects that did and did not get made. As we went through, I'd jot down a couple of notes about the circumstances surrounding each one on a Post-It. The things kept getting longer and longer."

Gilroy realized he had the bare bones of a book. The anecdotal form was not new to him: his 1970 novel, *Private*, based on his experiences in Patton's Third Army—

he was one of the first American soldiers to enter a concentration camp—is written in stark, impressionistic vignettes. "I was thinking about Matthew Brady's Civil War photos," he says. "I wanted to do with words what he did with photographs."

He also published a 1993 memoir called *I Wake Up Screening! Everything You Need to Know About Making Independent Films, Including a Thousand Reasons Not To.* Culled from diary entries, it details the making of *Desperate Characters, Once in Paris, The Gig,* and *The Luckiest Man in the World*, all written, directed, and produced by Gilroy. (The last two were filmed in the Hudson Valley; Cleavon Little and friends played their eponymous gig at Sacks Lodge in Saugerties, and Kingston stood in for New York in *The Luckiest Man.*) Shot in the seventies and eighties, these low-budget gems were part of the first wave of indie films.

"I define 'indie' as high wire, no net. You don't have a distributor beforehand, you've raised the money from private backers, just like a play; you open the picture yourself. I went from gambling on dice and things to making independent movies. This house has been put on the line more than once." Gilroy pauses. "*That's* gambling."

He alternated these labors of love with writing for hire. "People told me things that bothered other directors didn't seem to bother me, and I'd say, 'You have to understand, if I'm not here with you, I'm all alone in my room with a piece of paper.'"

Gilroy's workspace is a former maid's room, up a narrow back stair from the kitchen. "This is the inner sanctum," he grins, throwing open the door to a garret with sloping walls. Center stage is a card table bearing his typewriter. The day bed is littered with scripts—"I've never slept there, in all these years," Gilroy marvels—and even the walls are covered with writing: magic marker scrawls right on the pale yellow paint, bulletin boards full of vintage ticket stubs, a diagram of the solar system, a typed recipe for Red Cabbage Bavarian Style, a Writers Guild strike button.

He writes every morning, staying in his pajamas and robe till he's done his day's work. "Sometimes I don't get bathed and dressed till four o'clock," he grins, tugging at his tan sweater. "This is in your honor."

Gilroy has been a compulsive diarist for forty-five years. "It's the first thing I write every morning. It puts a platform under my day." He's planning to leave all his

papers to Dartmouth, the life-changing alma mater that accepted a scrappy underachiever from the Bronx on the G.I. Bill. "I just shipped them ten boxes, thirty pounds each," he gloats.

This may be the tip of the iceberg: along with the dozens of screenplays and plays he's launched into the world, he has numerous unproduced plays. "I'm a squirrel," he admits. Plays are, in his estimation, the hardest to write. "Six good plays is a career. Look at Chekhov. It's the smallest target of all. That's why movies were wonderful for me—they punctuate your playwriting career. They're fast, you stay busy."

Writing for Love and/or Money reminded him just how busy he had to stay to support a family of five on a writer's income. "When I pick up that book, it *scares* me. It's as if you walked across a moonlit field at night, and then you look back and realize you've walked through a minefield. How did you make it? You do it because there's no choice."

There was no choice about moving to Hollywood, either. "Now it's all on computer, you just fly out there for conferences. But in those days they wanted your physical body on the premises. They wanted to see you at your lathe."

Gilroy's bungalow on the 20th Century Fox lot was near Clifford Odets's and across from the Shirley Temple Cottage. He had his own parking space, a seat at the commissary writers' table, a Wednesday night card game. "It was very seductive and very nice, but too rarefied. You worked all day with people in the business, socialized with people in the business." As soon as he'd saved enough money, the family moved back east. "It's so ironic. I brought the boys back here so they wouldn't grow up in Hollywood, and all three of them work in the film business. I was dying to have a physicist or something, but that didn't happen." Gilroy laughs. "Your first reaction as a parent is, 'Oh my god, what are they doing to themselves?' But they found their lives—they love what they're doing and they're all good at it. What more could you want for your child?"

Dan and his family recently flew from L.A. for a visit, and Tony drove in from Manhattan. (John, who lives in nearby Tuxedo Park, is busy editing *Salt*.) The two

screenwriter brothers sit at the kitchen table, cheerfully trading anecdotes about growing up Gilroy. In a neighborhood of firemen and blue-collar workers, theirs was probably the only household that subscribed to *Variety.* "At this table, we all used to talk about movies," says Dan, who vividly recalls the magic of visiting sets and Hollywood backlots as a boy. "All the time," Tony nods, adding, "The library in this house is astonishing."

All three sons worked on film sets, but Frank never pushed them towards writing. "It's like being the son of a ballplayer, watching your father go through a slump or win the World Series," Tony says, recalling "huge triumphs, huge disappointments. Your father just had his teeth kicked in. How's he going to handle it? He's back up, he's fighting!"

The lesson, imbibed through osmosis, is just to keep going. "We all sort of work seven days a week, eight to ten hours a day," says Dan, and Tony shrugs, "I can't imagine any serious writer not working that hard. Can you?"

Right over their heads, on the wall of Frank's office, hangs the Worker's Prayer: LORD GRANT ME LABOR UNTIL MY LIFE IS ENDED AND LIFE UNTIL MY LABOR IS DONE. Snowy-bearded and dapper at eighty-three, Frank D. Gilroy shows no sign of slowing his pace; he just had a new one-act produced at Ensemble Studio Theatre. The thought makes him smile. "Every once in awhile, you get to do it for love *and* money."

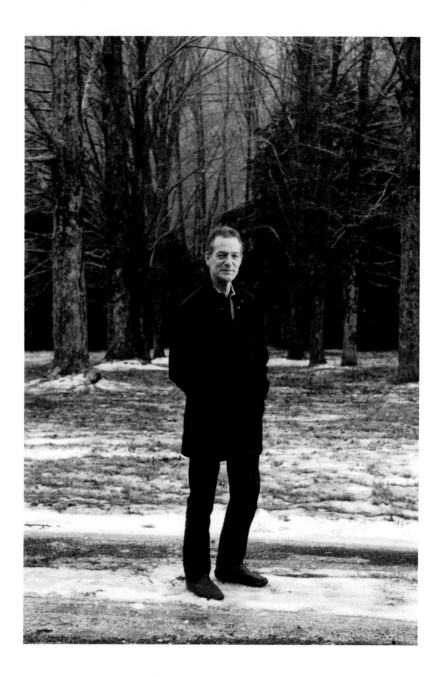

Jonathan Gould

IMAGINE: A STUDIO DRUMMER who's never written anything but letters decides to write the definitive book about the Beatles, subject of some five hundred previous books. His first query letter lands him an immediate book deal. Three editors, two publishing houses, and *seventeen years* later, *Can't Buy Me Love* is complete. It gets rave reviews and goes into its fourth hardcover printing within two months.

Welcome to Jonathan Gould's overnight success. The longtime Willow resident opened a reading at Woodstock's Kleinert/James Arts Center by saying, "I've run out of jokes about how long I've been working on this book." Then he posed "the eternal question: Why on earth would somebody publish *another* book about the Beatles?" As soon as he started to read, the answer was clear: Because no one has done it this *well*.

Despite the Beatles' ubiquity, *Can't Buy Me Love* avoids the familiar by eschewing gossip, spotlighting obscure songs, and selecting offbeat photos (not the classic Abbey Road cover shot, but the foursome lounging on the sidewalk, waiting to cross). Gould focuses on the Beatles' musicianship, but also examines their cultural context. And he makes it swing. Listen to him on "She Said She Said": "The track opens with the shrilly electrified, *Bride of Frankenstein* whine of George Harrison's lead guitar, wringing the neck of a G-major chord as it caterwauls up the scale—smack into the leaden crash of a downbeat and a series of evasive maneuvers from the drums."

Gould has a runner's weathered complexion, incisive blue eyes, and a radiant smile at odds with the worry lines on his forehead. He can talk a blue streak, reeling out perfectly formed sentences like silk off a spool. He gives the impression of someone who can't quite believe his good fortune, but secretly feels he deserves no less.

The author was thirteen in 1964, when he watched the Beatles on the Ed Sullivan show. ("Just me and 70 million other Americans," he writes.) Raised on New York's Upper East Side, with a lawyer father, psychotherapist mother, and two much-

older siblings, he attended Cornell University, but dropped out to be a rock drummer, studying with legendary teacher Alan Dawson in Boston. After working as a studio drummer in Boston and New York, he returned to Cornell to complete his degree in cultural anthropology; an independent study on post–World War II British social history spurred him towards four lads from Liverpool.

The first chapter he wrote covered the summer of '62, when Ringo Starr joined the band and the Beatles got their first recording contract. By now, Gould was back in New York with a wife and two children. One night he met *New Yorker* cultural critic Jacob Brackman at a dinner party.

"Jake said, 'If this book is as good as you seem to think it is, you should send it to William Shawn,'" Gould recalls. Recently deposed from the *New Yorker*, the legendary editor was now with elite literary publisher Farrar, Straus and Giroux.

For Gould, who venerated the *New Yorker*, Brackman had touched on a secret fantasy. "So I did what I always do. I procrastinated for a couple of weeks." Then he sat down, wrote "a really good cover letter" and mailed the first chapter to Shawn. A week later, the phone rang at ten-thirty on a Sunday night. "We had young kids. *Nobody* called us at ten-thirty," Gould recalls. "I was one step from yelling, 'Who the hell is this?' Then I heard a little voice, talking as if across a great distance: 'Mr. Gould? This is William Shawn.'"

Days later, Gould had a book contract. "William Shawn took it from being a project to a book," he says. "My aspirations were elevated." Shawn read Gould's work-in-progress and took him to lunches at the Algonquin. Gould describes it as a "very complicated relationship. He was the benevolent father, endlessly patient, endlessly appreciative." What makes that complicated? "Well, we all have our real fathers too," Gould responds mordantly.

Two years later, Shawn died in his sleep. Gould was assigned a new editor, Jonathan Glusman, but "felt orphaned, like the psychic apparatus propping me up wasn't there anymore." Everything he wrote seemed inadequate. "I have perfectionistic tendencies," he admits.

Meanwhile, both parents became terminally ill, and his marriage dissolved. Then a friend set him up on a blind date, saying only that the woman had blonde dreadlocks. ("I assumed she was white, not African American with *ironic* blonde dreadlocks," Gould laughs.) His response to painter and professor Lisa Corinne Davis is evidenced by the Lennon/McCartney lyric he wrote in her copy of *Can't Buy Me Love*: "Changing my life with a wave of her hand."

"Lisa kept saying, 'You *have* to write this.' She didn't have to say anything—it was just being around that forceful, dynamic energy, that striving approach to life." (A friend puts it more bluntly: "Lisa gave him a much-needed kick in the ass.")

Then Glusman left Farrar, Straus and Giroux. ("My editors on this book were like drummers in Spinal Tap," Gould quipped at the Kleinert.) But Glusman soon landed at Random House's Harmony imprint, wooing Gould there. They went over the unwieldy manuscript page by page. "I really learned to write by editing," Gould says. "Repetition is a form of insecurity."

Can't Buy Me Love's first prepublication review, from *Kirkus Reviews*, was so awful Gould's editor hid it from him. A week later, *Publishers Weekly* rolled out a starred review, calling it "brilliant," and *Booklist* and *Library Journal* weighed in with raves. Next came an effusive spread in the *New York Times Book Review*'s music issue. Seventeen years after he set pen to paper, Jonathan Gould had his hole-in-one.

His next project is a history of soul music in the 1960s, focusing on Motown and Stax, Marvin Gaye and Otis Redding. Just as *Can't Buy Me Love* parses Britain's obsession with class, the new book examines America's obsession with race. "Hanging around the edges is a much larger question about America and popular music worldwide: What is this thing all us white people have about black music and black culture?"

One more question remains. How does the professional drummer rate Ringo Starr, often reviled as "the luckiest man in show business"? Gould smiles indulgently. "What more would you want?" he asks. "Ringo never burdened the music with the sound of a whole lot of drumming going on. He did what he needed to do and no more. That's true of writing too. That's true of everything. That's what it means to be good."

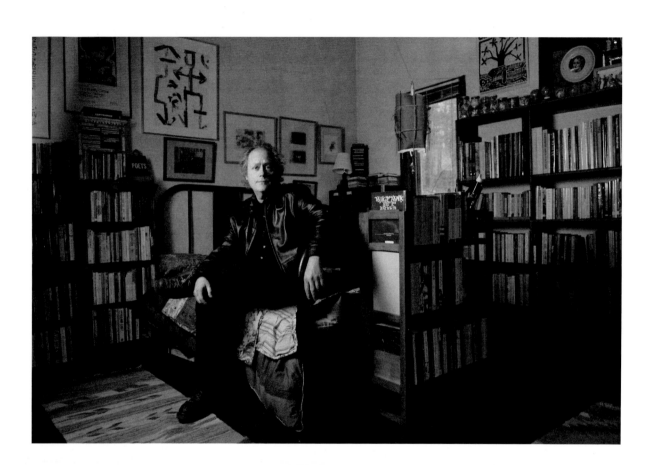

Mikhail Horowitz

IF THE CATSKILLS FOLLOWED Japan's example and designated Living National Treasures, Mikhail Horowitz—performance poet, literary rap stylist, and Zen *tummler*—would certainly earn a cracked halo.

The Brooklyn native discovered the region in 1961, when his parents sent him to Pioneer Youth Camp in Rifton. "It's the number one thing that made me what I am today," he asserts. The camp was integrated and politically progressive; Pete Seeger and Bob Dylan entertained campers. In a pageant honoring Cuba, young Horowitz played Fidel Castro, with a greasepaint beard and a real cigar. When he raised his fist and yelled, "Viva la Revolucion Socialista Nueva!" three hundred people cheered. "That," he says, "was being bitten."

At SUNY New Paltz, Horowitz did political theatre and helped found the Hudson Valley's first underground newspaper, *The Gargoyle.* After a right-wing radio host railed against the "vile rag," Horowitz was arrested for disseminating pornography; the offending illustration showed a cop with a gun poking through his unzipped fly. "I had Timothy Leary's defense lawyer from his bust in Millbrook, and the A.D.A. was G. Gordon Liddy," Horowitz laughs. The case was thrown out of court.

In 1973, Horowitz and Francesco Patricolo launched a "metaphysical stand-up tragedy team," Null & Void, and spent several years touring the West. Horowitz returned to the Hudson Valley solo, eventually teaming up with Woodstock Festival guitarist Gilles Malkine. Their shows are a nonpareil blend of musical, political, and literary outrageousness, blending rap versions of *Moby-Dick* and *Waiting for Godot* with Yiddish blues and doo-wop Edgar Allan Poe.

Horowitz also publishes "serious poetry" and collage art; his latest book, *Rafting Into the Afterlife*, boasts a striking linocut cover by his longtime partner Carol Zaloom. Their art-filled stone cottage, a mainstay of Saugerties Artists Studio Tours, is a fitting shrine for a brace of local treasures.

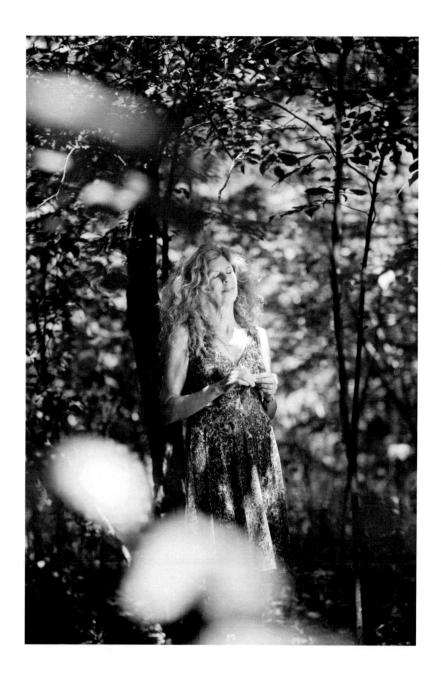

Marie Howe

MARIE HOWE WANTS to read a poem out loud. It's not one of hers. She grabs *The Collected Poems of Grace Paley*, explaining that she was reading it last night with friends and "we were just falling *down*. Grace wrote"—Howe makes quotation marks with her fingers—"very little, but every story is perfect, has greatness. Life is actually present in it, *real* life."

Like Paley, Howe has written "very little"—three books in a twenty-year span—but there's not a false note in a single poem. Hers is an art of essentials, life distilled to a crystalline clarity. Her first collection, *The Good Thief*, won the National Poetry Series open competition in 1988. Ten years later, Howe published *What the Living Do*, an indelible collection centered around losing a beloved brother to AIDS; *The Kingdom of Ordinary Time* followed in 2008.

As she reads Paley's poem "The Telling," Howe's low voice becomes huskier. She takes her time, and fairly shudders with enjoyment as she reads. She goes on to read three more poems, with outpourings of enthusiasm for every one. Urged to read one of her own, she opens *The Kingdom of Ordinary Time* to a poem called "Courage." She reads it aloud, then looks back at the penultimate stanza with a slight frown. "See, it could have ended right there. *'Are you brave?'* That could be the last line."

A relentless reviser, Howe often writes "eighty drafts. Well, fifty, anyway—an impossible amount. I write many poems, and throw most of them out. I work and work and work and then abandon them." Right before publication, she removed twenty-five pages from her latest book. "I don't want to waste anyone's time," she says simply. "A poem should be essential to the writer in order to be essential to the reader."

Howe is a strikingly beautiful woman with an intense, direct gaze. When she appears on the deck of the Harlemville home where she and her nine-year-old daughter Inan have been staying with friends this summer, she's barefoot, wearing a white

t-shirt and a flowered skirt. There's a delicate bracelet around one of her ankles; her toenails are painted a playful shell pink. A pair of sunglasses perches on top of her head, half-buried by leonine curls. She immediately offers coffee, tea, juice, leftover birthday cake, the "amazing" cinnamon rolls from the Hawthorne Valley Farm Store. She beams as Inan twirls through the kitchen, her body alive with a radiant joy.

Finally Howe settles down on the couch. She has two modes of discourse. Sometimes her words waterfall freely, sometimes she takes long, thoughtful pauses, searching for just the right word. The wrong word will not do.

Howe grew up in Rochester, the oldest of nine children. Her father was an alcoholic, and many of her poems allude to childhood trauma and the ways in which abused siblings look after each other. She describes her large family as "a tribe," with storytelling as an essential bond. She attended a convent school called the Academy of the Sacred Heart, of which she says, "It saved my life."

After college, she worked as a reporter for a Rochester newspaper and as a high school English teacher. She was thirty before she took her first poetry workshop at a summer program for teachers. Soon after, she entered the Master's program at Columbia University, where acclaimed poet Stanley Kunitz was her teacher and mentor. "It was one of the miracles of my life meeting Stanley," she says.

In 1983, Howe received a seven-month fellowship from the Fine Arts Work Center in Provincetown. "Back in those days, it was a banging shutter and a dog walking down Main Street in the winter," she recalls fondly. She started teaching writing at Tufts University and earned a 1987 residency at the MacDowell Colony. But two family crises pulled her back to Rochester: her mother had a heart attack, and her brother John revealed that he had AIDS. While shuttling between hospitals, Howe learned that Margaret Atwood had selected her manuscript *The Good Thief* for the National Poetry Series.

When John died two years later, Howe was devastated. She still speaks of his death with stark sorrow: "What is there to say? There's nothing to say." But her

poems found words to express the inexpressible. In an interview for *AGNI*, Howe says, "John's living and dying changed my aesthetic entirely. That's solely responsible—my involvement and response to his living and dying with AIDS. I wanted after that to make an art that was transparent, that was accessible to people who don't usually read poetry . . . the kind of talk that people talk in sick rooms, where it is very direct and very understated. I wanted to make movies without the photographer's thumb in the way."

She did. From "Why the Novel Is Necessary but Sometimes Hard to Read":

> *I can't read anything anymore*, my dying brother said one afternoon,
> *not even letters. Come on, Come on*, he said, waving his hand in the air,
> *What am I interested in—plot?"*

The title poem of *What the Living Do* is a heartbreaking litany of the mundane activities ("Parking. Slamming the car door shut in the cold. What you called *that yearning*") which the dead have given up and the grief-benumbed living must learn to cherish. Intensely personal as her poetry appears, Howe is quick to point out that although she often taps details gathered from life, including real names of family members and friends, this transparency is an intentional construct.

"The 'I' in a poem is not the self," she asserts. "I don't care if people assume it's autobiographical. It's none of my business, I don't care." But when a man came up to her after a reading and said, "I feel like I've seen right into your soul," her response was, "You haven't."

In *AGNI*, she explains the difference between personal and literary intimacy: "I'm making something, like Joseph Cornell makes his boxes and everyone looks into them, but it's the box you look into; it's not the man or woman. It's an alchemy of language and memory and imagination and time and music and sounds that gets made, and that's different from 'Here is what happened to me when I was ten.'"

"Things happen to us all the time, but they have to be transformed within the psyche," Howe says. This process may take a long time. Her poem "Practicing" opens with the lines:

> I want to write a love poem for the girls I kissed in seventh grade,
> a song for what we did on the floor in the basement
> of somebody's parents' house

"I tried to write that poem for twenty years—so many, *so* many times," says Howe. "I had the content, but not the form. I wrote down the first line and realized, oh, it's a song of praise. And it all just came out. After twenty years."

"There are so many elements that aren't as visible as the subject matter . . . musicality, breath, line, the sound of the words, what it makes your body do when you say it out loud." Howe says her poems "are all meant to be spoken." She speaks lines out loud as she's writing, then tape-records her drafts and listens, "twenty, thirty times. You really get over yourself. That's when the real editing begins."

Though she's based in Manhattan, Howe has been teaching at Sarah Lawrence College in Westchester since 1993. Once a semester, she asks her students "to compose a poem in their body and bring it to me in their mouth. No paper." The results, she says, are "amazing. I've never had a poem not work. I've had classes moved to silence." Such poems, she says, are composed in the heart, not the head.

Howe has been spending summers further up the Hudson—in Woodstock, Bearsville, Red Hook, and Harlemville—since 2003, the year she adopted three-year-old Inan from China. Adopting at age fifty-two "was a long story," Howe says. "I was married, we were trying, I got unmarried." Although she spoke next to no English, Inan went to the Woodstock Day School's preschool camp with the daughter of Howe's writer friends Chuck Wachtel and Jocelyn Lieu while her overwhelmed mother tried to regain equilibrium. "I felt like I was just staggering through that first summer," she says. The following summer, Inan returned to camp fluent in English, and Howe used the day-camp hours to write.

The house where they're staying this summer is just down the road from a swimming pond, and Howe wants to join her friend Steph, who's brought Inan there for an afternoon swim. It's one of the rainy summer's few perfect days, and a redtail hawk makes slow loops overhead. The pond is encircled by tall green reeds.

Marie Howe stands at the edge of the water, watching her daughter glide by like an otter. "How can we find words adequate to our experience of being here on earth? And yet poets have done it," she says. "Life wants to tell its stories, life wants to sing its songs. . . . So much of it has nothing to do with us. But art is our human discourse— we need it and we want it. I don't want it to be too mysterious. We make poems for each other."

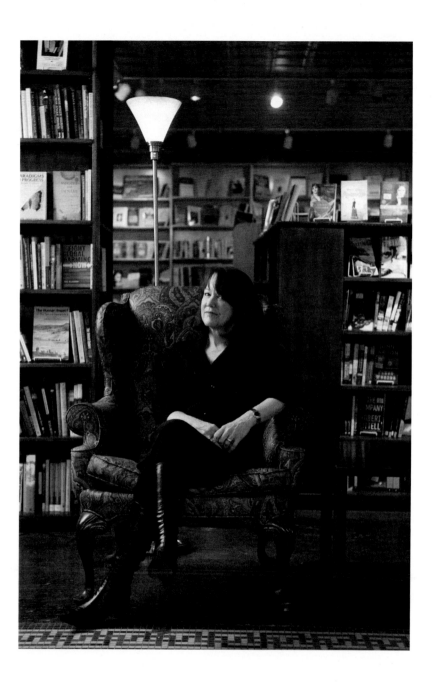

Marilyn Johnson

"Give me a dead celebrity any day," says Marilyn Johnson, author of *The Dead Beat: Lost Souls, Lucky Stiffs, and the Perverse Pleasures of Obituaries.* As a magazine writer raising three children in Westchester, she felt that "my timing was always off." The elusive Toni Morrison once returned an interview call while Johnson was cooking hamburgers for her kids; she took notes on a grease-splattered pad. When she flew to Chicago to interview Oprah Winfrey, their time was cut short and Winfrey generously offered another half-hour—two days later. With three kids under ten and husband Rob working full-time at *Sports Illustrated*, Johnson went into frantic schedule-juggling mode.

"Obituaries were the answer. They're *dead*, you don't have to sit around waiting for them," Johnson laughs. "It was the perfect job to do from home."

After penning obits for the likes of Marlon Brando and Princess Diana, Johnson explored the unexpected nooks and crannies of obituary culture in *The Dead Beat.* Her new book, *This Book Is Overdue! How Librarians and Cybrarians Can Save Us All*, lifts up the "plain brown librarian wrapper" to look underneath. Johnson thought, "Where are the anthropologists? These creatures are *fascinating.*"

Those words could be the rallying cry for all literary nonfiction, but Johnson didn't start out in that field. She studied poetry with Charles Simic at the University of New Hampshire, missing her MFA graduation when she was hired as assistant to legendary *Esquire* fiction editor Rust Hills. "I think I'll do this for a summer," Johnson recalls thinking. She stayed for five years.

Johnson and family have lived near the Rockefeller State Park Preserve since 1986. "I love being both in the woods and close to a world-class arts scene. I love The Hudson Valley Writers' Center." Besides, says the self-described research fanatic, "the Westchester librarians have had my back since the beginning."

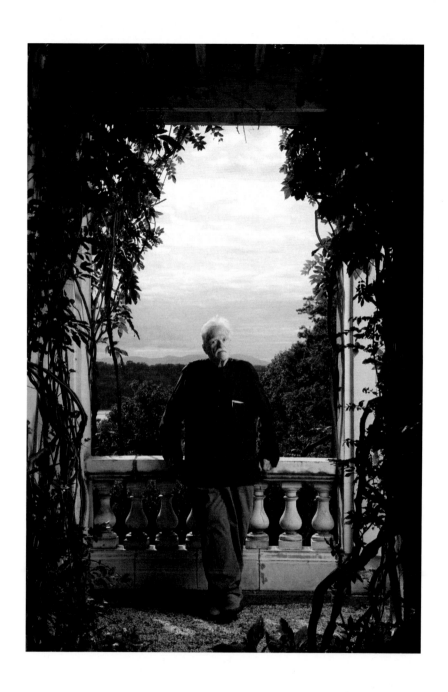

Robert Kelly

"I don't like to begin a day without writing," says Robert Kelly, author of more than sixty books of poetry and fiction. "A word comes to mind. I write it down and see what happens. When you do this every day for fifty years, you learn how to wait."

Kelly has a velvety baritone voice, expressive hands, and piercing blue eyes, framed by jutting cheekbones and a dense growth of bristling white eyebrow. There are two fountain pens in his shirt pocket. Around his neck is a maroon blessing cord with a circular conch-shell bead, formerly part of a prayer wheel cylinder. "When they get worn down, they're removed," he explains. "They're thought to contain all the recitations from the prayer wheel. It was a gift from Lama Norlha Rinpoche, abbot of the Kagyu Thubten Chöling monastery in Wappingers Falls. When he gives it to you, you don't take it off."

Outside Kelly's office at Bard College, a late-summer thunderstorm crescendos. As wind lashes trees and rain pounds the pavement outside, the poet's book-filled lair seems a true sanctuary. Behind his head, a computer monitor displays an animated screensaver of a night sky, so that Kelly appears to be at the helm of a fast-moving spaceship, burrowing through constellations.

It's an apt backdrop for his latest novel, *The Book from the Sky*, a nonpareil melding of visionary poetics and vintage space fantasy. In its opening pages, twelve-year-old Billy is abducted by aliens who create a changeling double, replacing his organs with a clock, an old postcard, and a tobacco pouch, with two grey squirrels where his lungs used to be. Years later, he will be sent back to earth as charismatic spiritual leader Brother William ("I used to be a little boy, like you, and now I'm a religion"). Ultimately, he and his earthly doppelganger are joined by a murderous act; it's a Cain and Abel story in which Cain *is* Abel.

It's also a feast of language from an effusive polymath—language, in fact, is one of its central concerns. When Billy wonders how he can understand his captors' speech, he's told, "Our language knows how to fit inside your language. Our sentences are like water, they find the spaces left in your ideas."

Billy, says Kelly, "is me at age twelve." In the late 1940s, his family spent a few summer weeks in a boardinghouse near Port Jervis, New York. One night, his father called them outside to see something in the sky. "All of us, *en deshabille*, stood on the lawn, looking up at this big flattened oval of great luminosity. I looked at it through binoculars. It wasn't much clearer, but I could see squarish window-like indentations, the same color as the rest, buttery in the moonlight," Kelly recalls. "We'd all read in the newspapers about flying saucers, so our reaction was rather as you might respond to a Smart Car—'Oh, there's one now, I've read about those.' There was no panic or fear, just interest. We stood watching for a long time. It didn't do anything else, so we went back upstairs and went to sleep. I've wondered for years what it might have been."

Even without UFOs, the upstate landscape had a magical effect on Kelly, who grew up as a bookish misfit in Brooklyn's Sheepshead Bay. Enamored of words, lists, and names, he was happiest during the private hours between school and his parents' return home from work. At fourteen, he applied for a library card at the main branch of the New York Public Library. The application form had a blank for "Occupation." After a brief hesitation, he put down WRITER. Then he set about making it true.

Kelly published his first book of poetry, *Armed Descent*, in 1961, the same year he started teaching at Bard. "A lot has changed since 1961," he asserts. "Rhinebeck had no *food.* If I wanted a loaf of bread or a piece of cheese, I had to go to the Italian market in New Paltz, or up to Hudson. It was all Wonder Bread."

There's a sudden immense bolt of lightning and near-simultaneous thunderclap, and three soaked students charge into the building for cover, screeching and giggling. Intrigued, Kelly opens the door to look out at them. He returns to his chair with a satisfied smile.

"Suddenness—it's all about that," he says. "A poem is suddenly there, or a story. It *occurs* to you. That kid outside will remember that lightning bolt for years." As a

teenager, Kelly saw a Sean O'Casey play at the Provincetown Playhouse. He still remembers the sound of feet pounding upstairs as the characters ran from the IRA, the vibration of air and sound all around the theatre: "It was an electric moment. We were inside the play."

Kelly's poems are full of such sudden, electrical bursts. From "A Lithuanian Elegy":

> You saw a man bleeding on the river bank
> We wash and wash and never come clean
> We know each other by the way we walk
> Red ribbons like strips of meat in the rain.

He observes that "we look at poems in two ways: as a whole shape on paper, in the same way one might encounter a painter's canvas, and sequentially, while reading from left to right, top to bottom. When we view a whole poem, certain words grab the eye, prompting subliminal connections which may run counter to the poem's sequential narrative." He enlarges the poem he's been revising on his computer and points out some words which link in this way: *naked, wicked, legal, debtor's prison.* "You see? It's a dark undercurrent quite different from the poem as read from beginning to end." Kelly is working with neurologist Barbara Luka "on what actually happens to us as we read a poem. I'm very interested in peripheral vision."

"Everything is connected," he says. "A poem is a painting, or an aria. I like to think of a sonnet as a syllogistic work: there are eight lines in opposition, then you solve it in the next six. It's a thought experiment."

A passionate teacher, Kelly treats his writing students "as if they're already who they're going to be. I treat them as poets. Well, that's what we *do*, isn't it? If you meet someone and want to go to bed with her, you treat her as if she's already your lover. Anyway, they *are* poets. A poet is someone who's written poems, and if they keep doing it, they'll be buried under that name with a flag flying."

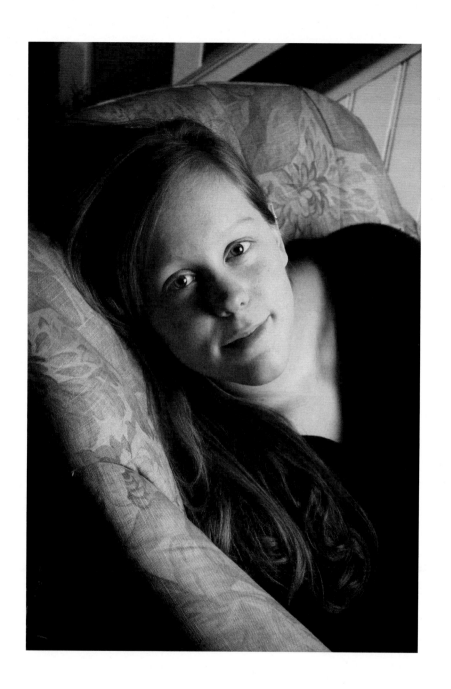

Lucy Knisley

"I'm one of those grassroots, got-started-on-the-Internet people," grins Lucy Knisley. An ebullient blonde who grew up in Rhinebeck, the twenty-three-year-old comics artist has reason to crow. Her "drawn journal," *French Milk*, published by Simon & Schuster, has just gone into its third printing, with rave reviews in *USA Today*, *People*, *Glamour*, and a slew of food blogs. It's also been optioned for film.

Originally self-published by Epigraph, *French Milk* was acquired by an editor at the Comic Arts Festival, where Knisley was selling her books at a friend's table. In drawings, words, and photos, she details a six-week trip to Paris with her mother, a professional caterer who shares her love for art and food—not necessarily in that order.

"In our family photo albums, there are literally more pictures of meals than of actual people," Knisley says. She describes her next project, *Relish*, as "an autobiography in food," inspired by Nigel Slater's memoir *Toast* and drawings made by sculptor Claes Oldenburg when his wife developed food allergies, "so she could visually digest it."

For Knisley, food writing is "inextricably linked to color, drawing, the visual aspects of looking at food." Like many members of the MySpace generation, she's at ease with public exposure; she's published an online live journal for years. "I have a very understanding boyfriend who loves, loves, loves being in my comics, so there's very little editing," she asserts. "I write about my emotions, illness, childhood memories—intimate experiences I share through my work. It's all about communicating and creating an intimate bond with readers."

Though she's currently living in Chicago and pursuing an online MFA from the Center for Cartoon Studies in Vermont, Lucy Knisley will always be beckoned back home. "The Hudson Valley is the only place in America that produces foie gras," she says. "It's a great place to live."

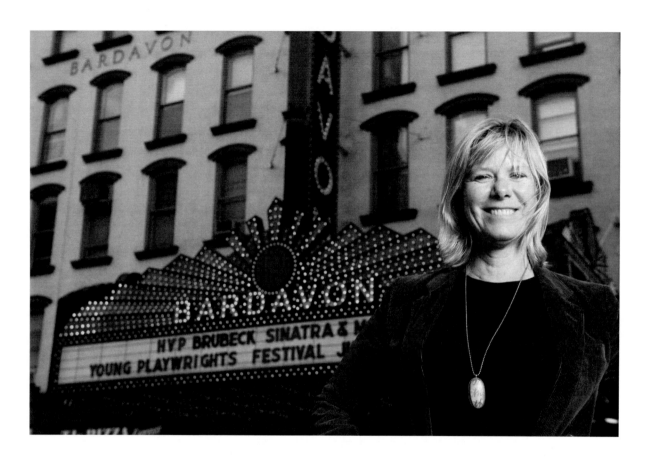

Casey Kurtti

"YOU KNOW THAT INDIAN CURSE? Once you've lived here, you'll always have to come back," says Casey Kurtti, spearing a forkful of beans at the Rosendale Cafe. The SUNY New Paltz theatre major moved to New York to intern at Theatre Genesis and stayed to write Off-Broadway hits *Catholic School Girls* and *Three Ways Home.* In 1989, she moved back with her husband, Bardavon director Chris Silva, to raise their two children in Ulster County. As curses go, you could do a lot worse.

When Kurtti was in sixth grade, her family was named Yonkers Library Family of the Year. Their apartment was small for a family of nine. "All the girls were in one room and all the boys in another," she recalls. "I'd go to the library with my sister, and we would pretend it was our house. I'd fill a shopping cart—an A&P shopping cart, to be detailed—with books twice a week."

Details matter to Kurtti. "Great writing is four things," she says. "Emotion, details, surprise, and voice. That's it." During the past fourteen years, she's passed this recipe on to over a thousand sixth graders through the Bardavon Young Playwrights Festival.

Young Playwrights began with a classroom visit to Poughkeepsie Middle School after Kurtti's Emmy-nominated *Girlfriend* was aired, and evolved into an annual residency with a cumulative performance at the Bardavon Opera House, featuring such A-list area actors as James Earl Jones, Melissa Leo, and David Strathairn.

"Writing is such a lonely thing. And I'm not the kind of writer where it just flows," Kurtti admits. "So when I go into that room, it's a vigorous negative workout." She finds balance through community activism and teaching.

"You can stumble on a moment in life, and if you write about it accurately and honestly, there's going to be some actor who will blow that moment out of the water," Kurtti says. "These kids are not necessarily going to be writers, but they definitely want that moment, that illumination, to happen over and over again in their lives."

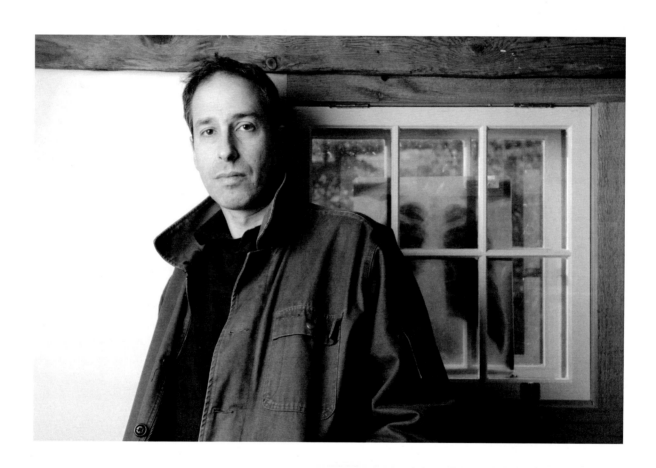

James Lasdun

JAMES LASDUN PACKS a prodigious literary pedigree. The London-born author has published two acclaimed novels and three collections apiece of short stories and poetry. Mary Gaitskill wrote of his first novel, "If you possess a spine, *The Horned Man* will set it aflame"; *Seven Lies* was longlisted for the 2006 Man Booker Prize. Lasdun's story "The Siege" was filmed by Bernardo Bertolucci (as *Besieged*). He's won numerous major awards, and he isn't quite sure what he does for a living.

"I don't think of myself as a professional poet," Lasdun demurs over coffee at Oriole 9 in Woodstock. "Right now I'm trying to be a professional fiction writer."

Most would say he's succeeded, but Lasdun seems to carry an unusually pernicious strain of self-doubt. Dark and lean, he has a faintly mournful aspect in repose. When he laughs, his face is transformed by an unfettered grin.

The author wears a gray pullover, jeans, and boots that would look right at home in the vegetable garden he tends on a hilltop in Shady. Though he emigrated two decades ago, he's retained a mellifluous English accent—at least to American ears. "My mother thinks I sound American," he comments with some satisfaction.

Lasdun moved to New York in 1986, when editor Ted Solotaroff found him teaching jobs at Columbia and Princeton. "I thought I'd stay one term, but the minute I arrived in New York City, I realized that I wanted to stay," he asserts. The eighties were "an exuberant time in New York. It was the Reagan era, a time of real extremes, and there was a feeling of *life* all around, in exciting, bizarre, and disturbing ways. I liked that." He also liked being a foreigner.

"I never felt English," he says. "It became clearer, once I moved here, how alienated I already felt. It was a relief to formalize my outsider status." His father, eminent architect Sir Denys Lasdun, always told his children they weren't English. Descended

from Russian and Eastern European immigrants, the Lasduns weren't practicing Jews, but young James was acutely aware that his family was different. "When I was growing up, England was very homogenous, very Church of England. There was always a pull between belonging and not belonging."

Themes of expatriation, exclusion, and self-reinvention run throughout Lasdun's work. The narrators of both novels are émigrés (*The Horned Man*'s is English; *Seven Lies*' East German) and the poetry collection *Landscape with Chainsaw* may set a record for use of the word "apostate" in title and verse. The prizewinning poem "Locals" concludes, "there were always locals, and they were never us."

As a teenager, Lasdun dreamed of becoming a playwright. He was thrust into the London theatre scene when his father designed the new Royal National Theatre. Denys Lasdun's stark, modernist vision drew both praise and controversy: Sir Laurence Olivier called him "possibly the most brilliant man in England," while Prince Charles compared the concrete complex near Waterloo Bridge to a nuclear power station.

"The National Theatre was the backdrop of my teen years," Lasdun says. His mother, a trained artist, worked on the interior design of her husband's buildings and wrote books on social history. Lasdun's brother became a sculptor; his sister, a musician. "It was a family with a very high premium on creativity," he says drily.

Lasdun's debut novel, *The Horned Man*, is narrated by an expatriate Englishman who teaches at a college outside New York City. In deceptively measured and rational prose, he describes a series of odd occurrences that send him into a spiral of paranoid nightmare. It's a profoundly unsettling reading experience, a plunge down a mineshaft illumined by Lasdun's glistening prose. "It was going to be this little short story about a man who teaches creative writing and has writer's block," Lasdun says. "I made one small change, making him a professor of gender studies, and it was like opening some weird box. It got stranger and stranger, and I just went with it. I wrote most of the book in six months."

This outpouring came after a decade of struggling with novels he couldn't complete. At one point, he became so discouraged that he spent eight months as an

organic farmhand at Orange County's Blooming Hill Farm. In time, the mood he likened to Kafka's "inner leprosy" lifted. He underwent psychoanalysis, became a father, and wrote with renewed vigor.

During the 1990s, Lasdun collaborated with director Jonathan Nossiter on two independent films, *Sunday* and *Signs & Wonders*. (He wasn't involved with adapting *Besieged*, but did visit the set, where Bertolucci greeted him with, "Here's the writer, the superego of the film.") Screenwriting was a bracing change of pace. "In a screenplay, time is money. Every page is a proportion of the budget. It speeds you up. You become very intolerant of anything that drags."

Economy is also a hallmark of the short story, a form at which Lasdun excels. "In a way it's more like a poem than a novel—it demands speed, economy, concentration, finding images that express an enormous amount of emotion. It's an art of omission, where a novel is more about accumulation. But it's a narrative art: everything counts, every *word* counts, like a poem. Every detail ought to be kind of luminous, as well as contributing to the whole." The London *Times* called his 2009 collection, *It's Beginning to Hurt*, "elegant, acutely observed, and utterly unflinching."

Lasdun and his wife, Pia Davis, have found a unique way to pay bills without leaving the family behind. They updated their classic guidebook *Walking & Eating in Tuscany & Umbria* in 2005, following up three years later with *Walking & Eating in Provence.* Both research trips included the couple's two children; Lasdun enjoyed "doing something different from sitting in your room all day writing."

He writes every day when he's home, and keeps a notebook with him "at all times" to jot down stray thoughts and observations. "I try to catch them on the wing—things I see on the street, details of a story that come to me when I'm not pushing it." He's filled forty-five notebooks since emigrating.

"You think it's going to get easier as you go on, but every book is a new challenge," he sighs. "I feel consumed by writing. I don't want to do anything else. I would do nothing but write all the time if I could." When reminded that he just enthused about leaving his desk for Provence, James Lasdun breaks into a grin. "I'm conflicted about everything. Isn't that obvious?"

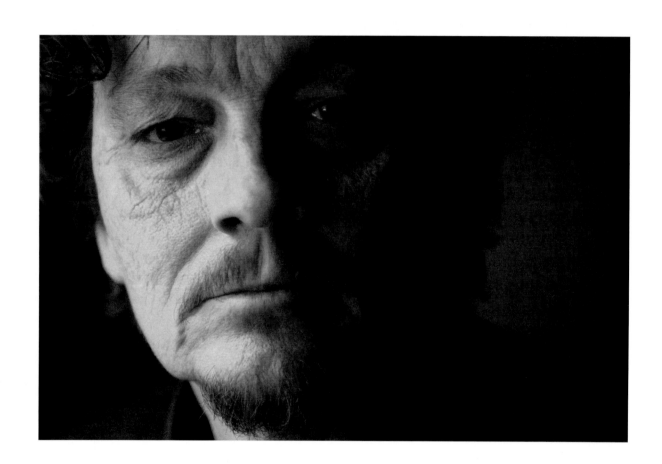

Naton Leslie

NATON LESLIE KNOWS HOW TO make things last. Growing up in Ohio's industrial belt, he spent every weekend in the Appalachian mountains of western Pennsylvania, where his extended family still lives. "I always felt I had my feet in two cultures," he says. "That's an important position for writers. When you're on the edge, sometimes you get to see the whole view in a way that you can't when you're in the middle."

Leslie attributes his love of literature to "a lack of affordable childcare." His father was a factory worker; his mother a teller at a bank that stayed open late on Fridays to cash steelworkers' paychecks. "I liked to read, so my mother would take me to the public library across the street and say 'Stay here till I'm done.' I chewed through the children's section and moved on," he says. "This was exotic stuff: words, worlds created on paper. I decided early on that I wanted to do that."

A professor at Siena College, Leslie has published five books of poetry, an award-winning story collection, and *That Might Be Useful: Exploring America's Secondhand Culture*, a paean to all things reused. Years ago, he and his wife decided to reject consumer culture by buying "everything but underwear and flashlight batteries" in the Hudson Valley's antique barns, consignment shops, auctions, and yard sales.

Leslie comes by his thrift honestly: One of his uncles made his own pickup truck out of sheet metal gleaned from abandoned refrigerators, washers, and dryers. "On the side where it would say Ford or Chevy, it said Maytag. He drove it for years."

His latest poetry collection, *Emma Saves Her Life*, is itself an act of creative recycling, fashioning sturdy, eloquent, and surprising poems from the letters and words of his late Appalachian grandmother.

Leslie traces his working-class roots to eleven ethnic groups, mostly northern European and Seneca. "I'm what America becomes after awhile," he says with a laugh. "We're all secondhand."

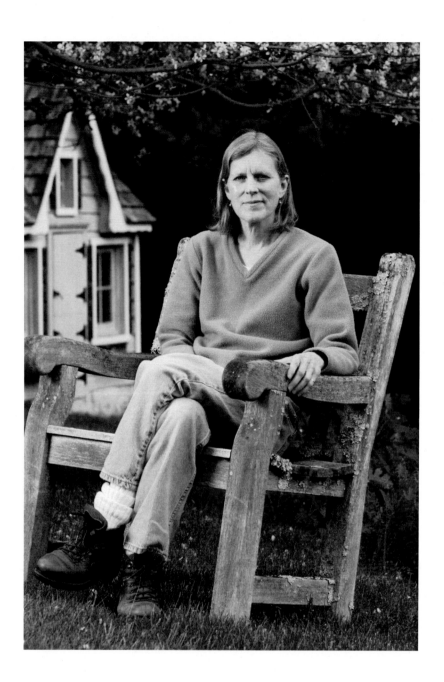

Ann M. Martin

NAME A SMALL TOWN with the following Christmas Eve tradition:

After the parade, Santa Claus arrived in town and not just waving from the last float. No, the method of his arrival was magical and unexpected and different every year. No one (except the mayor) knew who played Santa; it was a big [town] secret. And no one knew how he would appear. Min said that once Santa had sprung out of a giant jack-in- the-box in the town square, and once he had been flown in on a helicopter, and once he had even ridden down Main Street on an elephant.

If you answered Woodstock, you're close. The small town with the mysteriously athletic Santa is Camden Falls, Massachusetts, created by bestselling young adult author Ann M. Martin for her latest series. "Woodstock was definitely my inspiration for *Main Street*," Martin affirms between bites of a grilled veggie sandwich from Bread Alone. Soft-spoken and simply dressed in a pink fleece sweatshirt and jeans, she's extraordinary self-effacing for a publishing phenomenon.

Martin's long-running series *The Baby-sitters Club* has sold more than 176 million copies, prompting *Publishers Weekly* to declare, "Ann M. Martin rules the paperback roost." Her other books include the award-winning *A Corner of the Universe*, *Belle Teal*, and two more series coauthored with Laura Godwin (*Doll People*) and the late Paula Danziger (*P.S. Longer Letter Later* and *Snail Mail, No More*)—in all, over two hundred titles.

Martin never imagined such a prodigious output when she published her first book, *Bummer Summer*, in 1983. A recent Smith College graduate, she worked as an editor at Scholastic and Bantam Books. *The Baby-sitters Club* was originally sold as a series of four, and Martin remembers her editor talking about how to construct a story

arc that spanned several books. "I'd never *heard* the term 'story arc.' I didn't know what I was doing—I was just thinking of each book and how to tell that story best."

Clearly her instincts were golden. Scholastic commissioned more BSC books right away, planning to release four a year. "I was surprised and very grateful," Martin says. By book six, "they realized it was taking off, and the schedule jumped up to one a month." Scholastic also launched the *Little Sister* spinoff series, hiring writers to work from Martin's outlines. By the time the Baby-sitters Club's perennial eighth graders booked their last client in 2000, Martin had been on the production treadmill for fourteen years. "I thought I would never write a series again," she asserts. But one of her BSC editors, David Levithan, wooed her back via her love of sewing, and *Main Street* debuted in 2007.

Though Camden Falls's shops and row houses seem Norman-Rockwell timeless, Martin fills their interiors with lives that are not picture-perfect. Her leading characters, Flora and Ruby, lose both parents in a car accident and come to live with their grandmother, whose neighbors include an African American widower struggling to remain independent, and families coping with a mentally handicapped teenager, Alzheimer's disease, and the shame of poverty.

These edgy topics unfold in a reassuringly old-fashioned context. At a time when most fiction aimed at tween girls reads like chick-lit-in-training-bras, it's refreshing to see middle-school characters act their own age.

"I always wanted to write children's books because they were so important to me growing up," Martin says. Her mother taught preschool, and her father was a *New Yorker* cartoonist; young Ann met his colleagues George Booth and Charles Addams. Though Henry Martin kept a studio downtown, he often worked at home in the evenings. His daughter remembers standing behind his chair, watching him draw.

Martin describes herself as an introspective, studious girl who loved sewing and crafts, and was scared to try sleepaway camp. Her vivid imagination concocted a family of foxes under her bed. "When I got out of bed, I would leap three or four feet away so Mr. and Mrs. Fox couldn't get me. I sort of knew they weren't really there, but I still had to leap," she says, adding that she always slept with the light on.

Martin bought her imposing Victorian house near Woodstock in 1990—the same year she launched two charitable foundations with her BSC earnings. She's an animal lover whose household includes several foster cats and Sadie, an adopted golden retriever/beagle mix with a BSC zipper pull on her collar. Sadie's mother was a stray, and Martin's award-winning novel *A Dog's Life* traces the sometimes heartrending fate of two stray puppies born in a summer house toolshed; she recently published a sequel, *Everything for a Dog.*

For someone who writes so much about the complex emotional lives of children and animals, Martin is strikingly reticent about her own. This may be temperamental—she refers several times to her shyness—or a buttoned-down remnant of the WASP heritage she can trace back to the Mayflower.

It's telling that even what Martin calls her "most personal book," Newbery Honor winner *A Corner of the Universe*, is based on tales of her mother's mentally ill younger brother, who died before Martin was born. Twelve-year-old Hattie is a shy nonconformist in a town where the biggest divide is between Presbyterians and Episcopalians. Into this straitlaced community comes Uncle Adam, a schizophrenic savant just discharged from the residential school where his tight-lipped parents have tucked him away. Inappropriately dressed for every occasion and constitutionally incapable of hiding emotions that swing from childlike glee to frightening volatility, Adam is like nobody Hattie has ever met. Her reflections at the book's end could serve as a credo for Ann M. Martin's fiction:

I thank Adam, as I have thanked him almost every night since August, for showing me that it's possible to lift the corners of our universe. Adam told me about lifting the corners the second time I met him, but I had no idea what he meant. Now I think I do. It's about changing what's handed to you, about poking around a little, lifting the corners, seeing what's underneath, poking that. Sometimes things work out, sometimes they don't, but at least you're exploring. And life is always more interesting that way.

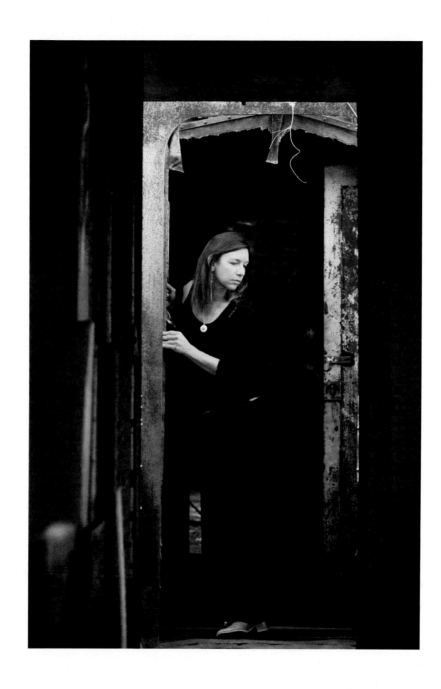

Jana Martin

"WORDS PUNCH ME, and I punch them back," says fiction writer Jana Martin. "I love the idea that you can coerce a reader into taking a creative leap with you if the diving board is set at the right angle."

Martin lives near the Ashokan Reservoir with dog trainer Kyle Warren, six German shepherds, and two hunting dogs. "When you live with eight dogs, you're committing to a different kind of life," she admits. "I *love* it. But when six of those dogs are working-line German shepherds, you're dealing with a different kind of intelligence and alertness. You have six Type A personalities with fur and teeth who need a job."

Three days a week, Martin heads into the woods to train with other Search and Rescue volunteers. She especially enjoys being tracked. "I often get clear, really crystalline ideas. I've filled many pages of a notebook waiting for a dog to find me. I like working with beginners, because it'll take a long time and I'll get a lot of work done."

Martin's galvanizing *Russian Lover and Other Stories* was published by Yeti/Verse Chorus Press in 2007; her story "Hope" was a *Glimmer Train* prizewinner. "I knew when I was four that I was a writer," she asserts. Her mother was an abstract painter and teacher, her father a Hungarian photographer who curated the Nikon Gallery. The family's commerce was culture, books, and upheaval: they moved eleven times before Martin turned ten.

As a young adult, she was equally peripatetic, attending Oberlin College and the University of Arizona, then living in Oregon and Miami during what she calls "my lost years. Looking at it objectively, I'd say I was gathering material. I was in danger a lot, doing really stupid things, I got my heart broken—it was *perfect*."

When Martin moved to the Hudson Valley in 2002, she knew she was finally home. "I didn't realize this was such a fertile place for writers, but it is," she exults. "There's enough quiet that you can hear yourself think." Even with six German shepherds.

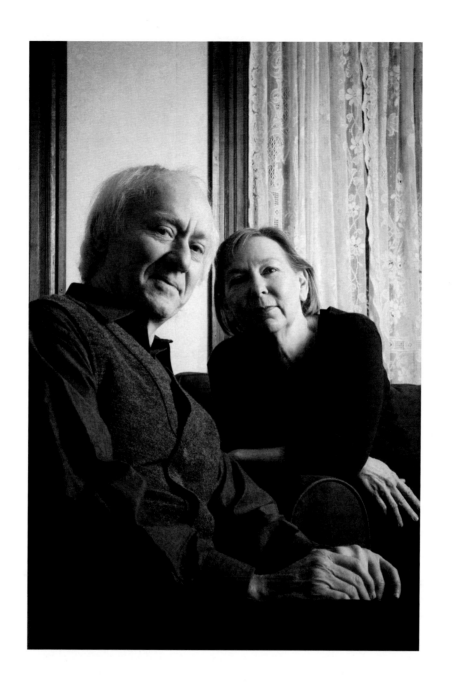

Valerie Martin and John Cullen

VALERIE MARTIN'S EXTRAORDINARY story collection *The Unfinished Novel and Other Stories* is a suite of indelible portraits of artists. There's the arrogant painter who torments his muse in "His Blue Period"; the mercurial Hamlet of "The Bower"; the deluded hack of "Beethoven"; the still-bitter author who faces his ravaged ex-lover (and her final opus) in the title story; the unsatisfiable lesbian poet of "The Open Door"; the printmaker who inhabits a wildly different realm from her spouse in "The Change." Written in crisp, limber prose, these six stories are Goldberg Variations on a shared theme: the only thing harder than being an artist is living with one.

Given this worldview, it may seem surprising that Martin enjoys a long-running affectionate partnership with a literary compatriot, noted translator John Cullen. They're the sort of couple who touch each other unconsciously, a hand brushing a shoulder in passing. They sit side by side on the sofa, listening appreciatively or interjecting details as the other one speaks. Both their voices are tinged with a soft Southern purr; Cullen's has a touch more New Orleans grit, like the chicory flavor in dark-roasted Café du Monde. There's even a hint of physical resemblance; both are slight, fine-boned, and fair. Surely these people were made for each other.

They met in New Orleans when Martin was nineteen and Cullen in his early twenties, though it took them two decades to move in together. Meanwhile, Martin married, divorced, raised a daughter, and wrote, supporting herself as a bookstore clerk, welfare caseworker, waitress, and writing professor. Cullen roamed throughout Europe, living in Paris, Rome, Florence, Vienna, Madrid. "You know that blues song, 'All My Life I've Been a Traveler'?" he smiles. "I liked it when I was young. I could fit all my belongings in a little Fiat."

But he often returned to his native New Orleans, where he ran into Martin "again and again." Eventually he followed her to Massachusetts, where she was teaching.

"John had the terror of Yankees," Martin says drily, and Cullen responds, "More terror of Yankee *winters. I still have it."

Martin had already published two volumes of stories and three novels. After the breakthrough success of *Mary Reilly*, a reimagining of the Jekyll and Hyde story (she calls the Julia Roberts film "inescapably awful"), the couple spent three years in Rome. They've lived in the Hudson Valley for over a dozen years, first in Lagrangeville and now Millbrook, in a white-porched colonial they share with "a very important cat."

Both writers work at home. They've set up their offices at opposite ends of the house, to minimize the distraction factor. Cullen says, "She's upstairs back, I'm downstairs front. She gets the phone, I get the front door." Their work hours are staggered as well. Martin prefers to work mornings; Cullen customarily starts around five o'clock, breaks for dinner, and works until three o'clock in the morning. "It's very, very quiet in Millbrook after nine-thirty," he states with deep satisfaction, noting that the neighbors' incessant lawnmower din is the bane of his downstairs-front workspace.

Cullen is a freelance scout for foreign books, evaluating works in French, Italian, German, and Spanish. "Usually the foreign publisher is pushing hard for an American edition, saying this is an important author, you *must* print this book." He reads ten to twenty a year, generally recommending just two or three for translation. There's a fringe benefit to scouting: "If I really like it and find it compatible, I suggest that it should be translated by *me.*"

One such book was *The Swallows of Kabul*, by Yasmina Khadra (former Algerian army officer Mohammed Moulessehoul took this feminine pseudonym to avoid censorship by the military). Now living in France, Khadra earned international acclaim for his latest novel, *The Attack.* Set in an Israel ripped from the headlines, it charts an assimilated Arab surgeon's descent into hell when he learns that his beloved wife was a suicide bomber.

"I learned languages rather quickly as a kid," says Cullen, whose mother was Spanish. He took Latin and Greek ("the foundation") in high school, and studied French at the University of New Orleans. After graduation, he took off for Europe, "not to become a translator, but someone who could read Proust and Dante." He'd

done some teaching in grad school, but "hated it," seeking work outside academia. For some years, he worked as an abstracter for oil drilling companies on the Gulf Coast, translating old deeds from French and Spanish.

The leap from business translation to literature "was because of her," Cullen says, patting Martin's leg fondly. Martin introduced him to her editor, the legendary Nan A. Talese, who hired Cullen to translate Alice Miller's introduction to Anne Frank's *Diary of a Young Girl.* This led to jobs translating blurbs and reviews, then books by Susanna Tamaro, Margaret Mazzatini, Allessandro Barbaro, Carlos Ghosn, Adolf Holl, and Henning Boetius. Cullen met Yasmina Khadra for the first time in Toronto, since the post 9/11 American government gave him visa trouble. "He's a very proud guy. They wanted him to jump through more hoops than he was willing to jump through, so he just said no."

Cullen's artistry sometimes seems invisible. Martin cites a rave in *The Nation* for a Christa Wolf novel, which neglected to mention its translator, though the reviewer took pains to praise Wolf's prose style. "That's *my* style!" says Cullen, who's surprisingly blunt about how much editorial power a translator wields. "We translators flatter ourselves that authors need a little help that only we can give them."

While careful "never to betray the author's intent," Cullen considers it kosher to prune purple prose. "Yasmina Khadra just needs a bridle sometimes." He also points out that "all Western European languages sound more formal than English if translated literally; you need to loosen it up, find the equivalent diction."

In Martin's story "The Open Door," an American poet in Italy muses,

> Would the double entendre on the words "ice pick" get lost in translation? This seemed amusing, the idea that richness, nuance, got lost in translation. Where did it go? She imagined the land of what was lost in translation, imagined herself in it.

Cullen observes, "You can get a nuance, but it's not the *same* nuance." For him, the key is rendering the *flavor* of somebody's speech, or a narrative voice. He spends

far more time on a manuscript's first twenty pages than the rest of a text, which he generally covers at four to five pages a day.

Martin does the same thing when inventing a narrator's voice. "It's like trying to tune in a radio," she says. "You know when you've hit it." Narrating in first or third person is "a strategic choice. When I choose first person, it's always in self-defense. The character is trying to justify his existence by telling you a story." ("Call me Ishmael," Cullen grins.) Third person, Martin continues, "allows you to be a little more conscious, more distanced from the character. You can have a bigger palette, characters who don't know things about each other that the reader knows, which is fun."

Cullen reads Martin's books in translation, and praises the French version of *Property* and the Spanish *Salvation*. (Martin, who struggles with foreign languages, perused these as well; "If I've written the book myself, I can whiz right along.") They both enjoyed the French book jacket for *Property*, with the title *Maitresse* [mistress] above Martin's photo; Cullen displays it in his office.

The two of them rarely share work in progress, though they often consult about phrases or synonyms. (Cullen: "I talk about mine more than she talks about hers." Martin: "Well, you would, wouldn't you?") Martin may spend years on a book, while Cullen translates several a year. "Tell you a secret," he says, leaning forward. "Translators aren't paid very well. I estimate my earnings at a dollar and three cents an hour."

Martin smiles indulgently. She's lived every kind of a writer's life, turning out books in obscurity, finding mainstream success with *Mary Reilly*, challenging expectations with her remarkable follow-up novel, *The Great Divorce*, and finally achieving literary renown with the prestigious Orange Prize for *Property*, her tenth book.

A pitch-perfect evocation of a Louisiana slave owner who chafes against her husband's oppressions while unconscious of her own, *Property* is tight as a corset. The novel grew out of conversations with Cullen "about our education, lies we were told about the Civil War, the myth of the South. I wanted to knock all that down."

Martin's devastating 2007 novel, *Trespass*, is set in the Hudson Valley, Plaquemines Parish in Louisiana, and Croatia, ancestral home of many Louisiana oystermen.

With *The Confessions of Edward Day*, published in 2009, she returns to the intertwined lives of artists—in this case, an actor who owes his life to a rival.

Cullen goes into the kitchen, returning with twin pitchers of chicory coffee and warm milk as Martin serves fruit salad. Cullen tastes his and pronounces it "excellent." "Thank you," says Martin, dipping her chin with self-conscious enjoyment. Cohabitation with artists does not look so bad in this household.

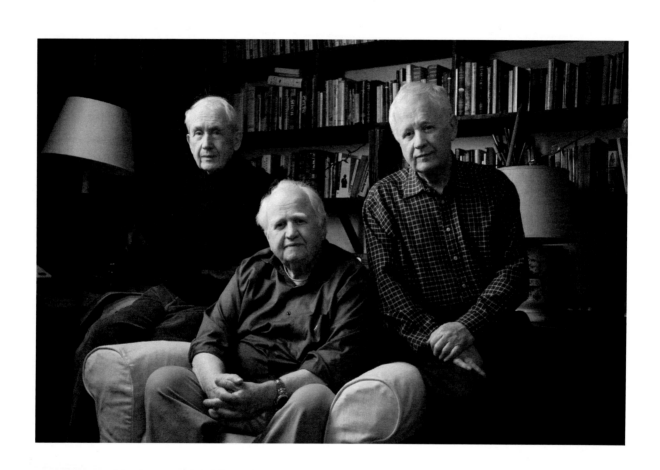

Frank McCourt, Malachy McCourt, and Alphie McCourt

"THERE'S A LITTLE-KNOWN TUNNEL that goes straight from the Upper West Side to Woodstock," says Alphie McCourt. Angela Sheehan McCourt's youngest son just published a memoir, *A Long Stone's Throw*. You might say it's a family tradition: His brother Malachy has two bestsellers under his belt (*A Monk Swimming* and *Singing My Him Song*), and big brother Frank is the Pulitzer Prize–winning author of *Angela's Ashes*, *'Tis*, and *Teacher Man*.

All three brothers were headliners at the 2009 Woodstock Memoir Festival, regaling a sold-out audience with lively banter and several songs between readings; Frank even pulled out a harmonica. Before taking the stage, they agreed to an interview at Rosie O'Grady's, a congenial eatery near Times Square where the McCourts and a loose amalgamation of friends meet for monthly lunches, a tradition that dates back to 1973.

Though the core group is twenty or so, the moveable feast "swelled to bursting on the heels of Frank's books," reports Alphie. Visiting literati included William Kennedy, Pete Hamill, Mary Gordon, Thomas Keneally, and others; one regular called it "stargazing."

Alphie and his wife had a weekend place in Woodstock throughout the 1980s. "We'd start to feel better as soon as we crossed the bridge," he recalls fondly. Malachy's also lived in the Hudson Valley—he wrote *A Monk Swimming* in Krumville. Frank splits his time between Manhattan and Connecticut.

The door swings open, and in blows the force of nature that calls itself Malachy McCourt. The actor, author, Green Party gubernatorial candidate, and "larger-than-life of the party" is nursing a headcold. "I'm renting myself out to insomniacs," he declares. "I'll give you the full details of my cold, and either I'll bore you to death or put you to sleep. Either way I'll collect a check."

"You could write a memoir of your cold," Alphie says. It would probably be a bestseller.

"Malachy can turn the world on its ear with a phrase," Alphie observed just before his arrival; one senses such praise would be met with derision. At the book launch for *Singing My Him Song*, Alphie introduced his brother. "When the McCourts are around, everyone expects fun, fun, fun every minute. I thought, for once let's not do it that way." Alphie spoke at length about Malachy's kindness, how he took care of friends who were sick or in need. When the author got up, he said, "Thank you, Alphie, for that eulogy."

Reverence will get you nowhere. Ask Malachy how he writes, and he says, "On my arse." He elaborates, "I'm always looking, when I go to readings, for a magic formula that will allow me to write without writing."

"You could try talking," Alphie says drily.

"People say, just talk into a microphone." Malachy shudders. "I can't. I need the pen in my hand, that symbiotic relationship."

Malachy's pen has a way with words. *A Monk Swimming* is a hymn to excess and abandon. In *Singing My Him Song*, he cleans up his act without losing an ounce of his native joy. "America loves winners, but you need a sense of superiority about losers," he says. "Memoir is like going up icy steps: two forward, three back. As long as you're triumphant at the end, your memoir will be a success." Malachy's livid that Laura Bush got a seven million dollar advance for her memoir. "Who gives a fiddler's fuck about the wife of the most unpopular president in the history of the U.S.? Where's the triumph in sleeping with *him?*"

Of his brothers' books, he opines, "Alphie's version is right on the button. He has an astoundingly clear memory, and it's simply and beautifully written." Alphie looks as if he's just been eulogized, but Malachy continues. "When Frank wrote *Angela's Ashes*, I was amazed by his accuracy and perceptiveness, and more importantly, by the charity he exhibited to those people who were awful to us. He carries no chip."

Frank hasn't arrived yet, and Malachy says he's "off doing something with students" and may not make it. When Alphie notes that Frank hasn't been to Rosie O'Grady's for several months, Malachy shrugs, "If he doesn't come back here, we won't let him in."

But like his countryman's Godot, Frank McCourt has a powerful presence even without showing up. The conversation keeps circling back to *Angela's Ashes*, the 1996 phenomenon many credit with launching the current memoir boom. "When I look back on my childhood, I wonder how I survived at all," Frank wrote. "It was, of course, a miserable childhood: the happy childhood is hardly worth your while. Worse than the ordinary miserable childhood is the miserable Irish childhood, and worse yet is the miserable Irish Catholic childhood." After deftly acknowledging the story's familiar outlines, he goes on to make *his* miserable Irish Catholic childhood gloriously unique and specific.

Neither brother read Frank's work-in-progress. (Malachy states, "That's a rule of thumb: Don't show anything to relatives until it's too late.") But nobody could have anticipated the spotlight *Angela's Ashes* would turn on their lives.

"A number of people in Limerick took exception," says Malachy. "One guy tried to organize a book-burning—he said they'd burn twenty thousand copies. I told Frank, 'I hope it's the hardcover. That'd add a lot to your sales.'" The objection? "It wasn't *respectable.*"

Alphie adds, "One of the oddest things was people who said 'We didn't have much either, but . . .' as if they were apologizing for having food in the kitchen. After *Angela's Ashes* came out an English newspaper ran a contest for anecdotes about

families who were even poorer than ours. The winner wrote, 'We were so poor we lived in a hole, in a ditch by the side of the road.'" Malachy thunders righteously, "Ye were lucky to have a hole!" and both brothers laugh inordinately.

The lunch group trickles in. Today's celebrants include playwright Patrick Fenton and actress Mary Tierney; filmmaker Teressa Tunney; Malachy's sons Conor and Malachy Jr. (in town from Bali, where he runs a scuba school); and numerous writers. Mark McDevitt congratulates Alphie on his publication. "There's no room on the shelves for all these McCourt books. It's a *genre!*"

Reached by phone in Connecticut, the genre's progenitor says it's "very gratifying to read their version of events." Though he and Malachy once shared the stage in a semi-improvised Off-Broadway play called *A Couple of Blaguards*, Frank doesn't consider himself a performer. "I put in my thirty years of teaching. Now I just want to sit quietly at the desk and let it come," he says, adding, "Students are a very tough audience. They're heat-seeking missiles."

Teacher Man details his career in New York's public schools, where the one-time dropout flummoxed administrators with nontraditional assignments ("write a suicide note") and shared his passion for words with thousands of lucky teenagers.

"I loved teaching, but writing is what I was put on this earth for," he says. "It was always in the back of my mind while teaching: you should just shut up and write." But he was "too busy making a living" and lacked the self-confidence to make such a leap. He published his first book at sixty-six, disproving F. Scott Fitzgerald's maxim, "There are no second acts in American lives."

Frank's philosophy, as a teacher and for himself, is "to move from fear to freedom. You can't ever achieve it, of course—there's no Fourth of July in the human psyche—but you move slowly towards it, and if you're lucky, you can feel the shackles falling off."

All over the world, he's had former students show up at his author events. "It's very gratifying to have been a writing teacher, so-called, and then to go out and prove you weren't just talking through the hole of your arse." His advice to aspiring writers?

"Scribble. Don't try to write, just scribble. If you tell yourself, 'I'm going to write a book or a play,' you're sunk. Do what an artist does, sketch it out in a very casual way. The most important thing is to sit in the chair." Told that Malachy said the same thing, he deadpans, "And where d'you think he got *that?*"

It's telling that the McCourts' memoirs bear similar dedications. Alongside a litany of wives, friends, and children appear these words: "To my brothers, Malachy, Michael, Alphonsus. I learn from you, I admire you, and I love you" (*Angela's Ashes*); "With much gratitude to the brothers Frank—for opening the golden door and leading the way—and to Mike and Alphie with my love and thanks" (*A Monk Swimming*); "To my brothers, Frank, Malachy, and Michael, for blazing more than a few trails" (*A Long Stone's Throw*).

Which leads to an obvious question: will fourth brother Mike, a San Francisco barman, ever write a memoir? If he does, it's sure to find grateful readers.

Editor's note: Frank McCourt died of cancer on July 19, 2009.

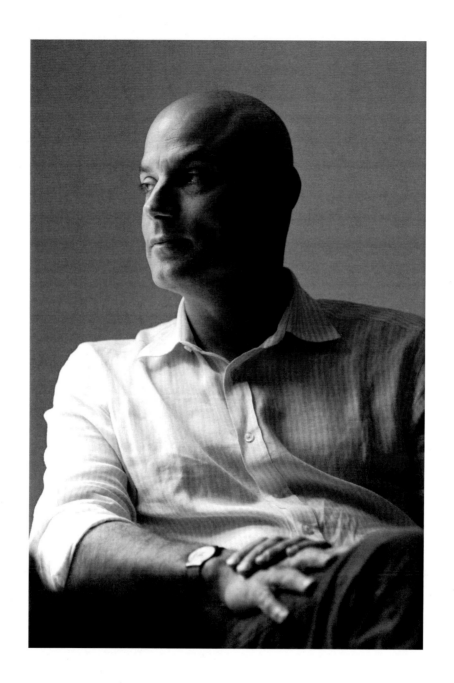

Daniel Mendelsohn

A YOUNG BOY WALKS into a room, and his elderly relatives burst into tears. The reason—usually offered in Yiddish—is that he resembles his great-uncle Shmiel, who, along with his wife and four beautiful daughters, was killed by the Nazis.

This piece of family lore was repeated, with great displays of emotion and precious few details, throughout Daniel Mendelsohn's childhood. After recounting it in his 1999 memoir *The Elusive Embrace*, the author set out to discover what happened to Shmiel and his family, tracking down relatives and surviving witnesses on several continents. The resulting book, *The Lost: A Search for Six of Six Million*, was a runaway bestseller, garnering literary respect while selling like hotcakes in twelve different countries.

When Mendelsohn isn't writing about himself or his family, he reviews books, plays, and films for the *New York Review of Books*, the *New Yorker*, and other A-list periodicals. "Being a critic is what I am," he declares on a sunny afternoon in his Bard College apartment. After spending "a solid five years" on *The Lost*, he collected his critical writings into a book entitled *How Beautiful It Is and How Easily It Can Be Broken*, followed by an acclaimed new translation of C. P. Cavafy's complete poems.

Mendelsohn's clearly enjoying his life. He's about to fly to Capri; a red suitcase sits packed on the rug. It's enough to swell anyone's head, but Mendelsohn hasn't forgotten his roots. When he finished his PhD and moved to New York in 1994, he wrote freelance magazine fluff like "Food Courts of Las Vegas." "I lived on ramen noodles for three years. I knew every CVS that sold them for five for a dollar instead of four for a dollar," he grins. "I am *not* one of those people who pretends to be blase about having an international bestseller."

That grin flashes often; a slightly skewed tooth lends it a Mephisthophelean air. Mendelsohn's head is neatly shaved, his light-blue eyes rendered more striking by high,

arching brows. In repose, his gaze is intense, even challenging—one senses nothing gets past him without being noticed. He wears his erudition lightly, with a vocabulary that swoops from "meretricious" to "nutty," sometimes in the same sentence. His coffee table displays books in several languages; his sink displays Believe in God breath spray and Oy Vey body detergent. There seem to be a lot of Daniel Mendelsohns.

This, indeed, is the theme of his extraordinary memoir. Subtitled *Desire and the Riddle of Identity*, *The Elusive Embrace* examines the multiple lives one person may lead, opening with "For a long time I have lived in two places." One is the New Jersey suburb where Mendelsohn lives part-time with a woman and child while teaching classics at Princeton. The other is a studio apartment near Chelsea's "gay ghetto," the epicenter of a cruising life he describes with startling frankness.

Mendelsohn's route to fatherhood was nontraditional. In 1996, when a friend was unpartnered and pregnant, he went with her to the delivery room. The depth of his bond with her son astonished him. He started staying with them several nights a week, at first because it was close to his teaching job, later because it was part of the complex geography of "home." Four years later, she adopted a second son; Mendelsohn refers to the boys "my kids."

Since that time, "home" has expanded to include Bard—not to mention a plethora of hotels. At one point Mendelsohn flew to France four times in three months. "I'm *huge* in France," he says, adding, "There's a different response in Europe because it happened in Europe. People come up to you afterwards and tell their stories, their family's stories. It's not theoretical."

His own family's response to *The Lost* was "very emotional." Mendelsohn's four siblings joined him on many research trips to Eastern European villages and to Auschwitz; his brother Matt's photographs appear throughout the book. "My mother had the hardest time—she had nightmares every night." (Marlene Mendelsohn's only request as her son wrote the manuscript was a plaintive, "Did you put that I had nice legs?") Publication was "a big thrill for everyone," Mendelsohn says. "My father's so cute—every day he checks my Amazon rating."

How Beautiful It Is and How Easily It Can Be Broken includes thirty critical essays culled from a vast body of work. Reviewing his reviews, Mendelsohn noticed recurring themes: masculinity and femininity, images of women, sexuality—and, of course, classics. (A graduate student once challenged him to write a review of *anything* without referring to Greek tragedy—"a bet I lost," he says ruefully.)

The critical scene is changing fast. "Books coverage is shrinking everywhere: newspapers, magazines. There's more competition for less coverage nationwide," observes Mendelsohn. "What interests me right now is the culture of criticism being transformed by the Internet and blogs, the blogosphere. Criticism used to be self-evidently a function of people having a certain training and background, which gave them a platform for opining. Now, everybody's a critic, to quote my grandmother."

Mendelsohn writes in bed, propped up on lots of pillows with his laptop. He starts by turning on the TV ("I can't stand to do it alone, that's the worst part of writing"), favoring *Law & Order* reruns or CNN. "I trick myself. I'm not writing, I'm just watching TV, and if an opening line *happens* to occur to me, I'll write it down," he explains. "If I think of my lede, I can write the whole piece. I'm in. I know the terrain. If I don't have that first sentence, I can't write anything else. I spend a lot of time eating Doritos and procrastinating: oh, I should plant more lavender. Then there's the point where my eyes roll back in my head and I'm *there*, I have no idea the TV is even on."

He shrugs. "I'm awed by friends who write fifteen hundred words a day, or ten pages every morning. It's idiosyncratic. Whatever works for you. But I hate the icky period, the Doritos period. And people who leave off in midsentence?" Mendelsohn shudders extravagantly. "This is what comes of being raised by strict, neat parents. I have to get to the end."

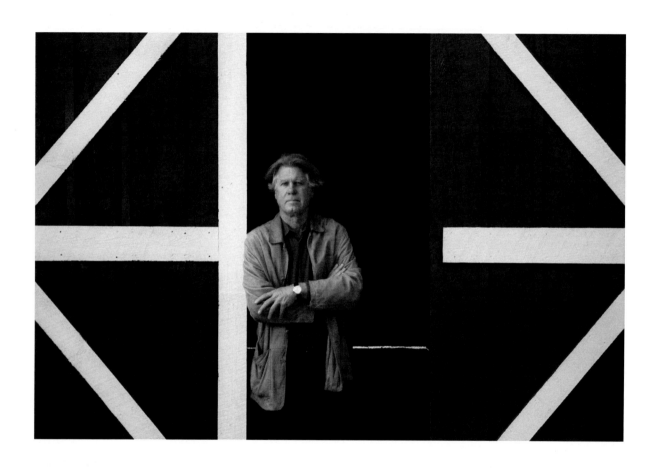

Bradford Morrow

T. S. Eliot's "cruelest month" has been kind to Bradford Morrow. In April 2007, the novelist, editor, and Bard College professor received a Guggenheim Fellowship. Two weeks later, he won the PEN/Nora Magid Award for excellence in editing a literary journal, *Conjunctions*.

How did he celebrate? By working, of course.

Morrow's novels include *Come Sunday, The Almanac Branch* (a PEN/Faulkner finalist), *Trinity Fields* (winner of an Academy Award from the American Academy of Arts and Letters), *Giovanni's Gift*, and *Ariel's Crossing*. He's also the author of five collections of poetry and the children's book *DIDN'T Didn't Do It*, a deft feat of linguistic gymnastics with illustrations by Gahan Wilson.

Morrow writes like an architect, using intricate mathematical structures to create three-dimensional worlds full of beauty and light. Jonathan Safran Foer (a former student and guest editor of an issue of *The Review of Contemporary Fiction* devoted to Morrow's work) wrote, "His narratives careen from the American West, to Central America, to the Northeastern United States, connecting these blazing sites like a sign of the zodiac that had never been noticed." Foer paints Morrow as a "writer of the Americas," but he could have added a couple of continents. *Giovanni's Gift* leapfrogs from rural New Mexico to the church bells of Rome; *Trinity Fields* traces a path from Los Alamos to the killing fields of Southeast Asia.

Morrow's writing, editing, and teaching careers form their own trinity. It's hard to say which voice sings lead in the trio: he seems to be going full-throttle in all three directions at once. His voice retains the flattened vowels and lilt of his native Colorado, and in spite of his polished black shoes and round dark-framed glasses, he gives off an air of the Western outdoors. His complexion is ruddy, and his hay-colored hair seems more in tune with the wind than the comb. He's proud of his "pioneer stock": his

paternal grandfather founded a miners' hospital in Steamboat Springs, Colorado; his maternal ancestors homesteaded in Willa Cather's Nebraska.

His mother was "a great storyteller" who spun "tales of the old days, narrated with great passion and intensity. I can still hear her stories in my head: the snake that got into the chicken coop, hiding from tornadoes, the lean times after my grandfather lost his farm."

Morrow's father recruited scientific talent for aerospace programs and secret projects his son later connected with high-tech weaponry. Both parents were outdoor enthusiasts, driving their children all over the Four Corners states. "Those landscapes are just seared into my memory," says Morrow.

Trinity Fields opens with a trio of boys joyriding towards Santuario Chimayo, an adobe church built on a site sacred to ancient indigenous peoples. "That one little valley, so near where the atom bomb was—politics, secularism, and high physics represented by the one place [Los Alamos] and the pure spirituality and sense of the divinity of the earth itself, the ancient practice of spiritual questing that's inherent to Chimayo—it's really the yin-yang of everything. The political and the spiritual are two poles I work with a lot in my writing," he asserts.

Morrow has made a Good Friday pilgrimage to Chimayo six times, walking with the *penitentes.* "I'm not a practicing Catholic, I just like being around those people," he says, adding that he considers the fifteen-mile journey "more of a Buddhist meditation."

That Morrow is able to make such a trek is its own miracle. A congenital weakness in his digestive system first manifested when he was four, and he's battled diverticulitis throughout his life. In 1994, an acute attack of peritonitis ruptured his colon. "I had no business surviving that," he says with gratitude.

Living with chronic illness forced young Morrow to narrow his multiple interests, which included painting and music. "It was easier to read a book than play piano when convalescing on my back," he told Patrick McGrath in an interview. He also considered becoming a doctor. At fifteen, he went to Honduras on a foreign exchange program with Amigos de los Americas, working with Peace Corps volunteers to inoculate thousands of people in desperately poor rural villages. The experience radicalized

him, leading to a deep ideological rift with his father. The Vietnam War was raging, and Morrow applied twice for conscientious objector status. Saved by a high draft lottery number, he threw himself into the antiwar movement, and still sports a "proud little bump" where his nose was broken in a demonstration.

Shards of these experiences are scattered like Southwestern pottery fragments throughout Morrow's fiction. He likens writing a novel to climbing a mountain, except that "you're climbing it and inventing it at the same time."

Narrative voice is paramount. "How it's being said is part of *what's* being said," he explains. "I think musically—narrative arcs are musical arcs." Morrow plays guitar, mostly classical now; he played in rock and jazz/fusion bands in his twenties. He also ran a rare-book shop in Santa Barbara, where poet Kenneth Rexroth, then in his seventies, became his mentor. When the older man died, Morrow sold the store and most of his books and moved to New York to publish a magazine.

Conjunctions was intended to be a one-shot deal honoring New Directions publisher James Laughlin; it's now been in print for three decades. Over a thousand authors and artists have contributed to its hefty paperback volumes; frequent flyers include Paul Auster, John Barth, Robert Creeley, Mary Gaitskill, Ann Lauterbach, and Paul West, alongside such wild cards as Red Grooms and Don "Captain Beefheart" Van Vliet.

Morrow calls his editing style "intuitional." His eclectic literary tastes led the PEN judges to marvel, "The range of writers he publishes is a sort of who's who of twentieth-/twenty-first-century serious writing, and he's found a way to keep reinventing it. The fiction, poetry, criticism, drama, and art is sometimes described as 'experimental,' but we would also say innovative, daring, indispensable, and beautiful."

"To be a good editor, you have to really love to read. You also have to be willing to read manuscripts that aren't successful," Morrow says. "I have a lot of respect for anyone who uses that tool we all share, language, to express some sort of vision. I think that's such an honorable enterprise."

He looks up at a lilac in radiant bloom. "I'm in no hurry to get back inside," he sighs, then amends that. "I can't wait to write."

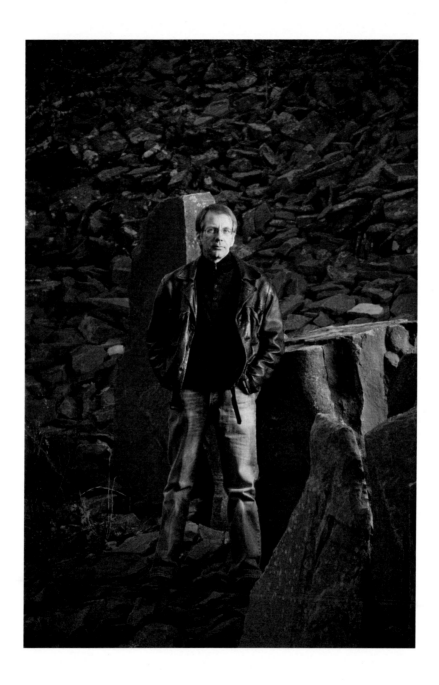

Ron Nyswaner

THE WALLS OF RON NYSWANER'S artfully redesigned farmhouse are covered with religious and outsider art, along with a faded wooden sign for Pam Poultry Farms. "That's real. That's what this was," says the Academy Award–nominated screenwriter.

Nyswaner first came to Ulster County in 1998, when friends offered him and his then-partner a share in a summer cabin in Alligerville. It was unheated, with no running water; they used an outhouse and bathed in the Peterskill Creek. "I loved it," he beams. By summer's end, he'd relinquished his city apartment and bought the farmhouse, overlooking an old bluestone quarry near Kingston. It's been his home base ever since, though he's frequently elsewhere.

Nyswaner's *The Painted Veil* was shot on location in China, his Peabody Award–winning *Soldier's Girl* in L.A., and the Showtime pilot *Filthy Gorgeous* in Toronto. Research for an HBO film about the Walter Reed veterans' hospital scandal took him all over the country, and he's advised budding screenwriters at the Sundance Institute and conferences in Rio, Santiago, Oaxaca, Jerusalem, and "some really gruesome Communist-era resort in Hungary."

He's also produced and cowritten a short film shot less than a mile from his house. *Predisposed*, directed by Kingston-born director Philip Dorling and starring award-winning local actress Melissa Leo, premiered at the Woodstock Film Festival and competed at Sundance. Nyswaner sees mentoring twenty-two-year-old Dorling as "an opportunity to do for someone what was done for me."

His own career took off when director Jonathan Demme optioned *Love Hurts*, a screenplay he wrote in grad school. "I made twenty-five thousand dollars, which seemed like a *fortune*—more than my father had ever made as a yearly salary." Nyswaner's father, a postal clerk in a small Pennsylvania coal-mining town, wept with joy at the news.

"They flew me out first class. Almost overnight, I had an office on a studio lot, my own parking space. . . . I had dinner with Goldie Hawn, Warren Beatty. A few months later, the studio changed its mind. I didn't know that could *happen*," says Nyswaner. "Since then, I've found most of the writing business to be a rollercoaster ride." He shrugs. "I was the flavor of the month for about three years."

Nyswaner wrote Susan Seidelman's breakthrough film, *Smithereens*, and *Mrs. Soffel*, with Diane Keaton and Mel Gibson. He also kept working with Demme, developing an unproduced Paul Newman script and writing several drafts of *Swing Shift*. In 1988, the director invited Nyswaner to write a movie about AIDS.

Nyswaner's beloved nephew had just been diagnosed with the disease. He and Demme decided to make *Philadelphia* a courtroom drama, casting Tom Hanks and Denzel Washington in the leads. "We felt the imperative to speak to the largest possible audience about AIDS," Nyswaner explains. "We wanted to make a hit commercial movie—it was our goal from the beginning to be competitive with Bruce Willis. We wanted to have a dialogue with people who did not think the way we did about AIDS and homophobia." Though he "took some heat from the gay community" for the mainstream approach, Nyswaner maintains, "We weren't trying to reach the Sunday *New York Times* crowd. We were trying to reach *USA Today*, and we did."

In a moving essay for the Writers Guild journal *On Writing*, he describes how *Philadelphia* quietly opened the closet at home. When he and Demme appeared on *Nightline*, Ted Koppel's first question to Nyswaner was, "Are you gay?" Though he'd lived with the same man since grad school, Nyswaner had never come out to his church-going parents. He told Koppel, "Yes," and immediately made plans to take his parents out for a late dinner when the segment was aired. Later, he learned that a neighbor had videotaped it for them. It was never discussed.

"As a kid, I had a really intense attraction to fantasy," Nyswaner recalls. "I really loved play-acting and imaginative games, fueled by black-and-white melodramas I caught bits of on TV. I often played female parts, to the horror of my parents."

His film education began at the University of Pittsburgh, where he majored in writing and psychology. During his senior year, he studied with Marcia Landy, a

Marxist feminist who taught him to think about movies in cinematic and political terms. At Columbia University's Film Division, he studied screenwriting with the legendary Frank Daniel.

Nyswaner is a meticulous craftsman, filling notebooks with character biographies and background research before he embarks on an outline. He has the same starting point for scripts he originates himself and those done for hire: "a character who's running towards something or away from something." When he read a magazine story about transsexual nightclub performer Calpernia Adams and Barry Winchell, the young soldier murdered for becoming her lover, "I didn't get far before I realized I had to write the movie. These characters stumbled into their own story. I like writing about people who don't intend to have dramatic things happen to them, but they do."

This includes Nyswaner's searing 2004 memoir *Blue Days, Black Nights*, about his drug-fueled infatuation with a European hustler whose death provided more questions than answers. "Even when I was living it, I knew it was a great story," he says bluntly. "I wanted the pleasure of writing a book. I loved being able to write about *thinking.* That's what makes a book literary, when the author illuminates how people think. In movies, you write about what people *do.*"

At Sundance, Nyswaner offers a kind of tough love, trying to shake up and challenge young writers; he's famous for jumping out of his chair. "Talent is rare—that's why it's talent," he says, referring to writing as "a kind of calling."

If this smacks of the church, it's no accident. "My faith proceeds from my recovery from addiction, which I attribute solely to Divine Intervention," says Nyswaner. "That path led me back to church and a progressive form of Christianity. But I'm also a poker player, boxing enthusiast, and cigar smoker who thoroughly appreciates the pleasures of sin."

Nyswaner leans back in his chair, gazing out over the terraces built from his quarry's bluestone by local mason Ilario Techio. "I've reconnected with the small-town life I had as a boy, and realized I was meant to live," he says. "I park my car and stand looking up at the stars. The movie business makes me travel so much. This is a great place to come home to."

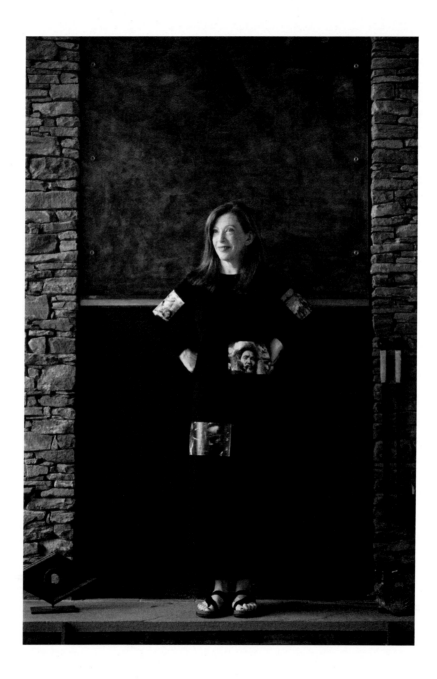

Susan Orlean

SUSAN ORLEAN IS NOT A fictional character. True, Meryl Streep won a Golden Globe for playing someone by that name in the 2002 film *Adaptation*, one of the loopier high dives in the annals of screenwriting, and seven years later, readers still tell the *Orchid Thief* author how much she resembles Streep. "Talk about power of suggestion," Orlean laughs, "There is not one feature we have in common!"

The nonfiction Susan Orlean is a fine-boned, incandescently friendly redhead with a freckled outdoor complexion, wide-set blue eyes, and a welcoming smile. She opens the door of her Columbia County home in a lacy blouse over a turtleneck, jeans, and black cowboy boots. As she introduces her rowdy Welsh Springer spaniel, apologizes for her cold, and offers tea, it's easy to see how she disarms her interview subjects: somehow her manner simultaneously implies that she can't wait to meet you and that you're already old friends.

Though Orlean has done some celebrity journalism, interviewing such media-savvy subjects as Hillary Clinton, Bill Blass, and Martha Stewart, most of the people she profiles are not household names. When an *Esquire* editor asked Orlean to interview *Home Alone* star Macaulay Culkin for a feature entitled "The American Man, Age Ten," she offered instead to profile a more typical kid the same age, and chose one from the New Jersey suburbs.

"I often write about things where the first response is, 'How weird, why would you want to write about *that*?'" she notes. But Orlean has made curiosity into an art form. As a writer for the *New Yorker* and other A-list periodicals, she's toured the South on a gospel choir bus, climbed Mount Fuji in pounding rain, accompanied Spain's first accredited female matador, and detailed an inventor's tireless pursuit of

the perfect umbrella. She has a gift for putting her readers right in the room with her subject; she gives good phrase. "It's just that people are so *interesting*," she wrote in the introduction to her 2001 collection *The Bullfighter Checks Her Makeup: My Encounters with Extraordinary People.* "Writing about them, in tight focus, is irresistible."

Orlean followed *Bullfighter* with *My Kind of Place: Travel Stories from a Woman Who's Been Everywhere.* Its very first line, "I travel heavy," gives the lie to the book jacket photo, in which the unburdened author, wearing a natty black suit and stiletto heels, tips her fedora as she strides off on her next adventure. Orlean, who's accumulated over a million frequent-flyer miles, describes herself as a "reluctant packer" who ritually overfills suitcases, makes fruitless attempts to winnow, and winds up packing even more "just to be safe." On the other hand, she says, "I'm a maniac unpacker. I find unpacking really tedious and just drudgery, so I get it over with as fast as I can."

Orlean has just returned from Morocco, where she was researching a *Smithsonian* piece about donkeys. She brought home a carved wooden donkey saddle, shaped like the roof of a tiny pagoda, which sits on a Chinese red end table. The house she shares with husband John Gillespie and their four-year-old son Austin is filled with mementos. It may be an architectural showpiece featured in the *New York Times*, with soaring glass windows framing a jaw-dropping view, but it's also a place people *live*, with toys on the floor and crumbs on the table. There are books and rural-themed artifacts everywhere. Four Warhol silkscreens of cow heads overlook a transparent anatomical cow model, several vintage toy tractors, and a virtual aviary of carved ducks and geese. Even the bathroom boasts glass jars of feathers and bones, antique dice and mah jongg tiles, and a chicken poster illustrating Mendel's law of genetics.

Orlean met writer, Democratic Convention consultant, and investment banker Gillespie through a mutual friend in 2000. Their courtship was supersonic: two of their first four dates were on different continents, and their wedding in 2001 made the *Times* "Vows" column. Orlean had owned a weekend cabin in Pine Plains since 1989, and when a fifty-five-acre parcel across the road came up for sale, she and Gillespie bought

it immediately, hiring Seattle-based architect James Cutler to design a house with "the feeling of being outside even when you're inside."

Orlean and Gillespie's neighbors include Eliot Spitzer, Coach Goat Farms, and a thoroughbred stud farm; late mystery grandmaster Donald E. Westlake lived just down the road. At this point, they're "ninety percent local," also spending time in New York and L.A.

Orlean's life wasn't always quite so high-flying. She grew up in the suburbs of Cleveland, attended the University of Michigan, and moved to Oregon right after college. "Portland was the town time forgot," she recalls with affection. Though most of her friends moved to New York, "I wanted someplace groovy, where I could go camping. I wasn't a hippie, but I wasn't sold on the idea of living in New York."

Orlean waited tables and worked as a legal aid volunteer before landing a job at a new magazine called *Paper Rose.* Though she'd only written a few book reviews for her college newspaper and some poetry, she was formidably determined, telling her interviewer, "This is all I want to do, you *have* to hire me."

Since the magazine was a start-up, Orlean got to propose and write stories immediately. She was in heaven. Eventually she moved on to the venerable alternative *Willamette Week* and soon started freelancing for the *Village Voice, Rolling Stone,* and *Vogue.* She relocated to Boston, where she wrote Sunday columns about New England idiosyncrasies for the *Boston Globe* (collected in her first book, *Red Sox & Bluefish*), and then to New York. In 1990, she published *Saturday Night,* a cross-country portrait of America's favorite night out.

Meanwhile, the *New Yorker* hired her to write "Talk of the Town" pieces; her first feature for the magazine was a profile of a Manhattan cabdriver whose other day job was king of the Ashanti tribe in America. She became a staff writer in 1992. With rare exceptions, she has free rein to write about whatever she likes.

It seems like a very charmed life, and Orlean enjoys it with palpable zest. She's a world-class enthusiast, stopping in midsentence to exclaim over cardinals at a

birdfeeder or the long-winged soar of a great blue heron over the meadow; she seems to be paying attention to everything at the same time. Indeed, she rarely sits still. She perches on her sectional couch with her legs folded under her, frequently bobbing up to refill a teacup, answer a phone call, or fetch a throat lozenge. When Austin charges into the room in his underwear, pursued by a laughing au pair, Orlean doesn't tell him that mommy is busy, but welcomes him onto her lap and gives him her undivided attention. It's not just that she's a doting mother; this, she implies, is the genuine stuff of the life she's discussing—as is what to wear to tonight's Yaddo benefit dinner, when she should feed her two chickens, or whether the cat's gotten out.

"I like seeing someone's life truly unfold, rather than asking about it," Orlean says of her own interviewing technique. "I do a lot of throat-clearing—aimless, pointless chit-chat, which isn't pointless at all, really—it's much more natural than specific questions." She avoids tape recorders whenever she can, and often spends weeks hanging out with the people she writes about, preferably at their home or workplace. "What people *do* is interesting," she asserts. "Ask them about their work or vocation, and in a roundabout way, they'll tell you who they are."

That approach won't work with Orlean's current project, a biography of canine star Rin Tin Tin. While researching a *New Yorker* piece about Hollywood animals, she was amazed to discover that Rin Tin Tin was an actual dog, born on a World War I battlefield, and not just a fictional character on a TV show (the nonfiction Rin, it would seem, had his own Meryl Streep). This won't be the first time she's profiled a dog—her *New Yorker* piece "Show Dog" begins with the unforgettable line, "If I were a bitch, I'd be in love with Biff Truesdale." But aside from some juicy portraits of Victorian plant collectors in *The Orchid Thief*, it's the first time she's written about a subject who's no longer living. "I welcome the challenge—I'm so used to seeing and hearing and touching what I'm writing about," Orlean says. "It's a learning curve for me to be writing this book. That's probably not the worst thing in the world. It's perfectly okay to put yourself in peril a little bit."

Though she still writes poetry occasionally, and recently collaborated with Rhinebeck illustrator G. Brian Karas on her first children's book, *Lazy Little Loafers*, Orlean feels no urge to write fiction. "I have a very concrete relationship to the world. If I see a door—a fiction writer might fantasize about the family who might live behind the door, their crises and dramas. My instinct is to knock on that door and see if the people will let me come in."

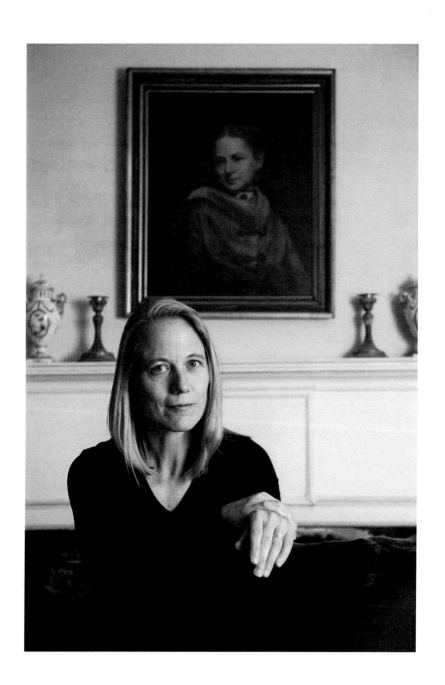

Leila Philip

THE SIGN IS MODEST: PHILIP ORCHARDS—APPLES, PEARS, FIREWOOD. A dirt road leads to a faded barn where a signboard lists pick-your-own apple varieties. Turn your head to the right and everything changes.

The farmhouse, Talavera, is an eighteenth-century neoclassical estate, crocus yellow with massive white columns. "It's a foolish house, but we love it," says Leila Philip, whose book *A Family Place*: *A Hudson Valley Farm, Three Centuries, Five Wars, One Family* details sixteen generations of struggle to keep this magnificent folly afloat.

Though she grew up surrounded by ancestor portraits, Philip says her father rarely discussed the past. "He didn't need to. It was so heavily everywhere." John Van Ness Philip's pride in his heritage was evident only from his deep commitment to carrying it on, and his death in 1992 threw the family into crisis. "Certainly it would have been easier to sell," Philip says. "These moments of generational transfer—for most family farms, that's when the rubber meets the road."

But her family drew together. Philip's mother Julia, now eighty-six, became the first woman fruit grower registered in Columbia County. Though Philip lives two hours away and teaches creative writing at Holy Cross College, she still works at Talavera on harvest weekends, as do three of her siblings (a fourth lives abroad) and her twelve-year-old son.

The hands-on work is fulfilling. Midway through college at Princeton, Philip spent two years as an apprentice potter in a remote Japanese village; her first book, *The Road Through Miyama*, describes her experience. "In Japan, I underwent a Zen style of training, which was nonverbal and involved repetition of a form," she says. "When you make two hundred of each kind of tea bowl, the attachment is to the process, not to each individual bowl. It teaches a kind of work ethic. Ninety-nine percent of any dream is getting it done."

161

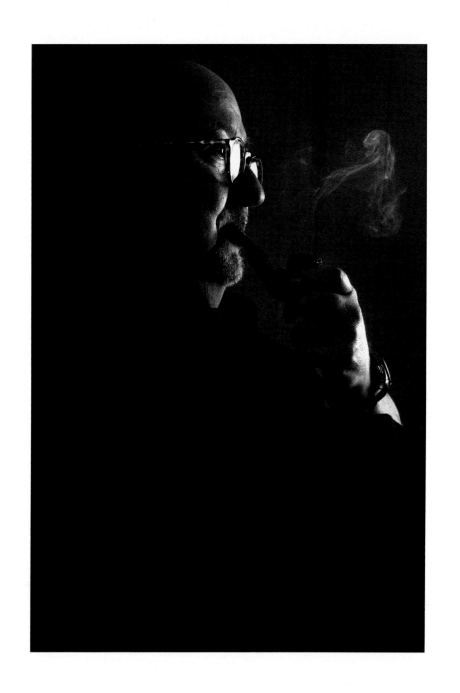

Daniel Pinkwater

DANIEL PINKWATER HAS WRITTEN a hundred books, give or take. The man who coined the monikers Clarence Yojimbo, Lance Hergeschleimer, and Flipping Hades Terwilliger has a way with a book jacket bio:

> Daniel Pinkwater was completely unknown until the early 1940s. Then he was born. Even then he continued to be known to a very few. In recent years, however, he has become so well-known that to add further facts would be to gild the lily. Suffice it to say that he is never mistaken for anyone else.
>
> —*The Snarkout Boys and the Baconburg Horror*

Daniel and Jill Pinkwater live in a nineteenth-century farmhouse in Hyde Park, hidden from the road by rambling hedges. Jill—redheaded, salty, and vigorous—opens the door of a black-and-white-tiled kitchen. A calico cat blinks on a rug in one corner, next to a wall lined with cookbooks and onions. There's a wooden Dutch door at the foot of the stairs, against which two dogs hurl themselves, barking and yodeling.

Daniel Pinkwater's voice—instantly recognizable to NPR listeners—resonates down the stairwell as he appears, a Hitchcockian silhouette dressed in top-to-toe black with a dusting of pet hair. He lets the dogs out, then plants himself at the kitchen table and cheerfully tells the photographer, "I'm not doing a thing you say, so just snap away." He takes out a pipe he will light and relight during infrequent gaps in his hour-long discourse.

He's a great raconteur, shaping stories with consummate timing. When he lands a punchline, he opens his eyes wide, flashing a snaggle-toothed grin. "I give a good interview, don't I?" he says at one point.

Pinkwater's kitchen table is piled high with children's books, some of approximately three thousand he receives yearly from publishers vying for one of his monthly

review slots on NPR's *Weekend Edition.* Besides books well-suited to radio, Pinkwater looks for narrative skill. "Many picture books are a showcase for beautiful drawings, but they're not kid-friendly. There's no door for a kid to go through."

The doors into Pinkwater's oeuvre are many and varied, and kids hurtle through gleefully, romping from picture books like *The Big Orange Splot* to more complex stories like *The Hoboken Chicken Emergency* and *The Yggyssey.*

He's also written a handful of books for adults: the novel *The Afterlife Diet* and several volumes of essays, including *Uncle Boris in the Yukon and Other Shaggy Dog Stories.* "Memoir" may be the wrong word for a book that features a sled dog who speaks fluent Yiddish, but it spins tales from Pinkwater's childhood, including a trip on the Super Chief train from Chicago to Los Angeles with his parents, his mortified half-sister, several cages of parakeets, and a Zenith portable radio.

The Wentworthstein family in *The Neddiad* makes the same voyage, right down to the parakeets. But where the fictional Neddie's father is a benevolent shoelace mogul, Uncle Boris's kinsmen were "Jewish thugs." Pinkwater writes, "I have a photograph of my father and his brothers in those days. They are manicured and pomaded, holding whangee canes and kidskin gloves, wearing flash neckties, and staring into the camera with the expression of cape buffalo contemplating a tourist."

The family surname was minted on Ellis Island, probably an amalgam of Pinchus and Wasser. Philip Pinkwater was a ragman by trade, with a thick Yiddish accent. "My father took me to his office when I was little," Pinkwater recalls. "I'd sit at his desk and play with the things in his desk drawer. He had two blackjacks. I asked why there were two. 'Deh black vun is vit deh gray suit, deh brown vun vit deh blue suit.'"

Born in Memphis, Daniel grew up in Chicago, with several sojourns in Hollywood, where he attended a military school filled with children of movie stars and studio executives. His best friend was Sean Flynn, son of Errol; another classmate's father worked for the Clyde Beatty circus, inviting him to dinner with the Faceless Man and the Fat Lady.

He attended Bard College, where he spent most of his time "acting, smoking, and joking." One day his father appeared in his dorm room. Pinkwater's voice turns

to gravel: "So I looked around, deh kids here is crazy. I talked to deh dean, I said, 'Gimme two veeks, I'll get dis place in shape for you.' " (The shell-shocked dean apparently reported, "He would've, too.") Threatened with expulsion unless he stuck to something, Pinkwater majored in art.

After three years' apprenticeship with a Chicago sculptor, his mentor said, "You're not going to be a sculptor, you know." Even worse, he told Pinkwater what he *would* be: a writer. "Since I'm nine, everyone's telling me I'll be a writer," he complains. "I didn't *want* to be a writer. It's a sissy occupation. I wanted to do things where you attack big stones."

Artistic success eluded him. He taught art at a school for troubled teens and traveled to Tanzania. Then he met a New York editor who needed artwork and text for a book of African folktales for children. Even after this first publication, "I didn't think I was a writer. I thought I was a beatnik working a scam."

In 1969, he married fellow artist and teacher Jill Schutz. They moved to Hoboken, buying a loft building with a moribund restaurant downstairs. After its demise, the Pinkwaters, who'd joined the obedience circuit with an incorrigible Malamute, used the space for a dog-training program and wrote *Superpuppy: How to Choose, Raise, and Train the Best Possible Dog for You.* Its success paved the move to Hyde Park, where the animal population swelled to include an Icelandic horse and eleven cats. They're planning a cat book—"There isn't as much to know, but we know it"—and often collaborate as author and illustrator. "I basically do my thing and then hand it over to Jill," says Daniel. "I get to make suggestions and she gets to top them."

Of his writing process, he claims, "I don't know what I'm doing. My books are all flawed. I don't outline, I don't rewrite, and I don't allow editing. I hand it in, it goes to the copy-editor, and god have mercy on all our souls." Asked about his books' tendency to levitate into fantasy realms, he says, "I don't know what you're talking about. I just see myself as a reporter of the everyday," adding that a friend once called him "a weird magnet."

"A *unique* magnet," Jill corrects. Daniel Pinkwater shrugs, unimpressed. "Everyone has the same life, they just don't notice it."

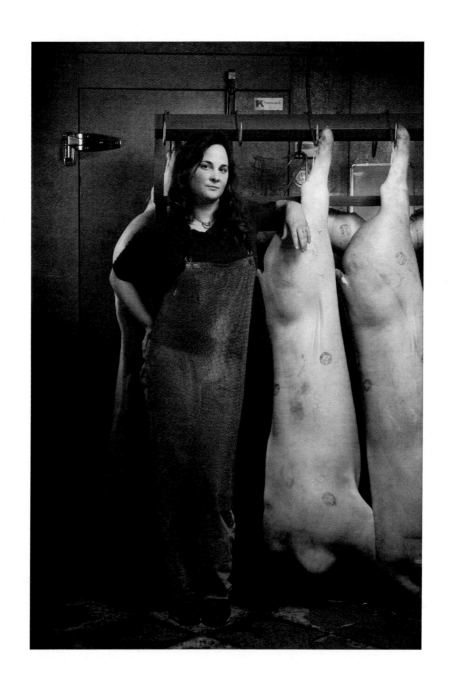

Julie Powell

JULIE POWELL DOESN'T mince words. Her second memoir *Cleaving: A Story of Marriage, Meat, and Obsession* is a startling followup to the bestselling *Julie and Julia*, which inspired one of 2009's most effervescent films, starring Amy Adams as Powell and Meryl Streep as Julia Child.

Julie and Julia started its life as a blog. With her thirtieth birthday looming, Amherst-educated cubicle-worker Powell ("government drone by day, renegade foodie by night") set out to cook her way through Julia Child's groundbreaking *Mastering the Art of French Cooking*: 524 recipes in 365 days. The ups and downs of this "deranged assignment," detailed in her signature breezy, tell-all style, won a huge online following and landed Powell book and movie deals.

Happily ever after, right? Only in the movies.

If *Julie and Julia* was a frothy soufflé, *Cleaving* is beefsteak tartare. This tale of carnal and carnivorous yearnings is not for all palates, but if you like your memoirs raw and juicy, it won't disappoint.

Powell enters a Manhattan coffee shop with a gust of winter wind. She doesn't look a thing like Amy Adams. Her hair is dark, her brown eyes sharp and bright. She's wearing a parka over a nubby brown sweater with a few stray pine needles in the weave, a distinctly non-urban, non-celeb outfit. Her conversation is equally down-to-earth; she can be jaw-droppingly uncensored. Even when gleefully skewering fellow authors with phrases like "sanctimonious prick" and "smug bitch," Powell never invokes the dreaded "off the record." "I'm a pretty confessional kind of girl," she says with a grin.

Indeed. "Cleaving" is one of those rare English words with near-opposite meanings; its dictionary definitions include "to stick or adhere, cling or hold fast" and "to split, rend apart." In Powell's case, both meanings are equally apt.

The high-pressure Julie/Julia Project sent shock waves through a relationship that began when both partners were still in their teens. By the time *Julie and Julia* was published, Powell was deep in the throes of an obsessive, sexually kinky affair, and her husband Eric was seeing another woman. "During the book tour, we were separated. And I'd written a book about this wonderful supportive marriage, which was true at the time," she asserts. "But by the time it came out, things were so much thornier. So there was a certain amount of cover-up. It made me feel like a liar."

Cleaving uncovers the truth with a vengeance, describing Powell's marital struggles and her apprenticeship at Kingston's celebrated Fleisher's Grass-Fed and Organic Meats. Fleisher's, writes Powell, became "My haven. My butcher shop. I spend my days now breaking down meat, with control, gentleness, serenity. I've craved certainty in these last troubled years, and here I get my fix."

Why butchery? "For me, it's not that strange," says the author. "I've always been fascinated with food, and butchery is a craft I've always admired." She isn't alone: the *New York Times* recently ran a food feature entitled "Idols With Cleavers Rule the Stage," about the new breed of cool-dude butchers with "swinging scabbards, muscled forearms and constant proximity to flesh."

"It's definitely a sex thing. I find it hilarious and a little bit overblown," says Powell, who nevertheless describes Fleisher's co-owner Josh Applestone as sporting a "seventies porn star mustache." In the rock-star-butcher hall of fame, she says, "Josh is the big buff guy" and Tom Mylan of the Meat Rack is "the Williamsburg hipster— he's a wild man, the Hunter S. Thompson of butchers."

"I was so lucky I did my apprenticeship with Josh and Jessica—they're such amazing, generous people. We matched up real well," Powell says. The Applestones clearly agree–they've devoted an entire page of their website (www.fleishers.com/cleaving.htm) to *Cleaving.* Powell's husband was not quite so sanguine, though he— and the Other Man, identified only as "D." for the bulk of the book—granted Powell permission to write about their entanglements.

"Does it feel like *Cleaving* is a betrayal, exposing something that shouldn't be exposed?" Powell asks. "I think it's a good thing to talk about how hard even a really good marriage can be." Her only regrets are for Eric's discomfort. "He's a much more private person than I am. It's not coincidental that I found my voice as a writer on the eve of this new blogging medium. I was always a person who spilled—that was why blogging connected so much," she explains. "There's a freedom you get, and a sense of communion with people. Twenty-first-century life is so fractured, it's so difficult to feel grounded. A blog is an effort to reach out and say, Here I am."

Powell talks fast, often using her hands; sometimes her fingertips seem to be tapping a text message onto the table. Hints of her native Texas still pepper her speech—when asked how many interviews she's done, she drawls, "Oh, sweet God. Dozens and dozens and *dozens.*"

Topping the list of questions she never wants to be asked again: What was your favorite Julia Child recipe? (If you must know, in the *Los Angeles Daily News* she picked Bifteck Sauce Berce With Shallot and White Wine Sauce. And no, she never did meet Julia Child.)

Powell did meet Nora Ephron, the movie's writer and director. "She had my whole blog printed out on pink paper," she laughs. "That's so Nora. She's this ferocious woman—all sharp edges, very, very smart in a very particular way, with a very particular worldview. So of course she goes and makes it into a Nora Ephron movie."

This included casting the role of Julie Powell. "Amy Adams is completely adorable, and she makes perfect sense in Nora's movie," says Powell, who has elsewhere described the actress as "completely un-me like." She imagined someone "more neurotic, weightier. Before casting became a reality, I used to say Kate Winslet. She's a good cusser, a little earthier—she looks like she might actually *enjoy* eating butter."

In a blog for website Double X, entitled "What 'Julie & Julia' Butchered," Powell deftly displaces her frustrations to the movie's miscasting of her beloved cat, concluding, "It is my role now to be the good author, to be meek and sweet and endlessly

accepting of harsh words and misinterpretations, no matter how much I might want to scream, in weaker moments, 'But that's not ME!' Er, I meant, 'That's not my cat.'"

Meek and sweet Julie Powell is not. Her blog is now called "What Could Happen? Musings from a 'Soiled and Narcissistic Whore.'" This is one of the gentler epithets that's been thrown at Powell since she revealed her extramarital affair in *Cleaving*. The backlash against her became so intense that fellow food-blogger Jennie Yabroff published a *Newsweek* piece entitled "Stop Hating Julie Powell, Please."

"People have very strong reactions and feelings about this book," Powell says. "I was really surprised by how intensely people reacted to adultery and infidelity by a woman. It's a really visceral reaction. To me, it's not that shocking—nothing Philip Roth hasn't written about forty years ago. But the things people say about me, *to* me, online . . ." She shakes her head, speechless for the first time. "There's a code of adultery. It's acceptable if your partner is cruel, or not giving you something you need. But this was because I had a relationship with this other man, not because Eric was lacking in some way."

Some readers find it hard to sympathize with a woman juggling a generous, supportive husband and an irresistible bad-boy lover, griping that Powell wants to have her steak and eat it too. Others find her too unfiltered. "I'm often accused of the TMI thing," she concurs. "But memoirists are memoirists because writing through their experience is a vital piece of processing. I was in the middle of this insane, crazy thing—I wouldn't have gotten through it without writing."

Powell and her husband own a country house in Olivebridge, but lately they've been trapped in Queens by a series of pet health crises. Their brood includes three cats (one seventeen, with kidney disease), a 110–pound dog (lame), and a five-foot ball python named Zuzu Marlene, who's been with Powell since 1993. "We're a decrepit bunch," Powell admits. She and Eric are currently seeing a couples therapist. "It's not all tied up with a bow, but we're committed to working on it," she reports. They're learning to compromise—despite his reticence, Eric agreed to be taped at home for an *Oprah* segment, but not to appear live on the show.

Powell shifts in her seat. "I need to go home and help clean the apartment for Oprah," she says, pulling her parka back on. The handshake she offers is firm enough to crack pigs' knuckles, though she's no longer working at Fleisher's. "I'm a recreational butcher these days," says Julie Powell, who's currently writing a novel. "I am now the turkey carver for sure."

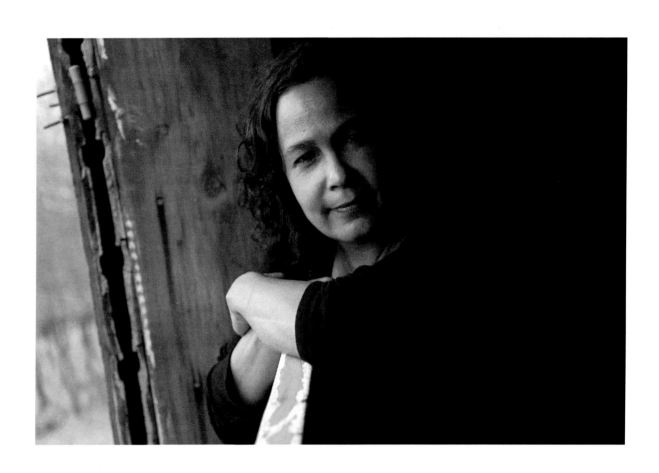

Nicole Quinn

THE BIG BLUE BARN in an Accord meadow doesn't appear haunted, but a Civil War battle was fought here a few years ago. When playwright and filmmaker Nicole Quinn needed a low-budget location for her 2007 film *Racing Daylight*, starring David Strathairn and Melissa Leo, the answer was literally in her backyard.

"*Racing Daylight* started when my family died—my mother, brother, and sister in a three-year period. The story was what led me through a minefield of grief," Quinn says. "It's a love story, it's a ghost story, but for me it's about the soul."

Although she'd written screenplays for Jodie Foster, John Singleton, and HBO, directing and coproducing offered new challenges. Quinn surrounded herself with local talent, including producer Sophia Raab Downs and both stars. Funding proved elusive, but "when we stopped asking for money and started asking for help," it poured in. Adirondack Trailways donated bus tickets, realtors wrote checks, local farmers gave seasonal produce for catered meals.

Adopted by multiracial parents, Quinn attended a "very cush" Catholic boarding school in California, where she and her sister were the only students of color. "I was raised on the razor's edge of cultural reality—an insider who never belonged," she asserts. As an adoptee, "I've always been free to be anything. The sharp side of that sword is I don't know who I am, so I'm always searching."

"Every ten years, I change. I was an actor in my twenties, in my thirties a mother, in my forties a writer. In my fifties I became a filmmaker. I don't know what I'll do in my sixties." Quinn is currently planning a second film, *Slap & Tickle*, and completing a fantasy adventure, *The Gold Stone Girl*. She smiles, surveying the meadow she owns with her husband Paul. "This is such a beautiful place to live. There are lots and lots of stories that live here too."

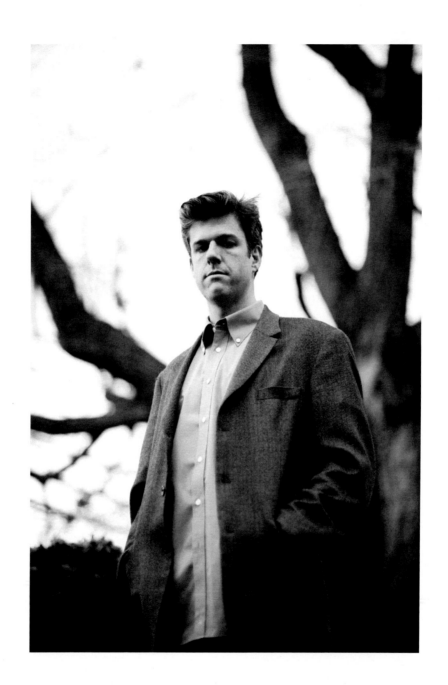

David Rees

TWO DAYS AFTER Barack Obama's landslide, leftists of every description were wafting around in a grinning daze. David Rees, whose scathing political comic *Get Your War On* lit up the Internet and *Rolling Stone* magazine throughout the Bush regime, was not taking chances. He points to his cover design for *Get Your War On: The Definitive Account of the War on Terror, 2001–2008*: a blue field with white text in its upper left quadrant, the rest of the page striped with comic strips printed in trademark red ink. "Can't burn it. It's an American flag," he says, tapping his head sagely. "That was my Palin insurance."

Get Your War On was launched on the Internet just weeks after 9/11. The nation was shell-shocked, confused, and paranoid. Rees's public assertion that the War on Terrorism and invasion of Afghanistan deserved a good profane bash was a breath of fresh air. Using a handful of anonymous-looking clip-art figures, he tapped into collective anxieties and taught them to breathe comic fire.

GYWO quickly developed a cult following, and Rees quit his day job as a magazine fact-checker and moved to Beacon with his wife. He also donated over a hundred thousand dollars in royalties to Adopt-a-Minefield.

Rees's clip-art comics career began with two deadpan volumes about karate nerds and cubicle workers. Raised by "really religious" parents in Chapel Hill, North Carolina, his formative influences were "church and political punk rock like the Minutemen."

His post-Bush comics include *Relationshapes* and *The Adventures of Confessions of St. Augustine Bear*, which pits an inept clip-art hunter against a beatific bear and other wildlife, including a strutting turkey who muses, "Should I believe in God, or what?" He's also developing "an ironic self-help book. People will think I'm making fun of self-help books, but by the end, their lives will be totally better. The goal is not a bestseller. The goal is sainthood."

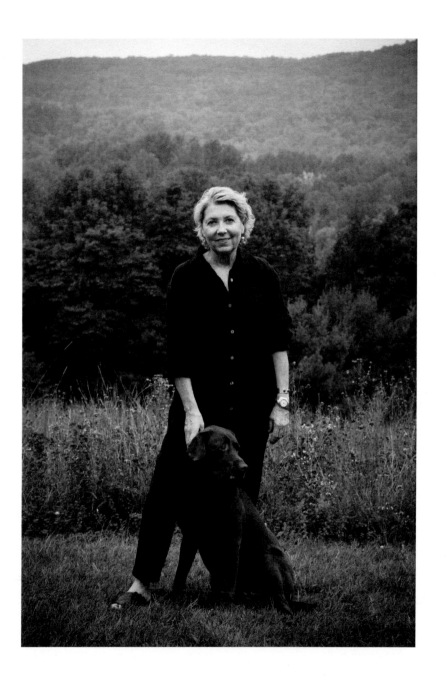

Susan Richards

"WHEN I READ A MEMOIR, I'm looking for answers," says Susan Richards. "How do you do life? I get a piece of the puzzle from each one I read."

Richards was a teacher and social worker before giving herself permission to write at forty-five, when her father's death offered "the freedom to do what I'd always wanted to do without fear of being ridiculed." She studied writing with Maureen Brady ("a saint") and finished three novels. After hearing David Sedaris at Harvard, she decided to write something closer to home. Ninety days later, she'd completed a draft of *Chosen by a Horse*, about an abused racehorse she'd rescued.

"I thought it was purely a journaling project. I absolutely didn't believe there was a living person on earth who wanted to read about anything that happened to Susan Richards," she asserts. Memoirist Laura Shaine Cunningham helped edit the manuscript; New Paltz agent Helen Zimmermann sold it to SoHo Press. The advance was tiny, but "it felt huge to me," says Richards. Her labor of love became the little memoir that could, spending six months on the *New York Times* bestseller list.

Richards's Cinderella story had just begun. After a reading to benefit the Catskill Animal Sanctuary, a silver-haired man approached, praising her courage. He was legendary Magnum photojournalist Dennis Stock. Their late-blooming book-tour romance is the heart of her second memoir, *Chosen Forever*.

"I have a visual image whenever I write a book," she says. "For *Chosen by a Horse*, the image was a cracked heart. That's what I was writing about—how it got cracked, how it became whole again."

For her third memoir *Saddled*, the image was a horse walking down a path. Richards's obsession with riding helped her to get and stay sober. "When you have a passion for something outside yourself, it can save your ass," she says, citing a line from one of her early novels: "Everything I know about people, I learned from a horse."

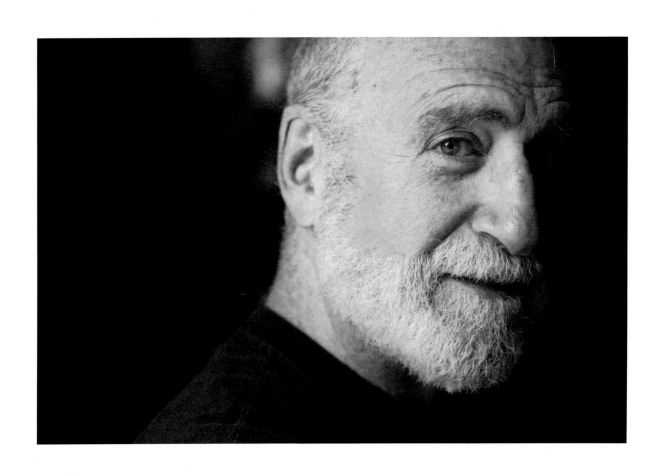

Charley Rosen

CHARLEY ROSEN LIVES HIGH on a hillside in Accord, at the top of a quarter-mile driveway so quiet that deer stroll across at midmorning. As his two dogs bound towards a visitor, frisking and scrimmaging, the six-foot-eight former coach appears on the deck, shouting, "No jumping!" in a Bronx-tinged growl that both dogs obey at once. Moments later, he's gushing at them in affectionate baby talk.

Rosen wears old shorts and a t-shirt with a graphic of a gramophone. A self-described "goon," he's strikingly more comfortable seated than standing. At full height, he appears stiff and furtive, abashed by his bulk. Kicked back in a chair with his bare feet sprawled out, waving long arms as he talks, he seems richly at peace.

Rosen's persona is an odd mix of street fighter and Bodhisattva, with a dash of vintage Deadhead. A *Wall Street Journal* reviewer called him "the game's foremost literary chronicler," and he's generated a steady stream of hoop lore, including two books coauthored with legendary coach Phil Jackson, *Maverick* and *More Than a Game*.

Rosen also wrote *Players and Pretenders: The Basketball Team That Couldn't Shoot Straight*, a freewheeling account of coaching Bard's 1979–80 Running Red Devils through a season in which they won one lone ballgame (against younger players at Simon's Rock) and numerous personal victories. The coach's CV included two graduate degrees in medieval studies, four mismatched jobs teaching English at junior highs and community colleges, varsity basketball MVP at Hunter College, and numerous publications. Not listed: a world-class collection of Grateful Dead bootlegs, an unraveling car named Foodini, and humor to burn.

His application essay concluded, "Coaching basketball at Bard is a chance to participate in basketball in its purest form—no money, no pressure, no statistics, no concept of the 'enemy.' Free-form and spontaneous. Meditations. A zen exercise seeking the spiritual radiance of the game." He was hired on the spot.

Rosen grew up on the streets of the Bronx. His father was a chronic invalid, a volatile man who took out his frustrations on his hulking son, who reached six-five at fourteen. "People expect more of you—they think you're older, so you should be more mature," he reflects. "Everyone notices you; you can't get away with anything."

Sports were his refuge. He spent every free minute playing sandlot baseball and street games: kick-the-can, punchball, stickball, and a basketball knockoff played by shooting a pink Spaldeen ball through fire escape ladders. He encountered his first real hoop at a camp for emotionally disturbed kids in New Hampshire. "Swimming was awful, we called it Leech Lake. I found this old hoop nailed onto a tree and would stand throwing rocks through it."

Basketball was "a home for someone my size, the first time I didn't feel like a freak." At thirteen, he started playing indoor games at Bronx House and in the off-season locker room of a public pool with an alleged former Harlem Globetrotter. Clumsy and stiff, Rosen wasn't a natural. But he'd seen how the game could be played, and longed to join those "joyful warriors."

Rosen compares basketball to jazz. "It's a quintet. You're finding a balance, one guy supporting another, playing roles, creating enough structure so you can be creative without descending into chaos," he says. "Unlike baseball and football, the play is continuous. Basketball players have to make decisions on the move, they don't have time to gather into a huddle and plan. It takes a different kind of vision, instinct, reaction. It's less intellectual, more here and now. Ten guys and one ball. You need to have respect for yourself, your teammates—everyone but the referees."

Rosen's contempt for zebra-shirts is a running theme in his books. He was once banned from a game for asking a ref what he terms "a pair of purely rhetorical questions: 'What are you? Fucking blind?'"

After nine years coaching in the Continental Basketball Association, his volatility erupted, and he was arrested for assaulting a rival coach. His players gladly chipped in the four-hundred-dollar bail (some offering reminiscences of their own busts), but Rosen knew he'd crossed a line. In *More Than a Game*, he describes this turning point,

"I finally had to face it—I was a writer. I needed to edit reality, over and over again, until I got it right."

Though the NBA is big business, basketball hasn't penetrated our national culture as pervasively as baseball or football. Nobody's told Charley Rosen, though, and over the years he's crafted six novels with hoops at their center: *Have Jump Shot Will Travel*, *A Mile Above the Ring*, *Barney Polan's Game*, *The Cockroach Basketball League*, *The House of Moses All-Stars*, and *No Blood, No Foul*.

Rosen and his third wife, Daia Gerson, are Tibetan Buddhists, and after mumbling that his meditation practice is "lazy," he confirms that Buddhism profoundly affects his approach to basketball. "You leave your life behind once you step over that white line. That's where you are, this is what you're doing. You play the game with as much awareness as you can."

As chief NBA analyst for FoxSports.com, Rosen churns out seventeen or more columns a month. Eager to distance himself from the right-wing TV network, he calls it "a good gig" with no muzzle on content. He enjoys baiting bloggers by posting idiosyncratic lists; his Top 10 NBA international roster included Tim Duncan (St. Croix), Steve Nash (South Africa), Manu Ginobili (Argentina), and Dennis Rodman (Mars).

In 1995, at age fifty-three, Rosen won a bronze medal in the World Senior Games in Utah. But he hasn't shot hoops in over a decade. He lays his big hands on the table, displaying gnarled joints. "That one got snagged in Rick Barry's jersey," he says, launching a knuckle by knuckle autobiography.

In *More Than a Game*, Rosen describes his "Over-Fifty Defense":

> Instead of playing bone-on-bone, instead of staking my ego on every possession, I came to joyfully dance through the games as best I could. I admired and vocally applauded good plays made by both teams. Just as happy to lose as to win, I was thrilled just to be playing. At long last, when I was too vulnerable to play with hatred anymore, I finally got it right.

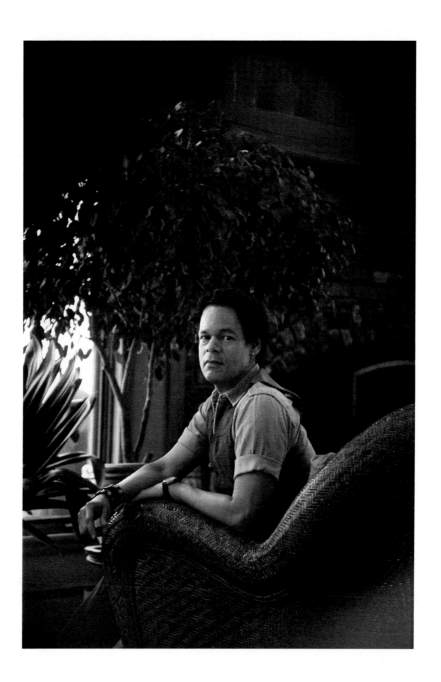

Edwin Sanchez

EDDIE SANCHEZ KNOWS how to make a theatrical entrance. As he steps onto the deck of his mountainside home in Sullivan County, he's joined by a peacock in full iridescent plumage. This is Percy, who showed up "out of nowhere" three years ago. Sanchez and his partner of twenty-eight years, Alden Thayer, lured him with birdseed and music; Cher did the trick. "We looked at each other and said, 'Oh, he's gay. Another dresser.'"

Sanchez was born in Arrecibo, Puerto Rico. His family lived in the Bronx until he was thirteen, then returned to Puerto Rico. At twenty, he moved to New York to be an actor. "At that time, the only roles available to me were stereotypical: you were either a gang member, a pimp, or a drug dealer, and your one big line would be, 'Yo!'"

He wrote *Trafficking in Broken Hearts* "to explode a stereotype": the complex lead, Papo, is a gay hustler. "At the first staged reading at South Coast Rep, they posted a sign that said 'Adults Only,' so of course the whole staff went—they're no fools. I was so nervous, I was climbing the walls." The Q&A afterwards wowed him. "They were so *kind*. They called it a lovely play, a love story." The play launched his career.

He went on to upend other controversial topics, including a priest's love for a ten-year-old boy (*Clean*) and serial murders (*Unmerciful Good Fortune*). A professor at Yale's drama school once told Sanchez he'd be more successful if he didn't write so many Hispanic characters. "So of course I wrote more," he shrugs defiantly.

Sanchez just finished his first novel, *Diary of a Puerto Rican Demigod* ("I love it when people ask, 'Is it autobiographical?'") But he'll never be far from the theatre. "I still adore writing plays," he says. "You're creating this whole world. My favorite moment is tech week, when you see all these people working: Actors, people with tool belts—everybody came here because one day I looked at a blank page and wrote down 'At Rise.'"

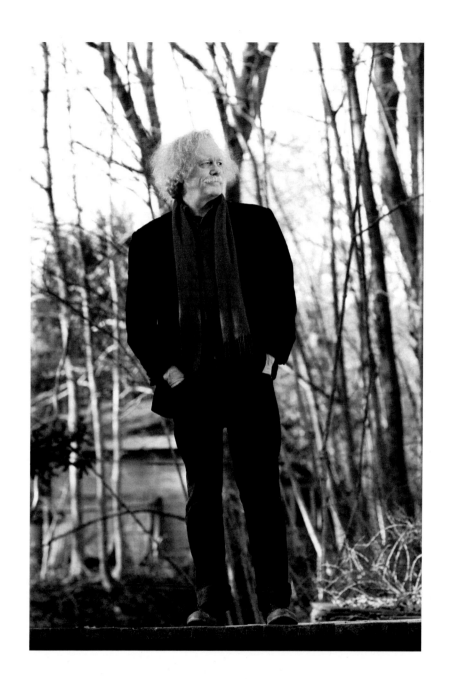

Ed Sanders

WHEN YOU LOOK AT Ed Sanders, even his hair leans left. The asymmetrical frizz and bushy mustache have been trademarks for decades. In February 1967, *Life* magazine featured the owner of the Lower East Side's Peace Eye Bookstore, publisher of *Fuck You: A Magazine of the Arts*, and cofounder of The Fugs on its cover ("Happenings: The Other Culture"). A few months later, Sanders led thousands of antiwar marchers in an attempt to exorcize and levitate the Pentagon.

Where is he now? In Woodstock, of course.

Sanders and his wife Miriam live in a modest house within walking distance of the village green. A trio of preternaturally mellow deer graze under a birdfeeder a few yards from their door. When the poet emerges, they glance up, unruffled. Behind them is a rushing brook with a small but tuneful waterfall.

"Negative ions," gloats Sanders. He's dressed in layered red and white shirts, black jeans, and black high-top sneakers. On his jacket lapel, a button reads "Imagine Peace."

Small as it is, the Sanders's home burgeons with creative life. There are bookshelves everywhere, even above the windows. On top of the piano sit several more musical instruments, including a homemade lyre. There are birdcages, fish tanks, orchids from places as far-flung as China and Chile. There's also a rainbow Peace flag, a few marble sculptures, and several framed prints, including a 2001 certificate with a linocut of a winged horse, declaring Sanders the Poet Laureate of Woodstock.

Any item in this lively assemblage may prompt a cluster of stories. A snapshot of a former pet duck named Jacques sets Sanders reminiscing about his kin, the first rescued by daughter Deirdre from a psych experiment at SUNY Albany. A later clutch of duck eggs hatched in a box on the floor, where the hatchlings imprinted on a row

of tennis shoes. "They became seriously screwed-up ducks. They'd try to mount your shoe," Sanders says, adding that a Scandinavian camera crew once filmed a duck humping his sneaker.

This may or may not be the reason he's turned down thirty-seven interview requests this year, mostly from European film crews. But today he seems eager to talk, settling onto a red settee at the room's epicenter and resting his head on the back like an analysand, often staring straight at the ceiling or closing his eyes as he speaks.

Foremost on his mind is his latest book and CD, *Poems for New Orleans*. A magisterial suite of poems tracing the Crescent City from its founding in 1718 through the ravages of Hurricane Katrina, *Poems for New Orleans* is a vertical history in verse, recalling Charles Olson's Gloucester and William Carlos Williams's Paterson.

The project began in Spring 2006 with an extraordinary offer from music producer Michael Minzer: he'd pay for Sanders to travel anywhere he wanted to research and record a CD of poems. Sanders's first thought was Iraq, but "Miriam was not interested in going to the Green Zone. We've been married forty-seven years—she has shoot-down rights." They considered the Egyptian pyramids, the Costa Rican rainforest, and other locales before choosing New Orleans. Sanders had given many readings there, and was already clipping news articles on the aftermath of Katrina and the grotesque failures of FEMA to allocate $8.3 billion in rebuilding funds. ("I'm Jack the Clipper," he says.)

He also had extensive material in his historical database. The French, Spanish, and American colonists who displaced Choctaw Indians from the Mississippi Delta reminded him of local history. "It's just like in Kingston—the Dutch took over the Esopus Indians' cornfields in the late 1600s. Martha Washington bought wheat from what's now Herzog's Plaza."

Listening to Sanders, you get the impression that *everything* interests him; there are no short answers. Describing the Battle of New Orleans, he notes that Andrew Jackson's troops included "Dirty Shirts" toting long rifles ("a new super-weapon, the equivalent of an AK-47, only it's 1814"); the "resplendent militia of New Orleans, all

fancied up"; coastal pirates; and free Haitian people of color, radicalized by revolution. All fodder for poems.

To anchor his narrative, Sanders created a Haitian family whose ancestry stretches from Jackson's troops to Katrina survivor Grace Lebage. The Katrina poems range from the pre-flood tourist city he calls "the anarcho-bohemian-freedomistic Polis / where everyone tried their fastest licks / on the Carpe Diem guitar" to the wake of the flood and beyond, to "the fullest commixture / of everything that ever was in the Ever."

As a young poet in the 1950s, Sanders often wrote persona poems in the tradition of early Pound, Eliot, and Lowell. "It's very American to write in other voices," he says. The New Orleanean voices he channels include an exiled survivor in "Echoes of Heraclitus" ("Four days I sat in the attic / with 27 cans of beans / we were going to use on Labor Day / and some coca cola I drank very slowly / to make it last") and the trembling-legged hipster of "My Darling Magnolia Tree" ("Dope won't help. Tight shoes won't help. / The poems of Rilke won't help. // Help! Won't help").

On the CD, Sanders's Midwestern diction sometimes morphs into such personae as good ol' boy Johnny Pissoff, gleeful hijacker of idle FEMA trailers; he also employs several female readers. The entire CD is scored by New Orleans composer Mark Bingham, with sounds spanning marching-band Americana, jazz funeral, and even a healing raga. The final track, the thirteen-and-a-half-minute "Then Came the Storm," is an emotional tour-de-force, welding music and words.

Sanders has often been called an American bard; *American Bard*, in fact, is the title of one of his solo CDs. It's an apt appellation for many reasons, including his affinity for recitation and the epic scope of his ambition. He's currently working on volume six of his nine-volume *America, a History in Verse*; volumes one to five, completed over the past ten years, have just been released as a five-CD set. He's also penned book-length verse biographies of Allen Ginsberg and Anton Chekhov.

Though the terms "creative nonfiction" and "New Journalism" are embedded in the zeitgeist—Sanders's bestselling prose investigation of the Manson murders, *The*

Family, being a prime example—he was left to coin his own phrase for his nonfiction verse: Investigative Poetry. In a City Lights–published manifesto by this name, he exhorts poets to *Write everything down*, advice that he's clearly taken to heart. He's stored about five hundred banker's boxes of research material in his garage and outbuildings. "I try to organize so I can find stuff in less than a minute," he explains, adding that he learned to file data by working with revered local historian Alf Evers during his final years. "Information systems tend towards chaos if left on their own."

He uses a computer as well, but for longevity, "paper trumps digitalia." He and Miriam just returned from Europe, where they saw numerous medieval manuscripts. "They're still happening," he says with immense satisfaction.

Sanders overlaps many projects at once, following a regime he calls "All Projects Now." By his own admission, he's been known to fill out three-by-five cards while pushing a shopping cart in the supermarket. Indeed, he seems constitutionally incapable of *not* writing poetry: even his emails have line breaks.

Sanders often performs poems with musical accompaniment, and has invented a variety of instruments to suit his needs, including the Mona Lisa Lyre, the Talking Tie, and the Pulse Lyre. He fetches an attaché case and pulls out two partial gloves with dangling wires and metal strips on each fingertip. It looks like a homemade torture device, and can pose problems at airports, says Sanders. "Homeland Security doesn't like the Pulse Lyre."

Growing up in Kansas City, he studied piano and drums, listened to jazz and classical music, and belonged to the Society of Barbershop Quartet Singers. Quite a leap to the anarchic, exuberantly DIY sound of The Fugs, but the times, as one of Sanders's colleagues wrote, were a'changin'.

Sanders's *Tales of Beatnik Glory*, a four-volume suite of stories set between 1957 and 1969, limns the beatnik-to-hippie crossfade in a seamless braid of memoir, fiction, and the translucently fictionalized. Sanders's hybridized beat poets, amphetamine-heads, performance artists, and film freaks interact with such real-world colleagues as Andy Warhol, Jonas Mekas, and fellow Fug Tuli Kupferberg.

The opening story, "The Mother-in-Law," includes a "pretty accurate" vision of Miriam's mother. "We'd be planning indictment stuff with Abbie Hoffman and Jerry Rubin, and she'd come squinching up Avenue A with these shopping bags full of chocolate-covered Streit's matzos and palm hearts," Sanders recalls. The story's "m-i-l" eventually tracks the young couple to a striped party tent "in the Catskill hills near Phoenicia, New York."

Ed and Miriam Sanders moved upstate in 1977, buying their house with a royalty check from *The Family*. It's still paying bills: *The Family* was optioned for film (as was *Tales of Beatnik Glory*), and Sanders just received a set-up bonus. He's hopeful the film will be made: "It's a good bloody American crime story with nudity and communes and devil worship and the Beach Boys—it all maintains its Billy the Kid allure."

Maybe Ed Sanders is entering his Hollywood period: the Coen Brothers' *Burn After Reading* closed with The Fugs' "CIA Man." Or his Washington period: in 2008, *New Yorker* columnist Hendrik Hertzberg proposed Sanders (among others) for Hillary Clinton's just-vacated Senate seat. Meanwhile, there are more albums to record—his tireless band just finished *The Fugs Final Album, Part 2*—and more poems to write, including four more volumes of *America, A History*, and a verse biography of Robert F. Kennedy.

Does this prodigious output ever feel burdensome? Sanders shrugs. "It beats working," he says.

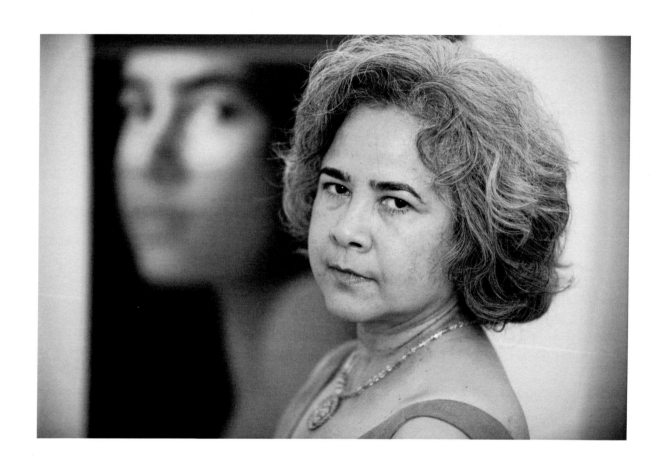

Esmeralda Santiago

MANY HUDSON VALLEY WRITERS divide their time between city and country, but Esmeralda Santiago may be the only one who commutes between country and lobster pound.

The acclaimed memoirist and novelist lives with her husband of thirty-one years, documentary filmmaker Frank Cantor, in a spacious, art-filled home in Westchester County. Their second home is outside Port Clyde, Maine, on a bluff overlooking a working lobster pound, "so it's funky." Though she and Cantor often go there together or with their two grown children, Santiago also uses it as a getaway for solo writing binges, during which her car may sit in the driveway untouched for a week between grocery-shopping excursions. She keeps in touch with her husband by phone and iChat, with an occasional neighbor dropping by to make sure she's all right. Other than that, her only companions are the voices in her head.

They're extraordinarily talkative. Santiago's books include a trio of bestselling memoirs (*When I Was Puerto Rican*, *Almost a Woman*, and *The Turkish Lover*), the novel *America's Dream*, and the children's book *A Doll for Navidades*; she's also coedited two anthologies with Joie Davidow. Her new novel, *Conquistadora*, the first of a planned trilogy, is forthcoming from Knopf in 2011.

"I thought it would be a quartet, but right now I'll be lucky to get *one* out of here!" Santiago says with a warm, earthy laugh. She's been working on the sprawling historical saga for "easily five years, but not a *consecutive* five years."

Puerto Rico's history "doesn't have *Gone With the Wind* drama," she admits. The island was claimed by Christopher Columbus in 1493, and remained in Spanish hands until the United States invaded in 1898. "I think eight guys were killed in the resistance," Santiago says, noting that one was a Jewish plantation owner who believed

Puerto Rico should cast off its colonial yoke. "It was one of two Spanish colonies that *didn't* revolt against Spain and become independent. I was curious: Why not?"

Nineteenth-century Puerto Rico was essentially a garrison for soldiers, so it would have been hard for nationalist rebels to triumph. But Santiago says the 1830s and 1840s saw "an emerging sense of island identity, a Puerto Rican culture that was different from the culture of the *peninsulares.*" (The term, meaning Spanish-born residents, was mildly derogatory, as was the Spaniards' term for the island-born: *colonos.*) "The children of the elite were sent to Europe to study," she explains. "When they came back, instead of becoming more European, they became rabid Puerto Ricans: We have something really special here. So there was a community of educated, passionate, politically involved, politically aware people. The book starts when this is developing."

The oldest of eleven children, Santiago was born in the San Juan suburb Santurce and spent most of her childhood in rural Macun, "uncontaminated by American culture." (In *When I Was Puerto Rican*, she describes the first incursion of *norteamericano* school meals to hilarious effect.) Her mismatched parents eventually split up, and her mother moved her brood to New York when Esmeralda was thirteen. "There was a concerted effort on the part of the government to get rid of millions of poor Puerto Ricans," she says. "They used to give people a one-way ticket."

When I Was Puerto Rican vividly evokes the sights, smells, and sounds of island life and the culture shock of relocating to wintry Brooklyn. Still struggling with English, the feisty teenager auditioned for LaGuardia Performing Arts High School, where she majored in drama and dance. In 1976, she graduated *magna cum laude* from Harvard.

Santiago has a theatrical presence, and it's easy to superimpose her strong-featured beauty and distinctive dark brows with the photographs of her younger self adorning the covers of all three memoirs. Of the cover photo for *When I Was Puerto Rican*, she says, "That photographer wanted me to be his muse, his model. I was eighteen, very flattered he followed me around. I didn't realize he wanted to get in my pants." She laughs. "When I found out, I was so offended! I was so innocent. I was not allowed to date, I didn't think that way."

Almost a Woman's cover photo was taken by her niece; *The Turkish Lover*'s by her husband, soon after they met. There's a large reproduction of it on the staircase to Santiago's writing office, a lushly feminine nest full of silk pillows and draped rebozos, family photos, a dangling Balinese mermaid, and an informal altar with carved Buddhas, incense, and amethyst. The bookshelves are labeled with librarian neatness, and two walls are covered with dry-erase whiteboards, one with word lists for a bilingual alphabet book, the other with timelines for *Conquistadora* and copious Post-its. Above is a quote from *Middlemarch*: "A Mind Weighted With Unpublished Matter." Below it, a stand displays rows of Victorian studio portraits, purchased for five dollars at a Maine garage sale.

"They're from the same time as my characters," Santiago explains. "One of the reasons I live in Maine is that I have many weird and peculiar habits that if I did around my family, they'd have me committed. I call the muses forth. 'Okay, what's up with you guys? Come!' I clap, I ring temple bells to call them in. If speaking doesn't work, I tickle my bells. These kinds of rituals are very, very helpful for a writer," she says with a shrug. "I'm not a drinker or drug taker, so I have to come up with *something.*"

She finds the creative process mysterious. "I really don't believe I'm creating anything. What I'm doing is setting down something that's coming to me from some mystical source that I don't understand, but don't want to get mad at me." Her laugh is full and rich. "I really believe your muses as an artist are these forces that are there to help you and nurture you, but you have to help them too. I call them my *duendes.*"

Santiago came late to publishing. After her graduation from Harvard, she and Cantor formed CANTOMEDIA, a film and media production company specializing in educational documentaries about artists and environmental issues, with Santiago as writer and producer to Cantor's cameraman/director/editor. Eventually, she also started to write for newspapers and magazines. An autobiographical essay in the *Radcliffe Quarterly* caught the eye of book editor Merloyd Lawrence, who invited her to write a memoir about her childhood. There was only one problem: Santiago couldn't remember it.

"I'd made a huge effort to block out the less pleasant aspects of life—I just consistently move forward," she says. "I'm very Taurean that way, just plowing ahead. But the more I looked back, the more I saw." Writing down the details of her few clear memories unlocked many more. It was a deeply emotional process. "I cry a lot, especially with the memoirs. Not just little tears, but gut-wrenching, my god. You need to experience it in the writing, but there's a whole other level you reexperience in order to write it. When you're writing, are you reliving it? Yes. That's why memoir is so hard, and scary, if you're honest."

But there's also a cathartic element to setting down painful memories. "Wanting to write about it doesn't mean it goes away, but you're no longer going in the hamster wheel—in order to write it, you have to have some kind of intellectual understanding," she explains. At one point, Santiago didn't speak to her mother for five years. "That silence didn't make it easier. It made it worse, actually. Writing *When I Was Puerto Rican*, I had to look at my parents as human beings, two people who would have been very good friends, but should never have had seven children together. When I started to see them as real people, a lot of my anger began to wane. Now I have a great relationship with both of them."

Strangers who've read Santiago's memoirs often approach her as if they're already old friends. Even her siblings aren't spared: a woman in a military PX once insisted her brother Raymond remove his boot to see if he had a scar from the bicycle accident his sister described in her book. The boundaries between life and fiction became even blurrier when PBS's Masterpiece Theatre aired its Peabody Award–winning version of *Almost a Woman.* "All of a sudden, my family looks like those people," Santiago says, shaking her head. "These are *actors*, they are not us."

In Cantor's documentary *Writing a Life*, though, Santiago is very much herself. In one moving scene, she's addressing an auditorium full of Bronx high school students when a young man stands up and says that her book was the first one he's ever finished. She's heard the same thing in emails from readers, both Spanish- and English-speaking. "It's fantastic. They read one book, and they love it, and discover they love read-

ing. I get just *chills* when I get those sort of messages," Santiago exults. But she also admits that celebrity can be a burden. "You don't set yourself up to do this. When I became a writer, everyone was saying, 'Oh, you're such a role model. It was *scary.* I was like, oh my god, I hope not. But people need guidance in very specific ways. I'm not Dr. Phil or Oprah or any of those people, but I do know about literature."

So do her *duendes*, it seems. And they come when they're called.

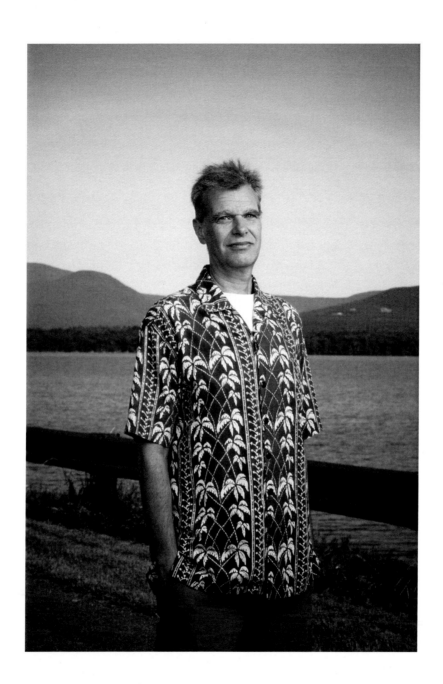

Gene Santoro

GENE SANTORO HAS NO IDEA how many musicians he's interviewed. A music writer for thirty years, with four published books and regular columns in *The Nation* and the *New York Daily News*, he can only estimate that it's "somewhere in the thousands." He laughs. "Kind of horrifying."

Most people would be more thrilled than horrified to converse with the likes of Eric Clapton, Miles Davis, the Neville Brothers, Lyle Lovett, Gilberto Gil, k. d. lang, Sting, or Sun Ra. Whatever is in your CD rack, Santoro's probably written about it.

He's chosen to meet at Stone Ridge's Bodacious Bagels, a healthy bike ride from his Shokan home, but arrives by car. There's a sixty percent chance of thundershowers, and he grumbles, "You know it'll rain if I'm on the bike."

Santoro's book *Highway 61 Revisited* bears the weighty subtitle *The Tangled Roots of American Jazz, Blues, Rock, and Country Music.* A wary reader might squint at the cover photos of Louis Armstrong, Woody Guthrie, Bruce Springsteen, and Willie Nelson, and think, "All that in three hundred pages?"

Well, yes. This is Santoro's fourth book for Oxford University Press, following *Myself When I Am Real*, an acclaimed biography of protean bassist Charles Mingus, and two collections of essays, *Dancing in Your Head* and *Stir It Up.* If these last two are roughly analogous to greatest hits anthologies, *Highway 61 Revisited* is a concept album. "I wanted to do a *book*, with a narrative shape," he explains. The opening section, "Avatars," consists of two long chapters on Louis Armstrong and Woody Guthrie. Santoro sees these mythic figures as the twin strands of DNA that spiral through American music, recombining in countless variations.

"This is how I think about American pop culture," he says. "Armstrong and Guthrie were the opening, in Marxist or Hegelian terms, of a dialectical process that you watch unfolding for the next fifty years, how those different strands came

independently and together through American culture. Armstrong and Guthrie stand for larger things—race, certain tendencies in American culture—and you can trace the way their descendants intertwine, mesh, and change sides." As examples, he cites Cassandra Wilson singing "This Land Is Your Land" and Ani DiFranco backing her protest guitar with a jazz sextet. "American pop culture is broader and deeper than America itself. It takes in more influences from outside and uses them—it's not embarrassed, ashamed, or frightened by what's unfamiliar. Unlike the people who live here."

This is vintage Santoro. He's an astonishing talker, quick-witted, wide-ranging, and *fast.* His conversation careens from erudition to street slang in dizzying, free-associative riffs that somehow always loop back to the theme from an unexpected direction, like Coltrane solos. His prose echoes his speaking voice in its depth and variety, often seeming to mimic the sound of the artist he's writing about.

Santoro's own musical roots were unprepossessing. "If you believe my mother, I used to fall asleep happily listening to Perry Como," he says. "I always remind her that I fell *asleep.*" He grew up in blue-collar Brooklyn and Queens, "the kind of neighborhood where you're either going to be a cop or a robber." His father owned a liquor store; his mother worked at Korvette's. But Gene's older cousins turned him on to Elvis Presley and folk music. He started playing guitar at eight, and eventually played in "garage bands with everybody in my neighborhood—we did covers from all over the place: rock'n'roll, soul, R&B, even show tunes, when we started playing bar mitzvahs and weddings."

Young Gene and his bandmates listened to "whatever was on the radio. Murray the K, playing stuff late at night. We heard Little Richard, not the Pat Boone cover." They found black radio stations way at the top of the dial and said, "What's *this?*"

The garage band guitarist always enjoyed writing—he wrote plays in grade school, and won a Fulbright scholarship as a young academic—but these loves didn't intersect until he edited an anthology called *The Guitar* and a contributor asked why he was editing, not writing. Remembering that moment twenty-five years later, Santoro grins, hitting his forehead ironically, "Write what you *know!*"

He started freelancing for magazines like *Guitar Player*, *Down Beat*, and *Guitar World.* Playing guitar, he says, gave him an inside advantage—"Musicians read your stuff and give you that left-handed compliment, 'You got it right.' Well, that's the *job*, isn't it?" Sometimes "the job" has incredible perks, like hanging out with Jeff Beck for a week in England, or, one golden evening, getting to play with his early idol Keith Richards. "We jammed for about an hour. I had a great time playing Keith Richards' licks back at him." Asked if the guitar great gave him any feedback, Santoro shrugs. "He kept playing. That was all the feedback I needed." Richards also invited him back to his apartment, fed him shepherd's pie, and played vintage reggae tapes.

Not all musicians are so accommodating. Santoro cites Paul Simon as one of the hardest to crack: "He was monosyllabic, wouldn't give me an inch." Finally Santoro resorted to baiting the star with an unflattering quote from a critic. Simon's temper flared, and he started talking nonstop. The interview opens *Stir It Up.*

Interviewing, Santoro says, is the art of sussing people out. "You need to have the information on the tips of your fingers so you can respond quickly to wherever they go. Interviewing is like improvisation: it's not just ad-libbing and filling up space."

Myself When I Am Real intersperses interview quotes with the text. "The structure is highly musical in form. Mingus wrote extended compositions that were elastic, with space for solos that were meant to be integrated back into the master theme," Santoro explains. "The long interviews are like solos. Different people carry different themes."

He worked on the book for six years, hoping to challenge the "standard-issue thumbnail sketch" of "Jazz's Angry Man," including some myths spun by Mingus himself. The portrait of the man and his work that emerges is multidimensional and appreciative, the work of a scholar and fan.

Mingus seems an apt subject for a writer who also straddles many worlds. Not only does Santoro write about music as diverse as Hawaiian lilt, Afropop, and Ornette Coleman's harmolodics, he provides a historical and cultural context, referencing everyone from Michel Foucault to the Marx Brothers. "Music is eclectic," he says, "because life is eclectic."

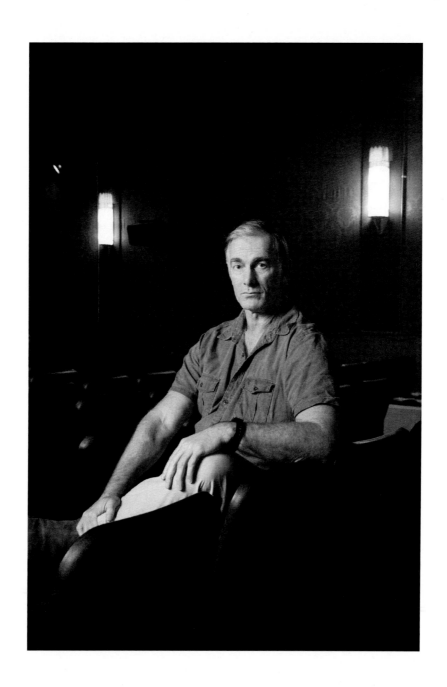

John Sayles

INDEPENDENT. The word echoes through the American mythos with a clatter of cowboy boots. "Independent filmmaker" carries the same smack of feisty, lone-wolf autonomy. But John Sayles, who writes, directs, edits, and frequently acts in his work, never claims an above-the-title possessory credit ("a John Sayles film"); in conversation, he invariably uses the first-person plural: *our* film. Call him an interdependent filmmaker.

Since 1980, Sayles and his producer partner Maggie Renzi have made sixteen films, starting with the shoestring-budget *Return of the Secaucus 7.* He's supported his indie habit with Hollywood rewrites ranging from quirky B-movies (*Piranha*, *The Howling*) to blockbusters like *Apollo 13* and the *Mummy* franchise; he's also directed videos for Bruce Springsteen's "Born in the USA," "I'm On Fire," and "Glory Days."

Between movie gigs, he's published three novels and two story collections, most recently *Dillinger in Hollywood.* Like a latter-day Woody Guthrie, Sayles spins populist tales that crisscross the continent, from Alaska (*Limbo*) to Florida (*Sunshine State*), with pit stops in the Rockies (*Silver City*), Chicago (*Eight Men Out*), New Jersey (*City of Hope*), Cajun country (*Passion Fish*), Texas (*Lone Star*), and Latin America (*Men With Guns, Casa de los Babys*). He's written about striking coal miners, Cuban immigrants, lesbian midwives, and alien slaves. Talking to him, it would seem that the only story he'd rather not tell is his own.

Affable and verbose, Sayles can shrug his way out of a personal question in seconds. Ask him about growing up in Schenectady, and after a nod to the Proctors Theatre, he's off on a tangent about Guyanese politics. Ask what background information he'd give to an actor who had to play him in a movie, and he'll tell you about the character bio he wrote for Joe Morton in *City of Hope.*

Sayles has agreed to meet at Rhinebeck's Upstate Films, where he's screened nearly all his films, often appearing at benefit screenings. He and Renzi have lived in a quiet corner of Duchess County since 1992. "We wanted a place in the *country*, not the suburbs," he says. Writer Akiko Busch, a longtime friend who grew up in the area, introduced them to a realtor; they bought the first farmhouse they saw.

Sayles is an imposing man, six-foot-four, with the burly arms of an ex-jock and thick, mobile eyebrows. His manner is friendly, but far from relaxed. He gives an impression of restless vitality, of someone who needs to be working to know who he is. After a photo session in the theatre, he stays on his feet, pacing constantly as he discusses his work. Only when we relocate to nearby Bread Alone does he settle reluctantly into a chair. He even answers a question or two about being John Sayles.

The Schenectady of his youth was a "multi-ethnic, multi-class place, a real cross-section of America." His dad was a school administrator; in high school, Sayles played football, baseball, and basketball. He also wrote stories for fun. "As a kid, I thought books came from someplace like Battle Creek, Michigan, where you sent away box tops for things. I didn't know there were professional writers who got paid for it. Writing was just something you did, like watching TV."

At Williams College, he began writing more seriously. He also started acting, appearing in *Of Mice and Men* with fellow students David Strathairn, Gordon Clapp, and Adam LeFevre, all of whom would eventually act in his movies.

After college, Sayles did summer stock theatre and honed his blue-collar street cred by working in factories and as an orderly at an Albany nursing home. "I was a *great* orderly, the Paul Bunyan of orderlies," he reports. He also sent stories to magazines, including obscure literary quarterlies he found in the back of *Best Short Stories* anthologies. "I started getting rejection slips like, '*Ararat* publishes Armenian fiction. There are no Armenians in your story.'" He hung them on the wall of his Boston apartment. "A handwritten 'sorry' was a big deal," he recalls.

An upstairs neighbor flooded the building, destroying Sayles's only copy of a seventy-five-page story he'd submitted to the *Atlantic.* He called up the magazine.

Editor Peggy Yntema suggested he cut his "novella" in half or expand it into a novel ("I recommend you put a plot in it," he remembers her saying). But she liked his writing enough to ask for more stories. He sent two, and the *Atlantic* published both.

Meanwhile, he was laid off from his day job at a sausage factory. "So I got my first grant for the arts: Unemployment." He nailed a board across the warmest corner of his kitchen to use as a desk, and set to work expanding *Pride of the Bimbos* into a novel. Atlantic Books bought it for twenty-five hundred dollars, "which seemed like a huge sum at the time."

Sayles's next novel, *Union Dues*, got him an agent, who opened the door to screenwriting gigs. He and Renzi moved to California, where he churned out three screenplays for B-movie maven Roger Corman. All three were made, and Sayles got to watch directors like Joe Dante and Lewis Teague on the set.

In *Thinking in Pictures: The Making of the Movie Matewan*, he writes, "One of the main ways that storytelling on film differs from writing fiction is that the choices you make are extremely practical as well as aesthetic and intuitive. I've never had to change a line of fiction because the sun was or wasn't out, because heavy machinery was operating in the neighborhood or union meal penalty started in five minutes."

For the next two decades, Sayles was a mainstay of the indie film scene, making film after film without compromising his vision. But the industry's climate has changed to the point where he's finding it nearly impossible to make movies and get them seen.

"The average Hollywood film spends a third of its budget on advertising. It can be thirty million dollars or more, twenty million dollars on the opening weekend—that's what you're competing with," he says. "Word-of-mouth movies can't live on one weekend."

In this bottom-line era, a distinguished track record won't float the boat; though *Lone Star* and other Sayles/Renzi films did respectably, none was the requisite breakaway hit. And though younger filmmakers are flourishing in a new world of low-cost equipment and YouTube promotion, Sayles points out that such DIY tactics can't recoup the expenses of using professional actors and crews, since the Internet isn't

monetized. The hope is to gain visibility, like a rock band launching a demo CD. But as he puts it bluntly, "We're not new. They can't discover us."

For the first time in years, Sayles and Renzi don't have their next project lined up. "I don't know that we're going to make another movie," he says. "I just don't know." Many of the production companies that used to fund smaller projects have folded, and there are only so many corners filmmakers can cut.

"I can't shoot fewer weeks. We did *Casa de los Babys* and *Honeydripper* in four weeks apiece," Sayles says. He's gratified that A-list actors routinely accept union minimum wage to appear in his films, but he wound up draining his own bank account to produce *Silver City*, a 2004 political drama in which Chris Cooper out-Bushes George W. Bush. He wrote more studio screenplays to pay for the blues fable *Honeydripper*, starring Danny Glover and a transcendent Keb' Mo'. Unable to find a distributor, he and Renzi hand-carried the film to thirty-five cities and eight countries. "I wrote a lot of my novel on delayed flights," Sayles says, searching for some silver lining.

Some Time in the Sun is a sprawling historical epic set at the turn of the twentieth century. Sayles describes it as "a mosaic. Different chapters are written from different mindsets, so they're in different styles. I have guys who are illiterate, Filipinos, African Americans, white guys. Mark Twain shows up, and Damon Runyon." But the publishing industry is heading the same way as film, with everything between "hot discovery" and "proven blockbuster" teetering on the endangered-species list. *Some Time in the Sun* has been out for six months with no offers—"at least not from anyone who's kept their job," Sayles says, adding mordantly, "I'm too old to write fiction as a hobby."

Without a new novel or indie film in the works, what will he do with his prodigious creative drive? It's hard to imagine him being fulfilled by Hollywood work-for-hire. Tonight's homework, he says, will be watching *Transformers* to prepare for a story pitch, since the current hot genre is toy-market tie-ins. "Hot Wheels will be a movie. Barbie will be a movie."

Maybe so, but do they need a script by John Sayles? He shrugs. "It's a job. It uses some of the same muscles as doing your own writing." Sayles won't write story-lines he finds offensive, but he's worked on projects that have racked up enough script doctors to turn them into Frankenstein's monsters.

Hearing him speak, it's hard not to picture some grizzled gunslinger, or maybe the cynical samurai played by Toshiro Mifune in *Yojimbo.* He's taking the work he can get, but you can't help sensing he's biding his time, and that under that crusty exterior the old fire's still smoldering, ready to put up one hell of a fight.

If money wasn't an obstacle, is there a movie he'd like to make next? John Sayles doesn't hesitate. "Dozens," he says with a welcome smile.

Editor's note: Sayles's Baryo *started filming in February 2010 in the Philippines.*

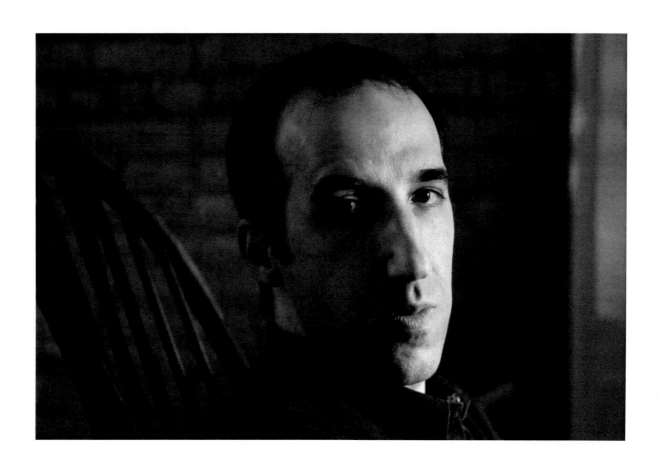

Edward Schwarzschild

DURING THE 2005 FIRST FICTION TOUR, Edward Schwarzschild spent consecutive nights in Boston, Ann Arbor, and Iowa City, touched down in Albany for a change of laundry, and flew to Seattle, L.A., and Austin. Then he did solo book signings for his debut novel, *Responsible Men*, in sixteen more cities.

There are people for whom literature is essential as air, and Schwarzschild appears to be one of them. His conversation is peppered with references to his "literary god" William Kennedy and allusions to stories by Tolstoy and Alice Munro. Married to writer Elisa Albert, he teaches at SUNY Albany and works for the New York State Writers Institute. "I get to hang around with every author who passes through town," he grins like a kid in a candy shop.

Responsible Men's hero is a third-generation salesman who drifts into real estate scams, selling shares in a mythical beachfront retirement home. Though Schwarzschild pays homage to *Death of a Salesman* and *Glengarry Glen Ross*, he has a unique, often slyly funny, spin; witness his kosher thug Boy Scout troop.

Schwarzschild's father, William, a textile salesman, sometimes brought young Ed with him to mills, an experience the author describes vividly in *Responsible Men* ("the dust like brightly colored snow, the smell like paint and sweat and laundry, the noise an endless train running over his head"). After a buyer asked Ed whether he'd be a salesman someday, the usually self-contained William told his son, "You are not going to be a salesman. Because it's a miserable job. You can be whatever you want when you grow up, just not a salesman. Okay?"

William got his wish: none of his three sons went into sales. But as he travels by plane, train, and Subaru to bookstores across the country, peddling his new story collection, *The Family Diamond*, Edward Schwarzschild has added a twist to the family tradition: he's a traveling salesman of literature.

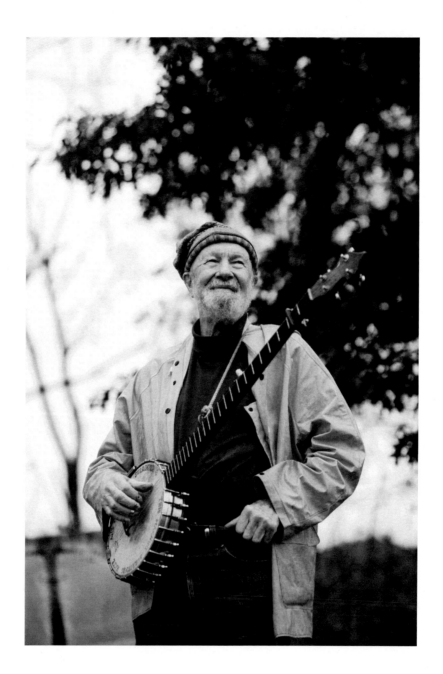

Pete Seeger

Barack Obama's inauguration celebration was full of indelible images, perhaps none more joyous than the sight of Pete Seeger playing the banjo in front of the Lincoln Memorial, flanked by Bruce Springsteen and grandson Tao Rodriguez-Seeger. "Can you believe this?" Seeger's mile-wide grin seemed to say. "Can you believe we're here?"

His ninetieth birthday was no less momentous. More than forty performers joined him onstage at Madison Square Garden for a four-and-a-half-hour concert to benefit Clearwater, an organization founded by Seeger to clean up the Hudson.

When Jen May and I invite him to participate in *River of Words*, Seeger calls right back and offers to send us a song. He has no interest in being interviewed or photographed. "They've taken too many pictures of me already," he says. "They've got me smiling, singing, mouth wide open—what do you want?" He's happy to talk about his beloved Hudson River, though, spinning historic tales and recommending his favorite books. Half an hour later, he says, "Tell you what. There's a group of us old peaceniks who get together every Saturday at noon for a peace vigil on the corner of Routes 9 and 9D. Come on down, and you can take some pictures there."

The following Saturday, a sky full of slate-gray clouds emits something that hovers between sleet and rain. At noon, a lone man stands at the intersection with a peace banner, facing a grim huddle of counterprotesters with flags on the opposite corner. Within minutes, the parking lot fills with cars, including a van with several long bamboo poles wrapped in a rug on its roof. The driver hops out and climbs up on the seat to loosen the knots on the roof rack. Wearing a patterned knit cap, a yellow rain jacket, and well-worn blue jeans, he looks from behind like a lanky college student. It's Seeger.

The weekly vigil is now in its fifth year, and the regulars are old hands. Within minutes, poles have been thrust into pre-drilled holes fitted with PVC pipe, wooden signposts hammered in with a sledgehammer. A clothesline strung between two trees displays tie-dyed banners. Somebody turns on a boom box: Joan Baez's cover of Seeger's song "Where Have All the Flowers Gone?" Passing drivers honk and wave.

Seeger has left his banjo case under a tree. "The good thing about banjos is they're made of plastic and metal. They don't mind getting wet," he says, slinging his instrument over one shoulder with a strap that appears to be made out of clothesline. Lettered around the banjo's periphery are the words THIS MACHINE SURROUNDS HATE AND FORCES IT TO SURRENDER. Seeger once walked across the highway to shake hands with the counterdemonstrators. "I told them I was proud to live in a country where we could disagree in public like this," he reports with a twinkle.

In 1918, a year before Seeger was born, his father lost his job at the University of California because of his outspoken pacifism. Charles Seeger and his violinist wife moved back to his family's farm in Patterson, New York, spending summers camping out in the barn. Young Pete resisted studying classical music, but learned to play several instruments by ear, eventually falling in love with the banjo.

He was admitted to Harvard, but dropped out in 1938 and went to work for Alan Lomax at the Archives of American Folk Music. Two years later, he met Woody Guthrie at a benefit concert for migrant farm workers. They rode the rails together and formed a progressive musical collective called the Almanac Singers. Seeger later joined fellow Almanac Singer Lee Hays in the popular quartet the Weavers.

Meanwhile, he'd fallen in love and married Toshi Ohta. In 1949, the young couple and their two children were living in Greenwich Village with Toshi's parents. "We didn't know how to raise babies on the sidewalks of New York," Seeger says. They looked at farms in Dutchess County, but couldn't afford even rock-bottom real estate prices. Instead, they bought seventeen acres of mountainside land in Beacon for a hundred dollars an acre. They camped out all summer, preparing to build a log cabin. Toshi hauled water from the brook with a toddler on each hip. "She was an absolute

heroine," Seeger asserts. He cleared land by day, worked in New York in the evenings, and came home on the milk train at two in the morning, sometimes with lumber scavenged from packing crates. When the Weavers' "Good Night Irene" topped the charts for three months, the Seegers celebrated by drilling a well and putting in electricity.

But the Weavers' new prominence cast a long shadow. In 1955, Seeger was subpoenaed by the House Un-American Activities Committee; his refusal to answer questions or name names earned him an indictment for contempt of Congress. Though a legal technicality kept him from jail, he was blacklisted from many performance venues. He and Toshi now had three children to support, and he earned a living the hard way, crisscrossing the country to perform in schools, camps, and "anyplace that would have me."

After a gig on Cape Cod in 1959, a teenager took Seeger out in a sailboat at midnight. "I found out what fun it is to sail," he recalls. "It's not how fast you go, but that you go at all. If there's a north wind, you go northeast, then west, zigzag into the wind. That's good politics."

Seeger bought "a little plastic boat" and learned how to sail on the Hudson. An artist friend told him the river had once been home to sloops with booms up to seventy feet, and lent him a tattered copy of William Verplanck's *Sloops of the Hudson*.

"I wrote a poem about those boats. I could not get them out of my mind," says Seeger. He stayed up till three A.M. to write a letter proposing that a group of Hudson River families build a replica. With Cold Spring businessman Alexander Saunders, he started a new nonprofit called Hudson River Sloop Restoration, Inc. Within three years, they'd raised enough money to build the environmental teaching sloop *Clearwater*.

The Seegers' hand-built cabin is now a guest house for children and grandchildren; they've moved to a larger but still modest house alongside it. "We can see the Hudson from Storm King to Poughkeepsie," beams Seeger. "We know how lucky we are."

The word "lucky" comes up often in Seeger's discourse. "I'm lucky enough to have lived long enough to see my songs carried along by young people," he remarks

at one point. Indeed, the songs he's written have been the living soundtrack for generations of activists: "If I Had a Hammer," "Bring 'Em Home," "Waist Deep in the Big Muddy," "Turn! Turn! Turn!," "We Shall Overcome" (adapted from an earlier spiritual), and "Where Have All the Flowers Gone?," which is also the title of his 1993 memoir from Sing Out.

A few days after we speak, I receive a small envelope, hand-lettered in red ink. Inside is a postcard ("How To Build Global Community") addressed "Nina!" and some sheet music, with handwritten instructions on how to get a crowd singing along.

"This is a song I've sung all up and down the Hudson River," Seeger explains. "It's not set in the Hudson Valley; it's about a man from Alabama, but it's about all of us. I feel that I learned things from MLK that I put into action in my home town." He signs his note, "Old Pete," with a drawing of a banjo.

Take It from Doctor King

Down in Alabama, nineteen hundred fifty-five
Not many of us here today were then alive
A young Baptist preacher led a bus boycott
He showed a way for a brand new day without firing a shot.

Refrain:

Don't say it can't be done
The battle's just begun
Take it from Doctor King
You too can learn to sing
So drop the gun

Ohh! Those musta' been an exciting thirteen years!
Young heroes, young heroines, there was laughter, there were tears
Students sitting down at lunch counters, children dancing in the streets
To think, it all started with Rosa refusing to give up her seat.

[Refrain]

Songs, songs, songs, kept 'em going and growing
They didn't know the millions of seeds that they were sowing
They were singing on marches, even singing in jail
Songs gave them courage to believe they would not fail.

[Refrain]

We sang 'bout Alabama, nineteen hundred fifty-five
But since September eleventh, many wonder: will this world survive?
But if the world learns the lessons from Doctor King,
We can survive, we can, WE WILL! And so we sing!

[Refrain]

—Words and music by Pete Seeger
© 2002 by Sanga Music

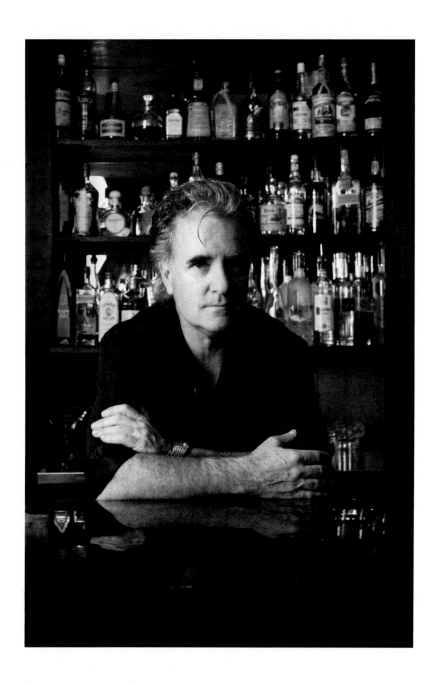

Danny Shanahan

WHEN *NEW YORKER* CARTOONIST Danny Shanahan first moved to the city, he tended bar at legendary Greenwich Village club The Bitter End. "I started out as a porter, getting up at five A.M. to mop, sweep, pick up everything that had happened the night before. Lot of bodily fluids." On the plus side, young Shanahan hung out with Keith Richards and Etta James, and even served drinks to a sloshed Thomas Pynchon. But he admits to one lapse in his bartending skills: "I couldn't remember jokes."

It's an endearing confession from someone who makes people laugh for a living. If you've opened a *New Yorker* in the last twenty years, chances are you've seen a Danny Shanahan cartoon, and chances are you've laughed out loud. He's published collections entitled *Innocent, Your Honor*; *I'm No Quack*; and *Bad Sex!* and edited Epigraph's local humor anthology, *Some Delights of the Hudson Valley.*

Shanahan's signature, printed in a neat schoolboy's hand, with the final "N" oddly distended, matches his humor: it's easy to read and just slightly off-normal. "You have to develop a personal style. When I first started sending cartoons to the *New Yorker*, I kept trying for some kind of highbrow, cocktail-party thing. As soon as I broke the mold, they started buying my work."

His first sale, a two-panel strip captioned "Lassie! Get help!"—with the dog winding up on an analyst's couch—was penned in a New Mexico tack barn. Now he works in the Rhinebeck home he shares with his wife, Janet Stetson (of cowboy hat royalty), and their two sons. Shanahan goes at cartooning with rigorous discipline. Words come first. He free-associates lists of ideas, then sketches his favorites. Whenever he's blocked, he draws animals—usually dogs and cats, or the odd lustful lion.

What makes a good cartoon? "Simplify your wording, simplify your line. The drawing has to nail it," says Shanahan. "You want the reader to turn the page and laugh."

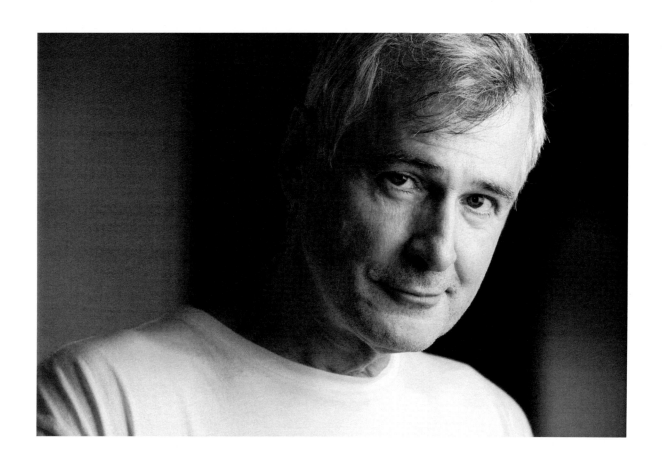

John Patrick Shanley

YOUR BROADWAY PLAY wins a Pulitzer Prize, a Tony, and a Drama Desk Award. You write and direct a film adaptation, which is nominated for five Academy Awards and as many Golden Globes. What do you do for an encore?

If you're *Doubt* author John Patrick Shanley, you do what you've always done: Write something utterly different.

The playwright, screenwriter, and director is presenting a staged reading of his latest play, *Pirate*, as part of New York Stage & Film's twenty-fifth season at Vassar College's Powerhouse Theatre. Emerging from a six-hour rehearsal, he blinks in the sunlight and speaks in a gravelly rasp with the unmistakable cadence of his native Bronx. "It got nice out. Let's walk."

Shanley strolls across campus at an easy lope. His manner is quietly confident, verging on cockiness; this is far from his first interview. He can be gracious, even courtly, but there's also a sense of some inner lava on permanent simmer.

The youngest of five, he grew up in East Tremont, a working-class neighborhood full of Italian and Irish immigrants. His father was a meat-packer, his mother a telephone operator. The home was tumultuous, and Shanley was often in neighborhood fistfights. He started school at St. Anthony's, a Catholic grammar school that served as his model for *Doubt.*

When Shanley was eleven, he started writing "kinda sorta Edgar Allan Poe poetry, gangster 1920s machine-gun kind of stuff." By thirteen, he'd written a four-line poem about the Holocaust that caught his teachers' attention. "People took notice of me," he says. "They thought I had something."

That wasn't the only reason people took notice: the rebellious teenager spent virtually every afternoon in detention at Cardinal Spellman High School. The poet

and the pugilist came together when he worked on the stage crew of "an amazing production" of *Cyrano de Bergerac.* "I loved the depiction of the poet as the toughest guy in the room—and a freak," Shanley says with a wild, braying laugh. "And that a poet can be in the theatre. And I liked colored lights."

Midway through high school, Shanley was expelled. He spent the next two years at a Catholic-run private school in Harrisville, New Hampshire, which he describes as "five hundred acres on top of a mountain . . . snowy, windswept—that's all it *is*, is winter." There were fifty-five students, all boys. "It was very intense, very different from the Bronx," Shanley says. Here, too, teachers encouraged his talent for writing.

He enrolled in New York University, but, characteristically restless, dropped out after a semester to join the Marines. After a two-year tour of duty, he returned to NYU and took "every writing class they had. The last one I took was a playwriting class. As soon as I started writing dialogue, I knew that was what I did." The final project was writing a one-act play. Shanley wrote a full-length instead; it was produced three weeks later.

Inflamed by his newfound passion, he churned out play after play, with Off-Broadway premieres nearly every year at such theatres as the Vineyard, Theatre of the Open Eye, and Ensemble Studio Theatre. "I earned on the average seventy-five to a hundred dollars a year as a playwright for ten years," he says without irony. He supported his playwriting habit with a series of blue-collar jobs: unloading trucks, painting houses, and working as a moving man, elevator operator, bartender, locksmith, and glazier. At thirty-four, he went to work in the licensing department of Dramatists Play Service. "I've never had another job to this day," he pronounces with deep satisfaction.

Shanley's next production was *Danny and the Deep Blue Sea*, an explosive two-hander about a volatile guy from the Bronx and the equally bruised, angry woman he meets in a bar. A joint production of Circle Repertory Company and Circle in the Square, it starred John Turturro and June Stein. Shanley, who seems to remember the details of every paycheck, earned five thousand dollars. That and a seventeen thou-

sand dollar NEA grant allowed him to patch together a living for over a year while he explored a new genre, having vowed to quit taking day jobs. "It was write or starve. I thought, I better learn to write screenplays if I want to make a living," he says.

He read lots of screenplays and wrote two on spec. "And they *made* them," he marvels, still sounding awed. *Five Corners* was optioned by the first person who read it, director Tony Bill, with ex-Beatle George Harrison as his executive producer; it starred Jodie Foster and Tim Robbins. "People kept telling me, 'It doesn't *happen* this way,' but it did," Shanley says.

Meanwhile, he finished a second screenplay, *The Bride and the Beast*, instructing his agent to send it to director Lawrence Kasdan, who liked Shanley's plays. She also sent it to Norman Jewison. "Both of them wanted it," Shanley recalls. "Norman responded first, and a week later, Larry Kasdan called him and asked him to step aside so he could direct it. So I knew then that there was no way Norman was going to let that screenplay go." Jewison shot the film and released it under a new title: *Moonstruck.*

Shortly after it opened, Shanley opened his mailbox at the tenement where he was living and took out a royalty check. It was for eighty-five thousand dollars. "I just knew that my life had changed," he says. "I was thirty-six years old, I'd been living below the poverty line for my entire life. Suddenly I could buy anything they had in the store."

The wild ride continued with six Academy Award nominations, including wins for Cher, Olympia Dukakis, and Shanley, whose acceptance speech included the much-quoted line, "I want to thank everybody who ever punched or kissed me in my life, and everybody I ever punched or kissed." (There may be long lines in both columns: the former Bronx brawler, twice married and divorced, has dated a string of celebrities, including actress Kim Cattrall and model Paula Devicq.)

Shanley's Hollywood track record veered from commercial fiascos *The January Man* and *Joe Versus the Volcano* to the much-lauded *Doubt.* He's never been tempted to move to L.A. "I could have just kept on earning a lot of money," he says, but "I was

very concerned with being able to write in a way that was real for the rest of my life. This is what I *do.*"

As a playwright, Shanley refuses to play it safe. Along with his Pulitzer/Tony/Drama Desk triple crown, he's garnered some brutal reviews. In his "Butcher of Broadway" critic incarnation, *New York Times* columnist Frank Rich sharpened his cleaver on Shanley so often it started to seem like a personal grudge. Shanley always came back punching, and once sent an unsolicited letter to a younger playwright whose debut had been panned by Rich, assuring her it was "a backhanded compliment, like being blacklisted by Nixon."

Pirate is the thirteenth script he's tried out at the Powerhouse, his artistic home since New York Stage & Film's inaugural season, which included his *Savage in Limbo.* It's a challenging work, a complex political allegory sharing a bed with a surreal comedy, full of music-hall accents and a central image of blinding which may allude to Shanley's ongoing fight with glaucoma. The playwright's bold choices and unmistakable dialogue thrill some audience members and seem to infuriate others. Midway through the reading, a man in the first row walks out, crossing the black-box stage so close to the actors that Fisher Stevens stops in mid-sentence and waits for him to reach the exit. When Stevens shrugs and continues the scene, the audience claps.

"This play is deeply, wildly different from my last, which was deeply, wildly different than the one before that," Shanley says. "You don't dream the same thing every night. Why would you write the same thing every day?"

Besides, he adds, "*I'm* not the same. I am what I was, plus what I am. You have to find a way to get to the next step on the road."

Shanley's writing process usually starts with "a title, an image, or a room that I think has power. With *Doubt*, all I had was the title. I didn't know the subject matter, didn't know it was about nuns." What interested him was the state of uncertainty, something he feels is alarmingly absent from modern debate. The idea developed through images of black and white: the nuns' habits, the first black child in an all-white school. Color is extremely important to Shanley; he often describes a set in meticulous

detail before he begins writing lines. "I really design it. I try to keep people out of the room for as long as possible, then they walk in and the play starts."

He was equally specific about decorating his Manhattan apartment, choosing colors so vivid they rated a spread in the *New York Times* Home section, and his cottage upstate. After staying with friends and at local B&Bs for many years, Shanley purchased a tract of land on a fishing creek in Ulster County. He didn't build on that site, but planted some tulips he hoped would come up every spring (the local wildlife thought otherwise).

Twelve years ago, he bought a cabin on a mountaintop near the Rondout Reservoir. His teenage sons Nick and Frank, adopted during his marriage to actress Jayne Haynes, grew up with the country house. "They love it," says Shanley, who also enjoys using it as a writing retreat. "I'd go up there for seven days alone. It was utter isolation—very, very remote. The house isn't on a dirt road, it's *off* a dirt road."

"I like the Hudson Valley. I always think of Washington Irving, and the Hudson River School of painting, that sort of stately magnetism the place has." John Patrick Shanley gazes at his interviewer, amused and a little impatient. "You done with me yet? There's a barbecue."

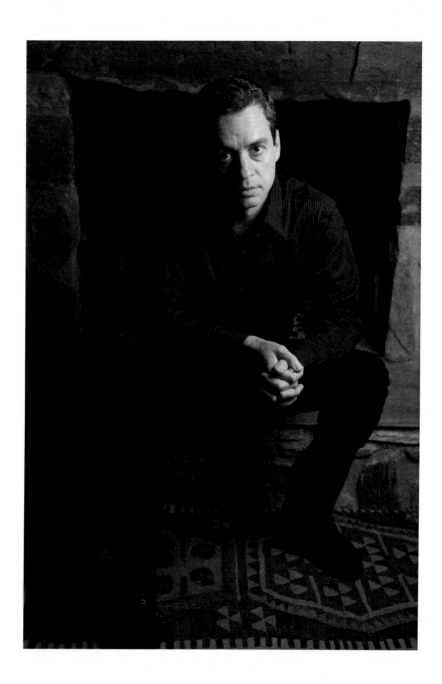

Russell Shorto

TWO MILES ABOVE Russell Shorto's Putnam Valley home, there's a plaque embedded in stone. Its text begins, "In 1699, the Dutch of New Amsterdam created a road to Albany which followed Indian trails called The Path." Driving down the plunging curves of the unpaved Albany Post Road, flanked by stone walls and unfurling spring maples, it's easy to picture how this wild land must have looked to a rider in topcoat and breeches. It's harder to make that imaginative leap in the author's old neighborhood, New York's East Village.

Unless, of course, you're Russell Shorto. In 1997, the bestselling author of *The Island at the Center of the World* brought his young daughter to play in the churchyard of St. Mark's-in-the-Bowery. As she ran around under the sycamores, he studied the worn seventeenth-century tombstones, including that of Peter Stuyvesant, the notorious peg-legged Dutchman who lost Manhattan to the English. Shorto wondered what sort of settlement Stuyvesant had once governed, and how this quintessentially urban neighborhood had looked without pavement.

The Island at the Center of the World (a title that provoked some affront in outer-borough book signings) conjures an untamed island of reedy salt marshes, waterfalls, and forested hills, populated by deer, mountain lions, and wolves. But no one Shorto asked, including historians, seemed to know much about Stuyvesant's colony. Then he met Albany scholar Charles Gehring, who's devoted the past thirty years to translating a twelve-thousand-page archive of handwritten seventeenth-century documents from the New Netherland colony. Initially planning a magazine feature, Shorto kept asking questions that started, "Do you mean to tell me . . .?" As he listened to Gehring, he realized his whole notion of America's roots was shifting. "Everyone knows about the Puritans in New England, the Virginia colony," he says, "Well, what was in between?"

A lot, it would seem. Shorto describes the first European settlement on the Hudson:

> It was founded by the Dutch, who called it New Netherland, but half of its residents were from elsewhere. Its capital was a tiny collection of rough buildings perched on the edge of a limitless wilderness, but its muddy lanes and waterfront were prowled by a Babel of peoples—Norwegians, Germans, Italians, Jews, Africans (slaves and free), Walloons, Bohemians, Munsees, Montauks, Mohawks, and many others—all living on the rim of empire, struggling to find a way of being together, searching for a balance between chaos and order, liberty and oppression. Pirates, prostitutes, smugglers, and business sharks held sway in it. It was Manhattan, in other words, right from the start.

A thriving multicultural community in the pre-Colonial era? Why haven't we heard about this? (Though every American schoolchild can recite the shopworn anecdote of the purchase of Manhattan Island from the Indians for twenty-four dollars, the Dutch colony is a mere footnote to the "original" thirteen English colonies.)

"It's the history we choose to remember versus the history we choose not to," says Shorto. "The Puritans made for a stronger creation myth." He's quick to point out that the English refugees who famously came to America for religious freedom would shortly wind up burning witches.

The New Netherland colony was far more freewheeling: a messy, contentious port where currency ranged from doubloons to beaver pelts and the salty residents spoke eighteen languages. In Holland, tolerance was not some lofty ideal, but a practical response to an international sea trade and different peoples living side by side.

New Netherland stretched from Manhattan to the upriver fur-trading settlement at Fort Orange, later known as Beverwyck, then Albany. There was little but forest between these two settlements in the Dutch period, though Wiltwyck (later Kingston) became an important outpost, where deeper-keeled tall ships were exchanged for boats that could navigate the shallower waters to the north. The Dutch settled much of the

mid-Hudson Valley, and hundreds of Dutch names remain on the land.

Shorto worked hard at shaping his tale for all readers, and *The Island at the Center of the World* popped up on bestseller lists around the country ("mostly in blue states," he observes wryly). He's a firm believer in presenting ideas through characters—"that's the way we transmit meaning, whether it's in a novel or nonfiction"— and *The Island at the Center of the World* juxtaposes the rigid, militaristic Stuyvesant and his freethinking challenger Adriaen van der Donck. (There are also some juicy cameo roles, like barmaid Griet Reyniers, who measured her customers' penises on a broomstick.) Van der Donck is a revelation, a university-trained lawyer who became fluent in Indian languages, kept meticulous natural history notes, and questioned authority at every turn; Shorto calls him the first American.

Shorto grew up in Johnstown, Pennsylvania ("famous for floods"). After studying philosophy and journalism at George Washington University, he and wife-to-be Marnie Henricksson impulsively moved to Japan, where they found work teaching English. Next they moved to New York, where Shorto sought work as a journalist and wrote children's history texts on commission, on subjects ranging from Jackie Robinson to J. R. R. Tolkien. "I think I wrote ten in a year and a half," he says.

Eventually, Shorto started writing for the *New Yorker, GQ, Travel & Leisure,* and the *New York Times Magazine.* He also published two books for adults: *Gospel Truth: The New Image of Jesus Emerging from Science and History, and Why It Matters* and *Saints and Madmen: Psychiatry Opens Its Doors to Religion.*

Shorto and his family are currently living in Amsterdam, where he went to research his latest book, *Descartes' Bones.* (The French philosopher and father of rationalistic inquiry moved to Holland in 1629 in search of intellectual freedom.) After his death, Descartes' bones were dispersed, and some were taken as religious relics. As Shorto says, in that day and age, "any investigation that looked into the heart of nature was religious. Cartesians were persecuted like early Christians."

Shorto also examines the origins of humanism, early science, and other aspects of social history, but "however abstract it could become, there's nothing more concrete than a bone." He grins. "That should be my mantra: stay with the bones."

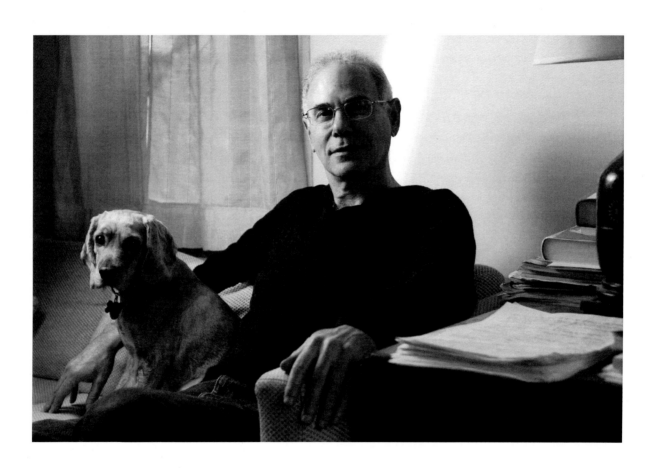

Zachary Sklar

THE FARMHOUSE SITS ON A sleepy back road near the Ashokan Reservoir, its front porch half-hidden by an immense rhododendron. Screenwriter Zach Sklar opens the kitchen door, wearing a Saratoga Racetrack t-shirt. He's lean and fine-featured, with a welcoming smile tempered by a guardedness that seems hard-wired into his posture.

Pancho, a cocker spaniel rescued from an abusive home, frisks around, wagging his tail. Sklar's longtime partner, film composer Sarah Plant, is pan-frying matzo brei at the stove, and the smell of caramelized onions sweetens the air. A health-conscious vegetarian, Sklar tries to avoid both sugar and gluten, but he's treating himself to a brownie today.

The living room is low-key and homey. The only clues to its owners' professions are a 3–D mockup of a cinema with a marquee reading *Eat Drink Man Woman* (Plant was associate music director) and a magnum champagne bottle with a logo for *JFK* (Sklar wrote the screenplay with director Oliver Stone).

"I grew up with a lot of writers," he says, settling into a chair with his contraband brownie within easy reach. "We had a surrogate family that was built around two things: most of them had been in the Communist Party, and most of them were writers."

Sklar's father, a politically active New York playwright and novelist, was wooed to Hollywood with others like Clifford Odets. Though George Sklar's Broadway plays *Laura* (written with Vera Caspary) and *Merry-Go-Round* (written with Albert Maltz) and his novel *The Two Worlds of Johnny Truro* were optioned by studios, he spent most of his time as a salaryman, doing endless rewrites to support his family.

The youngest of three children, Zach was born in 1948. A year later, George Sklar was named before the House Un-American Activities Committee. Refusing to

testify, he was blacklisted alongside Dalton Trumbo, Waldo Salt, Ring Lardner Jr., and other noted screenwriters. "My entire life was after he was out of film," Sklar says.

His mother, Miriam Blecher Sklar, a former Martha Graham dancer, became the family breadwinner, teaching modern dance classes for children and later for adults. "She was a very gifted teacher. People loved her," says Sklar, "But she kept her dance life totally separate from us. She never danced at home. We never danced."

Her husband became a recluse. "He crumbled a bit psychologically," Sklar says, emotion choking his voice. "He didn't fight back. He didn't wilt—didn't name names or sacrifice his principles—but he didn't leave the house."

He also never discussed his political affiliations, so his children would not have to lie if they were questioned. After his death in 1988, Sklar and his siblings—playwright Daniel Sklar and editor Judith Sklar Rasminsky—were sorting their father's possessions when his Communist Party card fell out of a book. "I just gasped," Sklar recalls. "He never told, even long after the blacklist was over."

Like many blacklistees, George Sklar warned his children against political activism, cautioning them not to sign petitions or get their pictures taken. "Of course the first thing I did was sign petitions and go to demonstrations," says Zach, who came of age during the Vietnam era.

He attended the newly formed University of California at Santa Cruz, which he describes as "a very communal-minded place" in Reagan-governed California. "But I was frightened. That was one of the big messages—not subconscious, it was pounded into me. 'Don't accept the way things are. Fight for justice, but you can get hurt. Be careful.' It was a very schizophrenic message. When I did things, it was always, always a way of overcoming that fear."

During college, he worked as a volunteer on poverty-stricken Daufuskie Island, off the coast of South Carolina. There were about a hundred residents, all black. "It was like being in the nineteenth century: no paved roads or running water," Sklar says. For a politically conscious Angeleno, seeing black people cross into the street in deference as a white person passed was shocking. "I was exposed to things I'd never

been exposed to. People living in shacks with newspapers on the walls, eating squirrels. I buried a body." He also worked with Donald Gatch, an idealistic doctor who served a community in which eighty percent of the children had malnutrition and parasites. "It was life-changing," Sklar says, "an abrupt introduction into the contradictions of life in America."

That summer, Sklar's family rented a house in Beacon, New York, and the three siblings drove to the Woodstock Festival. The closest they could get was twelve miles away. They parked on the roadside and hiked in, arriving at three A.M. to hear Joan Baez finishing her set in the distance. They slept in a field in the pouring rain, and hiked twelve miles back the next morning. "We never heard any music at all," Sklar laughs.

For several years, he took a series of blue-collar jobs, including lawn maintenance in a trailer park housing the last remnants of the Merry Pranksters ("you could still see the day-glo on the barn ceiling") and crewing on a salmon boat in Alaska. "I got a jellyfish in my eye on my birthday, and thought 'What am I doing with my life?'" Sklar recalls. It was 1973, the year of the Watergate break-ins. Inspired by Woodward and Bernstein, Sklar applied to Columbia's journalism school.

After graduation, he worked as a proofreader at *Time* and *Life*, and edited a national law magazine called *Juris Doctor*. He also edited books for the left-leaning Sheridan Square Press and wrote for *The Nation*, becoming its executive editor while Richard Lingeman was on leave. In 1984, he joined an international brigade picking coffee in Nicaragua, and fell in love with the woman who interviewed him. Sarah Plant was hard to pin down, but Sklar suggested they meet for breakfast in Riverside Park, and brought along a juicer and fresh oranges. "I think that got her," he laughs.

Two years later, he was stricken with incapacitating chronic fatigue syndrome and lost his proofreading gig at *Time*, unable to keep the late hours. It wasn't an ideal time to start a new project, but Bill Schap and Ellen Ray of Sheridan Square asked him to edit a book called *On the Trail of the Assassins* by a former New Orleans district attorney named Jim Garrison. "It ended up being the best thing that ever happened to me," he says.

Garrison's first draft was an attempt at an objective history. Sklar urged him to tell the story in first person, tracing his 180–degree turnaround from career military man and true believer to someone who became convinced that the CIA murdered President Kennedy. He helped Garrison reshape the book as "not a whodunnit, but a whydunnit."

Soon afterwards, Schap and Ray gave it to director Oliver Stone at the Havana Film Festival. Stone called three days later, saying he wanted to film it, but was busy with *Born on the Fourth of July*; did they have a writer to recommend? Stone hired Sklar over the phone, telling him "Don't read any of those screenwriting books, just write from the heart. And I don't care how long it is."

Sklar and Stone's models were Costa-Gavras's *Z* and *Rashomon*, using witness reports and flashbacks to interweave past and present. Sklar's first draft took a year, and weighed in at over five hundred pages. Stone cut and combined scenes, adding new ones. Sklar learned "a tremendous amount" from rewriting with his coauthor, who encouraged such liberties as resetting an office meeting with Jack Lemmon's character to a racetrack, where he's hungover, drinking coffee in the stands. "It gave you the milieu of this guy, a much deeper character," says Sklar. "It's not factually true, but it's actually *more* true—the audience understands him better."

The film came under attack even before it was shot, when a stolen script was leaked to the press. "Oliver enjoyed the fight—he stayed up late writing letters to editors," Sklar recalls. "It was an adventure. It was insane."

JFK was nominated for eight Academy Awards, including one for Best Adapted Screenplay. "It was a high-visibility film that caused a huge controversy. Oliver took a lot of the heat, and a lot of the credit. But it established me as a screenwriter. And ended my journalism career," Sklar laughs. "I think those doors closed the minute *JFK* came out."

He wrote an unproduced screenplay for Stone called *Mediocracy*, about a corporate media takeover, and continued to edit for Sheridan Square. But his health worsened, and in 1988, he and Plant moved upstate so he could heal.

Sklar has a penchant for hard-to-finance film projects. His other unproduced screenplays include *Tai-Ping*, set in China during the bloodiest civil war in history; *The Wounding*, set in Arctic Canada; and a biography of singer/activist Paul Robeson, developed with Robeson's son. He also adapted Mario Vargas Llosa's novel *Feast of the Goat*; starring Tomas Milian and Isabella Rossellini, the 2006 film was released in Europe, but not the United States.

In recent years, Sklar has mentored Latin American and Palestinian screenwriters through Sundance's international workshops. "This is where I think the vitality of film is now, in these cultures that haven't been heard from yet. There are stories they need to tell that nobody's heard," Sklar asserts.

Zachary Sklar also has stories he needs to tell. He's just interviewed for a controversial new screenwriting project. It's too soon to reveal any details, but he says with a grin, "If it didn't get panned by the *New York Times*, I'd be very upset."

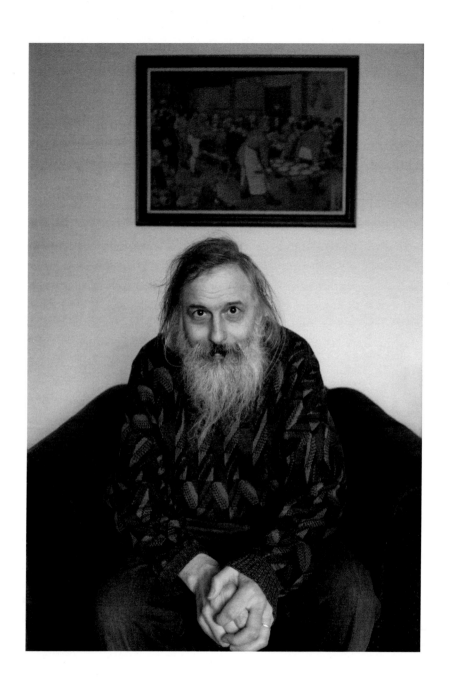

Sparrow

"IS IT JUST ME, or is there something about the Hudson Valley that makes every single person who lives here eccentric?" asks Sparrow.

He's wearing a parka over an unseasonably bulky sweater, and removes his shoes after sitting in Kingston's Wing Shui Chinese restaurant. He always carries a bag full of books in case he gets stuck in an elevator. "I have anxiety—that's why people think of me as a humorist."

Sparrow's laugh is a sharp, percussive, double bark which sounds almost as if he's saying, "Ha. Ha." At readings, he riffles through dog-eared piles of paper painstakingly lettered in different-colored inks. His comic timing is impeccable. Bob Holman once posted a sign outside the Bowery Poetry Club billing Sparrow as "the world's wisest, funniest, and worst poet."

The native New Yorker got his mononame from a fellow employee at Mother Earth Health Foods in 1975. He moved to Shandaken when his wife, writer Violet Snow, started yearning for greenery. "I begged her to go to Mexico—at least they have a culture. As you may have noticed, living in America is like living in a shoebox."

Sparrow has run for president in every election cycle since 1996, when he ran as a radical communist in the Republican party. His books *Republican Like Me*; *Yes, You ARE a Revolutionary!* and *America: A Prophecy* are published by Soft Skull Press. He also writes for *The Sun* and the *New York Observer*; his *Phoenicia Times* column, "Heard by a Bird," includes fictional gossip, imaginary bumper stickers, and biweekly portraits of actual clouds.

Sparrow calls himself "a subsistence writer. I grow just enough words to live." Where would he most like to subsist? He scratches his beard, then remembers a *National Geographic* he saw at a Laundromat. "The cover photo was this arid but bizarrely beautiful landscape, and I thought, '*That's* where I want to live!' It was Mars."

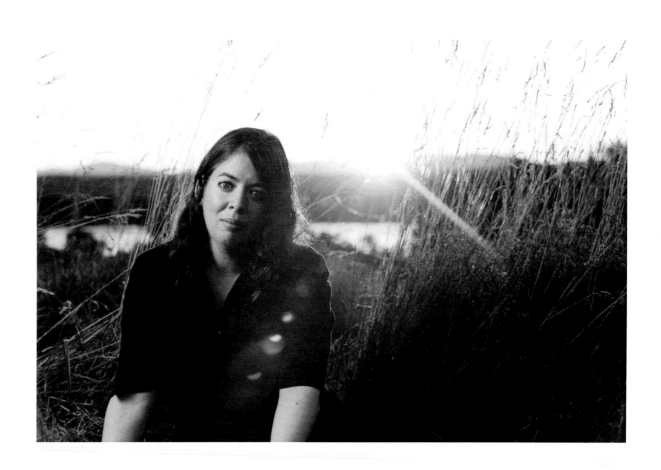

Nova Ren Suma

FADE IN ON THE MYTHICAL Catskill town of Shanosha, where thirteen-year-old Danielle Callanzano is spending the summer at the movies, avoiding her mother's grief and her father's desertion. Her imagination inflamed by film noir classics, Dani starts stalking a teen femme fatale wearing polka dot tights.

Welcome to *Dani Noir*, a perfect-pitch tween romp by Nova Ren Suma. The author grew up in Saugerties, Accord, and New Jersey, finally settling in Woodstock with her mother and two younger siblings. "It was the first time I ever lived in a town where I fit in," she says gratefully. "There were *other* kids with funny names and hippie parents." (Nova means "chases butterflies" in Hopi; Ren "lotus flower" in Japanese.) She liked to hang out in the Woodstock Artists Cemetery, writing in notebooks. "And you *had* to go to the Green," she recalls. "The stores would close, the tourists would go home, and the teenagers would come out. Every night."

Suma and friends also swam in the off-limits Ashokan Reservoir. In her upcoming young adult novel *Imaginary Girls*, a teenager dares her sister to swim across a dark reservoir, they're separated, and a body turns up; there's also a hint of the paranormal. "Basically, it's the night when everything goes wrong," Suma says. The unfinished manuscript sparked a two-day bidding war among six publishers.

Suma met her husband, filmmaker Eric Ryerson, at Antioch College. They moved to New York, where she got an MFA from Columbia University, wrote two unpublished novels for adults, and supported herself with editing jobs at Art Spiegelman's RAW Books & Graphics, Marvel Comics' *X-Men* series, Penguin, and Harper-Collins. While at Penguin, she started ghostwriting middle-grade series books, and realized she loved writing for tweens.

"I always wrote about teenagers," she admits. "The difference is the distance. You're not looking back at being fourteen; you *are* fourteen."

235

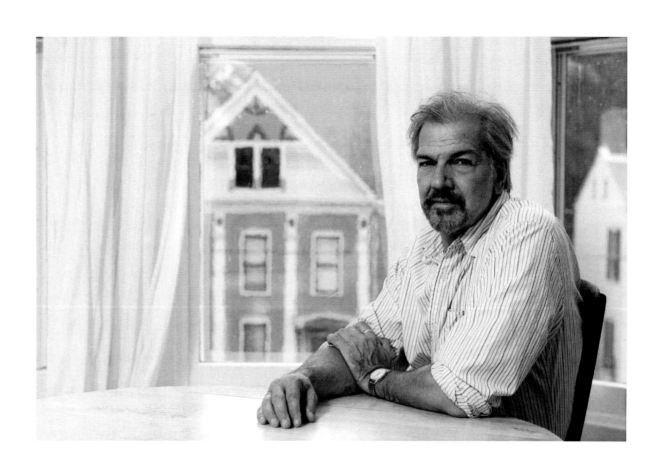

Hudson Talbott

WHAT'S IN A NAME? Ask Hudson Talbott. "It does feel kind of like it was my destiny to be here, and to write about it," says the children's author and illustrator, whose *River of Dreams* is a vibrant history of his namesake river. "All writers are in some way or another influenced by their environment. In my case, it's quite literal."

Born in Kentucky, Talbott "was always drawing stories, creating my own little world and diving into it." The young artist ended his bedtime prayers, "God bless Mommy and Daddy, may I please have a horse and go to New York?"

After studying in Rome, living in Amsterdam, and traveling through Asia, Talbott finally moved to New York City in 1974 with his late partner, hologram artist Rudie Berkhout. When they started to dream about owning some land, they "drew a circle with a radius two and a half hours from Manhattan," winding up in the mountains of Greene County. It was a perfect fit.

Though Talbott has written over a dozen books, including the popular *Tales of King Arthur* series and *United Tweets of America*, he's reluctant to think of himself as a writer. "I'm a visual person. I conceptualize visually, and it evolves into a storyline, and then it'll need some words," he says, likening picture books to screenplays and film storyboards. "As much as I can say through the pictures, I do."

Talbott's pictures are wonderfully eloquent: *River of Dreams* was selected to represent New York state at the 2009 National Book Festival in Washington. As the story unfurls from prehistory to Henry Hudson's *Half Moon* to colonization, pollution, and rescue, Talbott's visual style alters with every spread. "It's a big history," he says, noting that the Hudson Valley was the first tourist destination for working- and middle-class families. "The aristocracy took their grand tours of Europe, of course, but taking the boat up the river and taking a carriage up to the Catskill Mountain House made people *feel* like royalty." In Hudson Talbott's hands, it still does.

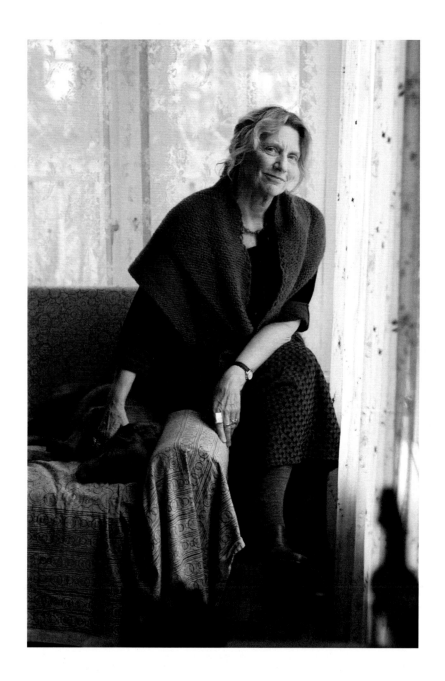

Abigail Thomas

A BEAGLE GETS OFF HIS LEASH. It's an everyday moment that will change whole lives. Abigail Thomas has made a career—two collections of stories, a novel, the acclaimed memoir *Safekeeping*—out of writing such moments, but this one is different.

Six years later, the same beagle barks outside a rambling farmhouse in Woodstock. Two more dogs join in as the front door swings open, emitting a waft of banana bread with warm chocolate chips and blueberries. Thomas is hosting her Wednesday night workshop. The writers—all women tonight—congregate in the kitchen, forking up cake with murmurs of bliss and, refreshingly, no talk of calories: the one writer who doesn't partake is recovering from a stomach flu. "Bring some home," suggests one of her colleagues. "But warm it," says Thomas. "It has to be warm."

The group migrates into the living room, full of quilt-draped couches and comfortable chairs, a round coffee table piled high with books and a bright ball of wool. Thomas sits sideways on an overstuffed armchair, legs dangling over one arm. Her blonde hair spills onto her shoulders, and one of her garden-tanned forearms bears the Southwestern-looking tattoo of a salamander she got on her sixtieth birthday. She is not wearing shoes and her socks don't match. Or maybe they do: Thomas's world embraces the different. A closer look at the colorful paintings on every wall reveals primitive brush strokes, obsessively lettered dense texts, and repeated motifs. Art critics call such works "outsider art." For Thomas, they are something else: paintings by friends, by people who speak the same language as her late husband Rich.

Six years ago, Rich took the beagle for a walk and didn't come back. Thomas got a call from the doorman of their Upper West Side apartment, telling her that her dog was in the elevator. Rich had been hit by a car.

"His skull is fractured like a spiderweb. Everywhere," Thomas writes in her mesmerizing memoir *A Three Dog Life*. The police report listed Rich as "dead, or

likely to die." But somehow he beat the odds, surviving multiple brain surgeries. For a few eerie days, he seemed almost himself. Then he fell into a spiral of unpredictable rages, paranoid outbursts, and fragmented perceptions, losing all sense of time and even the shortest-term memory.

"Rich is lodged in a single moment and it never tips into the next," Thomas writes. "I got stuck with the past and the future. That's my half of this bad hand. I know what happened and I never get used to it."

Eventually, Rich was transferred to a facility for patients with traumatic brain injury in Lake Katrine, and Thomas moved upstate to be near him. *A Three Dog Life* is the story of coming to grips with a reconfigured life, of unspeakable loss and precious, hard-won independence. Stephen King called it, "The best memoir I have ever read. This book is a punch to the heart." (It's also unexpectedly funny, as when Thomas writes, "Sometimes it's all I can do to brush my teeth, toothpaste is just too stimulating.")

"It's so hard to talk about Rich," she says. "The only way to get it so I can understand it is to write it down." She wrote first in diaries, with no thought of publishing. Then an editor at *Elle* asked her to write a short piece about grief, which became the memoir's first essay, "How It All Happened."

Both *Safekeeping* and *A Three Dog Life* are composed of short, discrete essays, which taken together form a complex pattern. This format may have a genetic antecedent: Thomas's father was National Book Award–winning scientist Lewis Thomas, whose bestsellers *Lives of a Cell* and *The Snail and the Medusa* are structured the same way.

"I have no memory for ordinary chronology, and really no interest in it. I don't even believe in it. How do we know we're going forward? We might all just be in this broth, rolling around, and time isn't going anywhere," Thomas claims. She calls *Safekeeping* "an unmoir, because I have no memory, except for moments."

Those moments gleam. Thomas's writings are often compared to stained glass, collage, quilts—art objects assembled from fragments. Like Grace Paley, Tillie Olsen,

or Alice Munro, she speaks in an unvarnished language of quirky plain truth, quintessentially female, collecting the glittering tidbits of everyday life like a magpie.

Thomas didn't start writing until her late forties. Pregnant at eighteen, she was expelled from Bryn Mawr in her freshman year; her boyfriend was not asked to leave. They got married and "spent a miserable eight years together." She spent the next years raising children, remarrying, battling depression.

After her second divorce, Thomas found herself at thirty-eight with no college degree and no prospects. She became a slush-reader for Viking, her father's publisher. After five years and thousands of manuscripts, she was promoted to editor. Next she became a literary agent, representing Anne Lamott, Annie Proulx, and poet Li-Young Lee, among others. "As an agent, you can work with anybody on anything," she grins. "It's like being the first person at a really great garage sale."

Then she met Richard Rogin, "the nicest man in the world," who proposed to her thirteen days after they met. Thomas began writing full-time. She led a Manhattan workshop called Tuesday Night Babes; its members included mystery writer Alison Gaylin, who would later urge Thomas to move upstate, closer to the Northeast Trauma Center.

The Wednesday night workshop started soon after that move, when Gaylin introduced Thomas to authors and former Woodstock Wool Company owners James Conrad and Paul Leone. "I wanted to feel rooted up here," Thomas says, "Nothing builds intimacy and trust faster than getting together to share what you write. We love each other. It's my favorite night of the week." The room fairly hums with support.

The format evolved as the group started bringing in ongoing projects. At first, Thomas read passages by favorite authors, and doled out her trademark "two pages in which . . ." assignments, many of which appear in her new book *Thinking About Memoir*. "It was like a spell," reports a former student. "I don't think any of us knew what we'd write until we wrote it. And then we would all give feedback, and of course everyone hangs on Abby's feedback, because she cuts right to the center. She asks the hard questions."

"I don't think you can teach writing. You see where the fire is and blow on it gently," says Thomas, who's taught in the New School's MFA program since its inception. "My job is to find where the heart is beating, and tell them how good it is. I want people to leave feeling that they can't wait to get home and start writing."

For Thomas, the mother of four and grandmother of twelve, creativity is an imperative. "You can bake, make a garden, write, knit, give it away. How could you get through life without doing that?" She shakes her head. "We're man the maker, we're supposed to make things. You can't just *shop.*"

In *Thinking About Memoir*, Thomas encourages others to take up the pen: "Writing memoir is one way to explore how you became the person you are. It's the story of how you got here from there." The principal tool for the job is honesty. "I write nonfiction because you can't get away with anything when it's just you and the page. No half-truths, no cosmetics. What would be the point?"

In *A Three Dog Life*, she shows how it's done. The heartbreak of loving someone who is "there, yet not there" resonates with many readers who care for Alzheimer's patients, stroke victims, or the mentally ill. "I don't know how anybody does it. It doesn't get any easier, and it doesn't ever get not really sad, but you do it anyway," Thomas reflects. "Once you accept that this happened, it's not going to unhappen, there's nothing that you could have done—once the paint is dry on that, at least for me, when the guilt comes back, I can make it go away."

Wrestling with survivor guilt is a major theme of *A Three Dog Life.* "I wanted to make something that would be useful for other people. A lot of people think that if one's life is happy after a tragedy, something is wrong. Everything I have now is based on what happened to Rich, and I love what I have. It's so hard to reconcile. It isn't a question of guilt, but accepting the life that you've got."

From *A Three Dog Life*:

Rich and I don't make conversation; we exchange tidbits, how well we've slept, what was for breakfast. We are stripped down to our most basic

selves. No static, no irony, no nuance. Once in a while Rich says something that takes my breath away: "I feel like a tent that wants to be a kite, tugging at my stakes," he said one day, out of a clear blue sky. He was lying in a hospital bed, but his eyes were joyous. In some ways, we are simply an old married couple, catapulted into the wordless phase ahead of time. An old pal of mine used to extol the virtues of basic body warmth in the days when I was more into the heat, but now I understand. Rich and I sit together, we hold hands; we are warm-blooded creatures in a quiet space, and that's all the communication we need.

Editor's note: Richard Rogin died on January 1, 2007.

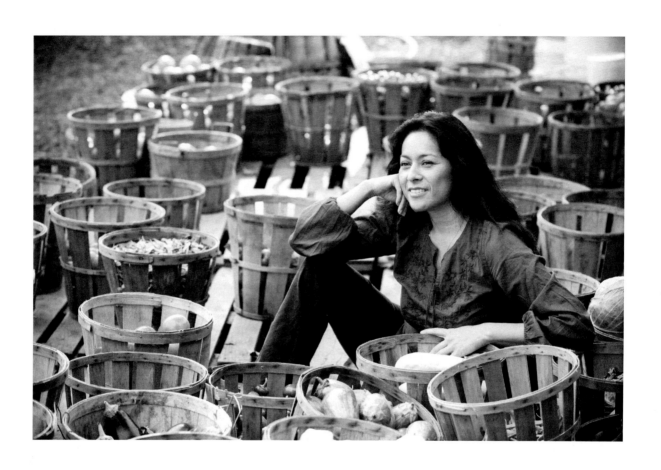

Corinne Trang

"BOTH MY GRANDMOTHERS were amazing cooks," says Corinne Trang. "My French grandmother was a blind baker—she never measured anything, but her tarts and crusts were superb. You learn how to cook by cooking—by touch, by feel." And by smell. The author of *Noodles Every Day*, *The Asian Grill*, *Curry Cuisine*, *Authentic Vietnamese Cooking*, and the classic *Essentials of Asian Cuisine* credits the aromas wafting through her Chinese-Cambodian grandmother's kitchen with awakening her international palate.

Trang was born in France, but within six months, her parents had moved to Phnom Penh, where her father had an enormous extended family. The Trangs lived there till 1970, then fled back to France as the war escalated. "Both grandparents died of starvation. I had uncles and aunts who were killed. It was war," she says bluntly.

Her family lived next with her mother's family in the Loire Valley. "Food is in our culture and in our blood, literally," she says. "Eating with the French side and the Asian side of my family is a whole different experience, it's like night and day."

Her French relatives spent hours around the table at Sunday lunch, drinking wine and talking endlessly about every dish. "It's part of the culture, you don't rush your food, you savor every bite. Four hours later, we're still having coffee. My grandmother would get up and say, 'Time for dinner,' and go back to the kitchen."

"In Asia, you slurp that noodle soup and you're *gone.* If you don't eat in five minutes, the texture changes dramatically, the noodles get soggy. You want the broth piping hot. Banquets are different. But lunch, you eat, you go back to work, that's the culture. So I'm very screwed up." She laughs, reaching across the table to her five-year-old daughter Colette, who's enjoying a chocolate chip cookie.

Trang moved to Ulster County in 1999, prompted by a *New York Times* spread about the region. "I'm a mountain person. I love high altitudes, really refreshing clean

air," she says. But scenery wasn't the only draw. "The food culture in the Hudson Valley is really awesome. I love going to farm markets and farm stands on weekends, knowing I could live here and have access to beautiful produce that I didn't have to buy in a supermarket, that wasn't waxed."

Her first dream was an old stone farmhouse, reminiscent of those in the Loire Valley where she grew up. Her ex-husband, green architect Michael McDonough, said, "I'll build you a stone house." They bought a thirty-three-acre parcel with a hidden meadow near the Ashokan Reservoir; McDonough's creation, e-House, received wide acclaim for a design which includes a self-watering rooftop garden and state-of-the-art kitchen. Trang still divided her time between Ulster County and SoHo, keeping both kitchens stocked.

As a chef who urges home cooks to get comfortable with foreign cuisines, Trang has often been called "the Asian Julia Child." "Every time I write about food, it's a little different," she says. "You need to make it fresh every time, like cooking."

Trang stresses the sensual aspect of working with food, its appeal to all five senses. The same applies to her writing process. "I hang on each word. I rewrite, rewrite, rewrite till it sounds right to me. I read it out loud so I hear it—there's a ring to something. When I'm writing about food, I have to get up and go to the fridge," she says. "If you're writing about the texture, smell, feel of a particular ingredient—say a lemon—you want to conjure the smell of the rind, the way the juice tastes on your tongue. You want to paint a particular picture, want the reader to smell and see what you smell and see." In *Essentials of Asian Cuisine*, Trang writes, "Food speaks. My clay pot 'sings' to me when I am cooking rice. When the rice and water come to their first gentle boil, the pot's lid rattles, and I know the rice is halfway through its cooking process."

Her advice to home cooks? "Read the recipe, get the ingredients, then just go. Start cooking and *feel* something. A recipe is a foundation for your creation. You have to let yourself be free in the kitchen—it's an art, it's like painting. You're playing with colors and textures, you're not just following steps."

When teaching culinary students, Trang tells them to taste as they go, and to visualize their creation. "Before I start cooking, I look at the ingredients. I'm imagining how this dish will *look* even before I start prepping. You don't want to overstyle, but you want it to be visually appealing, light, not just something you plop on a plate. Culinary students want to start cooking right away—they're chopping everything up, they're not visualizing the dish, they're not tasting. You should be completely, fully connected to every ingredient." She pauses for breath. "I'm *intense.*"

Trang has also taught schoolchildren. At New York's Sylvia Center, she recently made tofu dumplings and dipping sauce with a group of five-year-olds, reassuring their anxious parents that "if they touch it, they'll eat it." (They did.) "One of my biggest pet peeves is children's menus at restaurants. There's absolutely no reason for them," she asserts. At restaurants, Colette shares a plate with her mother, sampling every dish; her enthusiasm for slurping noodles inspired *Noodles Every Day.* The book's national tour got a local launch with a signing and tasting at BlueCashew Kitchen Pharmacy in High Falls. "They throw a great party!" the author says, grinning.

Corinne Trang's introduction to *Essentials of Asian Cuisine* explores the ancient Chinese concept of five flavor notes—salty, bitter, sour, spicy, and sweet—each tied to an elemental property, and present in every good meal. "The Hudson River Valley itself is full of these wonderful flavor notes," she says, recalling her first local sunset. "There's a little spice with the red skies, the water, the mountains, the vibrant greens. The colors are infinite."

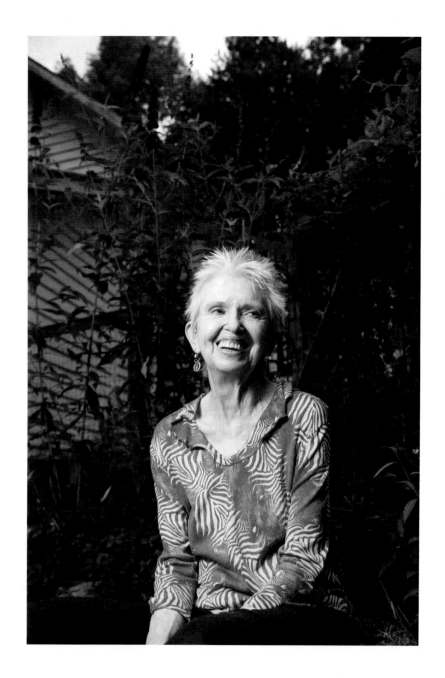

Janine Pommy Vega

THE DRIVING DIRECTIONS to Janine Pommy Vega's farmhouse outside Willow include the instruction "come up the hill in first gear." It's good advice. The unpaved road is rutted and steep, with a cascading creek far below and a whiff of high-altitude ions. "I love the Catskills," the poet says. "I've learned so much here. I get to the top of a mountain and there's no me left. It's a spiritual practice."

Vega likes to byline her poems with the date and place of their composition. Even a cursory browse through her recent collections *Mad Dogs of Trieste* and *The Green Piano* reveals a woman who's lived an extraordinary life. Local sites such as Windham High Peak, Woodstock, and South Fallsburg abut more exotic locales: Drumcliff, Ireland . . . Cholula, Mexico . . . Glacier Taulliraju, Callejon de Huaylas, Peru . . . Amalfi . . . Sardinia . . . Prague . . . Sarajevo. There are other addresses as well, such as Eastern Correctional Facility and Sing Sing.

"You walk into her prison class, and you can cut the love with a chainsaw, man," says poet Mikhail Horowitz. "These guys would die for Janine. They would take a bullet for her."

Vega wears her salt and pepper hair in bristling spikes, displaying opal and serpent earrings. She walks with effort, and her hands are gnarled like tree roots from rheumatoid arthritis, but her smile is luminous.

Vega grew up in Union City, New Jersey, where she spent weekends working with her Polish father on his three A.M. milk delivery route. He paid her a penny a bottle to fill the milk boxes of walk-up apartments; she saw her first sunrise and started to dream of the wider world. Her parents' marriage was tempestuous. "When I was eleven, my father hit my mother, several times, and she didn't forgive him," she says. "They spent the next twenty-five years without talking or fucking, or eating together."

But they didn't separate, claiming financial dependency. Many years later, when Vega wanted to dedicate a book to her parents, her mother said, "Don't put me next to him in any way." Vega shakes her head sadly. "They never made up. Isn't that a shame? There was so much *passion* there."

She became a voracious reader: Dostoevsky, e.e. cummings, *On the Road.* In high school, she and her friend Barbara decided to make the scene at Greenwich Village's Cedar Tavern, where Beat writers were rumored to hang out. The first person they met was poet Gregory Corso. "He was sitting right across from us in the bar, and he was clearly interested in my friend," she recalls. The two girls made a deal to lose their virginity the following weekend. "I was sixteen, I didn't want to be carrying it around anymore," Vega says with a shrug. Her first lover was Allen Ginsberg's partner Peter Orlovsky; she and Ginsberg were also lovers.

"When I was young, that's how I knew who people were, by fucking them. The sexual thing formed such a big part of who I was, how I perceived the world and the world perceived me," Vega says. On the down side, she was frustrated that none of the male Beat poets showed the slightest interest in reading her work.

After high school, she moved into New York, rooming with poet Elise Cowan. She read and wrote constantly, eagerly meeting fellow bohemians, including a Peruvian Jewish painter named Fernando Vega. Within six months they moved to Israel, and then to Paris, where Vega supported herself by selling newspapers and posing for art classes. He painted; she wrote. They made love and took drugs. When her young husband died suddenly while in Ibiza, Vega was heartbroken.

Her first book, *Poems for Fernando*, was published by City Lights in 1968. She moved from the Bay Area to Maui, where she lived surrounded by nature for the first time. "My sense of pilgrimage began there," she writes in her 1997 memoir *Tracking the Serpent: Journeys to Four Continents.* "To go on a pilgrimage, I discovered, you do not need to know what you are looking for, only that you are looking for *something*, and need urgently to find it. It is the urgency that does the work, a readiness to receive that finds the answers."

Vega became a poet-wanderer, exploring neolithic Goddess-worship sites in Europe, teaching English in South America, trekking in the Himalayas, and living for two years as a hermit on Isla del Sol in Lake Titicaca. "The lake just caught my heart," she says simply. She traveled alone, she traveled with lovers, she traveled with friends. Wherever she went, she wrote. "From the outside in isn't what I'm looking for," she asserts. "I'm after an investigation of the main material, the human psyche. If you're honest about it, it's a discovery as much for you as for the reader."

That sense of discovery is the torch Vega hopes to pass on to her students. Whether she's working with prison inmates, children, or migrant farm workers, she stresses the same thing: that they have their own voice. "There are a couple of billion unique points of view," she says. "I love to see somebody discover their voice, the light in somebody in prison when he suddenly gets that 'Aha!' Unless you're involved in some way where you care about that, you're missing a lot of access to joy."

Vega started teaching in prisons in the 1970s, when an activist friend asked her to lead a poetry workshop with inmates. Her response was, "Absolutely not, you'd have to be insane." The friend tried again, asking if she'd do it *once*. Vega agreed, choosing a poem by Pablo Neruda to read in Spanish and English. When she met her group of eight or nine men, they were sitting around a table on which was a book of Neruda's poems, open to the same one she'd chosen. "Serendipity," Vega says. She was hooked.

In the years since, she's taught writing workshops at Greenhaven, Huntington House, Attica, Eastern Correctional, Woodbourne, and Bedford Hills, among many others. She is the director of Incisions/Arts, which brings writers into prisons to teach and perform, and has served on PEN's Prison Writing Committee, coauthoring *Words Over Walls: Starting a Writing Workshop in a Prison* with Hettie Jones.

Inmates, says Vega, are "such willing and ready students and colleagues. There are two million in there. Some of them have done terrible things and have to work through it. You're in for seven years, you're not just playing basketball, you're going to do some soul-searching. It's a process the average citizen would do well to emulate."

Vega's prison experience infuses her own work as well. Her poem "Return to Sender/Inmate Is Dead" concludes with these lines:

> *The blood under the bridge is the bridge.*
> *The miracle is a green face of freedom.*
> *No them. Just all of us.*

When writing, Vega is acutely aware of a poem's spoken rhythm, often using an egg-shaped shaker to work it out. She sometimes performs with the shaker as a percussion accompaniment. "I think it's that rhythm that propels the message home," she says. "When I used to live on the island and had no one to talk to, I would recite poems to the beat of my hand on a pail as I walked up and down the hill for water."

Walking up and down hills—and 17,700–foot Himalayan passes—is not something Vega can do any more. Neither is holding a book or turning its pages; her arthritis has made her a books-on-tape addict and two-fingered typist. She's giving away sleeveless blouses and hiking boots. "Let's get real. You're not going to be in them again," she says. " It's a real milestone saying goodbye to your boots." But with physical challenges, "your will and your mind get sharper. They have to. It is a mountain. 'I *will* get to the top' is quite a discipline, and it stands you in good stead for everything else: I *will* get this shoe on."

In her mountain-climbing days, Vega became a member of the 3500 Club, an elite group of hikers who have climbed all thirty-five Catskill High Peaks, including at least four winter ascents. "Of course I am," she says, grinning proudly. "Driven. Yeah, man."

But now, she says bluntly, "Fun has changed. I'm sixty-seven. My fun is a lot of laughing, enjoying a good story, being with friends." Vega lives with fellow poet Andy Clausen, who still works as a construction laborer at sixty-five. "He has that whole ethic of the workman and the dignity and usefulness of work," she says. Her own

work day starts at ten or eleven P.M., often stretching till dawn.

"Andy's big, he has a big personality, there's no way I can shut it off. But when he's sleeping . . ." She smiles.

Vega is currently writing a mystery novel set in Woodstock during the Film Festival. It's been thirty years since she bought the farmhouse in Willow, using a small inheritance from her mother as the down payment. "I thought, 'Me, a house? I've been a traveler all my life. I'll never sit down and stay in a house.' True. But you can leave your stuff there and come back," she says. "And it's someplace to put all these *books*."

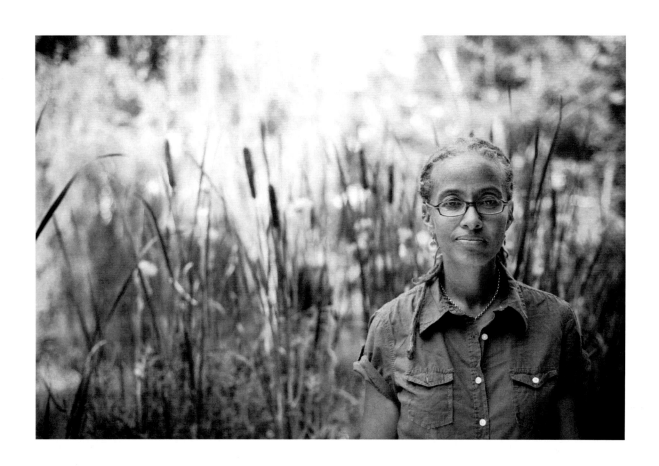

Linda Villarosa

LINDA VILLAROSA'S ULSTER COUNTY CABIN is surrounded by water. She and her partner Jana found it after attending an African American health retreat at the legendary Peg Leg Bates Country Club. The two ponds sealed the deal: Villarosa has a passion for fishing. Wearing a crisp white shirt and jean shorts, she sits cross-legged on a weathered Adirondack chair, watching her son Nic and daughter Kali take turns fly casting. Villarosa's debut novel, *Passing for Black*, was a 2008 Lamda Literary Award nominee. "That's like the Oscars of LGBT publishing," she exults.

She cheerfully calls her coming-out romance "a good airplane read," saying, "I thought my writing was getting not just stiff, but a little stale. Everything I wrote was so *serious*." Her previous credits include several health books, editing and writing for *Essence*, and frequent science features for the *New York Times*. "A friend said, 'You're so much funnier in person.' I felt as if I'd lost my voice in print."

Villarosa admits to the pressures of straddling two cultures. "A lot of us LGBT people of color don't feel like we're welcome in the larger community," she says, noting that many African American gays remain in the closet. "It's a circular thing. The more closet there is, the more homophobia there is, until someone breaks through it."

Her solution is being "aggressively out" in her writing and personal life. "I really couldn't be closeted with my children—I never wanted my kids to lie or be ashamed," she asserts. Her own family was close. Villarosa's late father taught her to fish; she and her mother coauthored the *Essence* feature "Coming Out," sharing their journey towards mutual acceptance.

"When I was a little girl, about six years old, my great-aunt called me out: 'You're going to be a writer.'" Villarosa says. "So I always thought of myself that way. If you have that, it doesn't matter what genre, it's your self-expression."

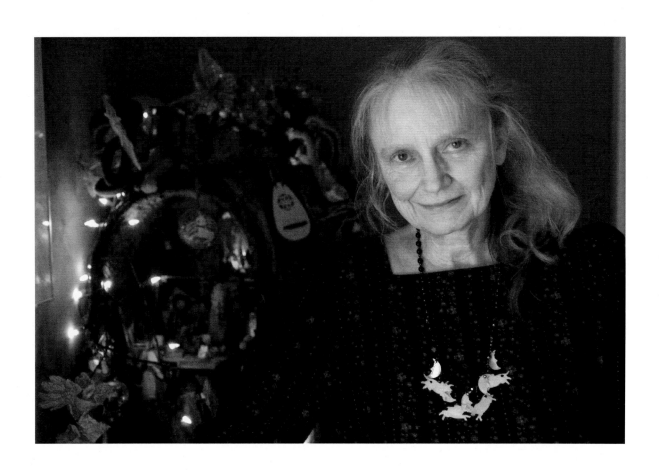

Nancy Willard

ON A QUIET STREET in Poughkeepsie, near the fairytale turrets of Vassar, there lies an enchanted cottage. Inside, angels canoe over doorways, unicorns nestle on armchairs, and the bathroom sink is filled with stars. There's even a spinning wheel tucked in one corner. It might be the kind that spins straw into gold, although one suspects that most of the alchemy in Nancy Willard's house takes place on paper. With a wave of her pen, brooms dance, beds fly, and poems bristle like seagrass.

Willard's writings include a brace of novels (*Things Invisible to See* and *Sister Water*), five collections of essays and stories, eleven volumes of poetry (most recently *In the Salt Marsh*), and a covey of children's books, including her Florentine fable *The Flying Bed*, with award-winning paintings by John Thompson, and such antic titles as *Pish, Posh, Said Hieronymus Bosch* and *The Well-Mannered Balloon*. Willard's 1981 *A Visit to William Blake's Inn: Poems for Innocent and Experienced Travelers* was the first book of poetry to garner a Newbery Medal.

The indefatigable Willard also finds time to lecture at Vassar, as well as to fashion the whimsical artworks that fill nearly every inch of her home. (The remaining wall space is claimed by her husband, photographer Eric Lindbloom.) Willard's assemblages include numerous figures of angels, a collaged children's stove entitled "The Back Burner," and an eclectic shrine made from the stump of an ancient apple tree.

The dining room walls are robin's egg blue, a tone which brings out Willard's eyes. Unusually large and set low in her face, they're the changeable blue-green of seawater, with a dreamy drift outward, as though she is looking both at and beyond you. She tends to lean backwards while talking and forward while listening; it seems as if listening, for her, is the more active verb. "I love to hear how people talk," she muses, "Both what they tell you and what they leave out. Anything that gets you to listen better is good practice for writing."

For Willard, the narrative voice is the key to the kingdom. "I'm always interested in stories that sound like someone could have told them," she says, citing *Huckleberry Finn* and the tales of Isaac Bashevis Singer and Hans Christian Andersen as examples. "It's the illusion of a spoken style, but it's very careful writing, too." Whatever she writes, the voice must come first. Her process allows for a good deal of hunting and gathering. "You dream over the material for a long time before setting anything down," she says, "Just walk around with a story inside your head."

During this long mulling period, she sometimes makes notes, but never an outline. "God forbid," Willard shudders. "You follow the story. You don't try to make it follow your plan. When you finally have the whole thing in your head, ready to go, you sit down to work. You work steadily and that's all you do."

Willard grew up in Michigan, summering at a lakeside town where the main occupations were gravel mining and gossip. Her essay "The Well-Tempered Falsehood" describes a childhood game she played with her sister. One would describe a place to the other as vividly as possible, adding texture until the listener said, "Stop, I'm there." Once, ten-year-old Nancy decided to conjure up Paradise, borrowing details from the church they attended—brass angels, stained glass, a stray whiff of peppermint. Without warning, her sister burst into tears and cried out, "I'm there!" From that moment on, Nancy knew what she wanted to do.

Six decades and fifty books later, she's still telling stories. "Stories find the writer. They're out there," claims Willard. She thinks of a picture book as a poem. "It's made to be read aloud, it has meter and rhythm. In a poem, you have stanza breaks and line breaks. In a picture book, it's the page turn." She reads manuscripts aloud ("usually very softly, so as not to alarm others in the house"), stressing the need to hear not just the sense, but the sounds.

Willard's poems are lyrical and precise, without a jot of pretension; they're written, to borrow a phrase from the late Randall Jarrell, "in plain American which dogs and cats can read." *In the Salt Marsh* explores two different places where water meets land, the shores of Cape Cod and the banks of the Hudson. In these liminal landscapes,

she finds the miraculous wrapped in the everyday. A bird crashes into a window; the poet is left with a small feathered body, the husk of a life.

There's room for sly humor in Willard's poems as well. One series spins metaphysical riffs from sports headlines, many of which—"Buffalo Crawls Out of Cellar," "Giants Anxious for Skins"—seem created expressly for some watchful poet to mine for double entendres.

How does one imagination take so many forms, like a genie inside a brass lamp? In *The Nancy Willard Reader: Selected Poetry & Prose*, Willard answers a reader who asks why she works in such different genres: "Each work chooses its own form, and I try to follow that lead—story, poem, novel, or essay. I hope the connections between them are clear. They all come from the same well, a metaphor I don't take lightly."

Willard's story well seems to tap into some underground river—or perhaps it's the stream full of blind fish that bisects the floor of a Midwestern family's backyard museum in *Sister Water*. Her response to the query continues, "When I was growing up in Ann Arbor, Michigan, I heard plenty of stories about folks coming into the world and going out of it and maybe coming back once in a while to keep an eye on us, the living. Call them guardians, ancestors, spirits; they glistened before us in a web of words: their stories were the gifts they handed down to us. Behind their gifts lay questions: *What will you give to those who come after? Who do you want to be?* Why, the village storyteller, of course."

Wish granted. The village applauds.

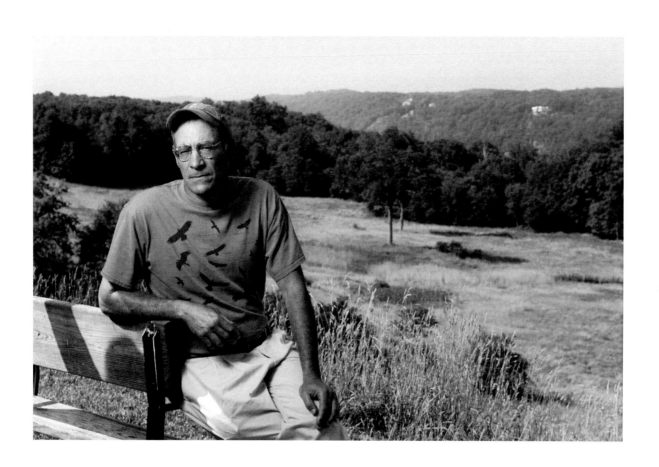

Daniel Wolff

"I DON'T THINK OF MYSELF as a writer with a capital W," says Daniel Wolff. "I'm a human being who's curious about things and has developed some communication skills." Wolff's curiosity has sprouted three nonfiction books (*You Send Me: The Life and Times of Sam Cooke*; *4th of July, Asbury Park*; and *How Lincoln Learned to Read*); articles for *Wooden Boat*, *Vogue*, and *Education Weekly*; two documentary film projects with Jonathan Demme; several collaborations with photographers; and two volumes of poetry, about which he deadpans, "That's just for cash."

Wolff is visiting the FDR Library to speak at a conference called "Teaching the Hudson Valley." As an activist parent in the Nyack school system, he asked many questions. What is school really for? How do we learn what we need to know?

How Lincoln Learned to Read describes the nontraditional early educations of twelve famous Americans, from Benjamin Franklin and Sojourner Truth to Elvis Presley; Wolff also examines the roots of the public school system, founded to "Americanize" immigrants and foster obedience. (Pledge of Allegiance, anyone?) "If you talk long enough about education, the definition starts to broaden," he says. "People tell you about how they learned wood-carving from their uncle. FDR would probably say the Hudson River was part of his education."

Wolff grew up in Mamaroneck. "According to my mother, I got asked to leave a number of schools, probably because I was a wiseass." He learned what he needed to know in part by hitchhiking during the seventies. "The story of America is a great story, with all its successes and failures. I was never able to get that from history books, but I sure got that from riding around in cars with all those oddballs."

A self-described "general practitioner," Wolff says his multiple interests cross-pollinate. "It keeps me lively. It's a mix. It's the Hudson River, fresh water and salt water, all the different elements that combine so you get an interesting ecosystem."

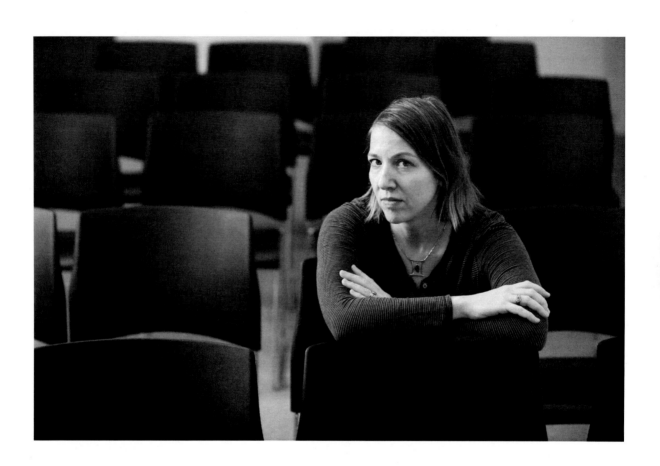

Rebecca Wolff

IN LATE NOVEMBER, thousands of crows congregate outside SUNY Albany's starkly modern science library. Three floors up, on a hallway housing the New York State Writers Institute, a sign with a hand-drawn arrow leads to Rebecca Wolff's office.

The award-winning poet and editor grimaces as she surveys her workspace. "It's not always so putrid," she says, gesturing towards a cluster of repurposed USPO mail bins and manuscript piles. "This is the mess of *Fence* you see around you."

The Fall 2010 issue of the lauded literary journal went to press late because Wolff, the mother of two young children, just spent ten days on a West Coast book tour for her new book, *The King.* She's also teaching the last session of her annual poetry workshop tonight. In spite of her hectic schedule, she seems unhurried as she sits at her desk, discoursing on life, literature, and the liminal zones that interest her most.

"The name *Fence* came in a true flash of inspiration," she explains. "I was thinking about ambiguity, and ambivalence, and how these are the most valuable dwelling places for our imaginations, and I was thinking about how usually people think of them in a negative light. So the word seemed to me to represent a positive, useful representation of that place of between-ness."

Wolff herself occupies "a place of between-ness" these days. Though her poetic career is exemplary—her 2001 debut, *Manderley*, was selected by Robert Pinsky for the National Poetry Series, and her next book, *Figment*, won the Barnard Women Poets Prize—she declares herself "frustrated with the culture of poetry right now" and has just started her second novel. (Her first, *The Beginners*, is forthcoming from Riverhead in 2011; Wolff calls it "a highly literary supernatural thriller" set near Massachusetts's Quabbin Reservoir.)

The new novel portrays "a youngish family with vaguely utopian urges trying to create a meaningful non-urban life." Five years ago, Wolff and her husband, novelist

Ira Sher, left New York City for the wilds of Greene County ("A second child will blast you right out of that apartment," Wolff says drily). Their new life in the village of Athens includes a CSA share in a Germantown farm and launching an alternative school. "We're trying to live in a way that seems sane to us," Wolff asserts. "We both grew up in New York City, so that's sort of a departure."

Wolff's photojournalist father once photographed his children for *Life* magazine. She describes her mother as having "a literary background, but it skipped a generation." Attending a series of progressive private schools, Rebecca decided at twelve to become a writer. "I was very serious about it. I filled legal pads with stories—long, terrible trash." She wrote her first poem for an English class, and the school's resident poet, Molly Peacock, was impressed enough to offer a private poetry tutorial. Wolff published her first poem at age fifteen, in *Seventeen* magazine.

She started college at Bennington, dropping out to intern at David R. Godine Publishers, work in a health food store, and hitchhike around Europe, eventually graduating from the University of Massachusetts at Amherst with a BA in "Poetry & Self-Consciousness." The *sui generis* major was "my attempt to formalize my serious existential crisis at the time."

Among other things, Wolff was struggling with depression. Several poems in *The King*, including one entitled "I am on drugs" ("on an airplane // mentally // and there are some things wrong with me // perennially / I have control over them"), allude to this "natural predator." "It's all true," Wolff says with characteristic bluntness. "It sort of blossomed early on, in my late teens."

She continued to study and write at the University of Iowa. "It was the only place I applied," says Wolff, who completed an MFA in poetry while living on an organic vegetable farm. Later, she "dabbled in" a second MFA in fiction at the University of Houston, where Sher was enrolled. "I was feeling pretty unmoored," she reports. A teaching assistanceship as associate editor of *Gulf Coast* gave her a new sense of direction.

Wolff describes the poets who taught at Houston as "extraordinarily conservative." *Gulf Coast*'s editors "were rejecting left and right all the things I found inter-

esting and accepting stuff I didn't," she says. "And these poor poets—I had a deep empathy with poets being rejected for strange and interesting work. It was the perfect breeding ground for *Fence.*"

Wolff founded the biannual in 1998 with coeditors Caroline Crumpacker, Jonathan Lethem, Frances Richard, and Matthew Rohrer. She had recently turned thirty, and "looking back on it, I realize some kind of internal alarm clock was going off: It's time to *do* something."

Fence's literary aesthetic is distinctive, but hard to define. Wolff cites its "three-pronged dualism" (thanks, that's *much* clearer), including experimental work alongside more traditional forms and writing that defies categorization. "As an editor, I'm most excited to find work that seems to be coming from a place in which writers are not really paying attention to anybody but themselves—their own music and sense of received wisdom. Idiosyncrasy is my favorite thing in writing."

Where most *Fence* covers feature illustrations and graphic art, the instantly notorious 2005 summer fiction issue sported a photograph of a punkish young woman cradling her ample bare breasts. In a breezy editorial note, Wolff wrote, "I don't consider myself post-feminist; I'm still just feminist. So what is it, then, with the tits on the cover? Let's call it experimental (though certainly not innovative) marketing. . . . It is a more than slightly ironic comment on my own initial promise to make *Fence* 'visually appealing and desirable as a consumer product.'"

Not all readers appreciated the irony, and Wolff came under attack from her fellow feminists. "I was surprised by the depth of reactions," says Wolff, who later told *Poets & Writers,* "I will never put another naked girl on the cover of *Fence* again." (Irony scored a victory, though: the issue sold out.)

Two years later, novelist Lynne Tillman, one of *Fence*'s fiction editors and a professor at SUNY Albany, suggested Wolff approach her colleagues Edward Schwarzschild and Donald Faulkner about bringing the magazine and its publishing partner, Fence Books, to the New York State Writers Institute. "And they just said, 'Come on in,'" marvels Wolff. Outside her window, the crows clatter skyward. There could be a poem in that.

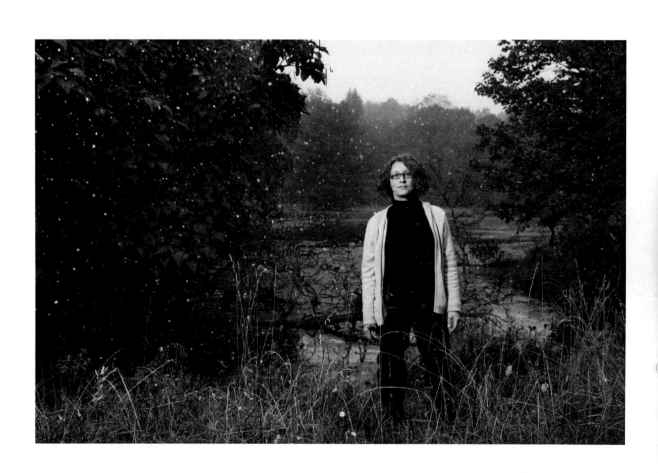

Kim Wozencraft

THE LEADING CHARACTERS IN Kim Wozencraft's adrenaline-pumping thriller *Wanted* are a veteran convict and a cocksure young officer who's been framed by corrupt Texas cops. Together, they stage a daring escape from a federal penitentiary, outrun baying bloodhounds, and hit the highway to settle old scores. Sound like your typical Hollywood buddy picture? Not quite. For starters, they're both women, and the highway they hit is New York State Route 209.

Stone Ridge resident Wozencraft tells their story with hard-won authority: she's been on both sides of the law herself. Her breakout first novel *Rush* is based on her experiences as a Texas police rookie, prematurely thrust into undercover narcotics work and eventually convicted for perjury, after denying in court that she had used drugs while making cases.

Ex-cop, ex-con, ex-junkie, international bestselling author, soccer mom . . . it isn't your typical resume. Wozencraft opens the door of the house she shares with her three school-age children. She's lean and athletic, with short russet hair and stylish glasses. Her manner is warm, but there's a hint of steel in her calm, steady gaze; a bumper sticker on her pickup truck reads DON'T MESS WITH TEXAS WOMEN.

Unlike many crime novelists, Wozencraft writes from a distinctively left-wing and feminist perspective. "*Two* strikes against me," she deadpans. "A lot of people want to believe that justice is done and the system is fair. They want that taste of danger and excitement, but it's comforting to think that the good guys will come out on top. My experience is that the good guys don't necessarily come out at all."

Rush was filmed in 1991, starring Jennifer Jason Leigh, and *Wanted* was optioned for film, with Meryl Streep and Jennifer Aniston attached as costars. Wozencraft's

other novels include *The Devil's Backbone*, *Notes from the Country Club*, and *The Catch*, a fictional smuggling drama set in a very real Ulster County: Scenes unfold in Davenports Farm Stand, the Krumville Country Inn, and the video arcade of the Hudson Valley Mall. "The domestic lives of drug smugglers, in a rural environment—that's not what you get on the Six O'clock News," says Wozencraft. "And this area is so beautiful."

ACKNOWLEDGMENTS

GRATEFUL THANKS TO the following people and organizations who helped us along the way: Susan Cohen, Sonia Pabley, and Phyllis Wender at The Gersh Agency; Dana Foote, Fran Keneston, and James Peltz at SUNY Press; Brian Mahoney and David Perry at *Chronogram*; Mary Gannon and Kevin Larimer at *Poets & Writers*; Frank Juliano and Jerri Lynn Fields, The Hudson Valley Writers' Center and Slapering Hol Press; Carolyn Bennett, Catskill Mountain Foundation; Deborah Allen, Black Dome Press; Georgia Dent and Paul Cohen, Monkfish Publishing; Danelle Myron, Anarchists Convention Films; Mark Primoff, Bard College Public Relations; Emily Darrow, Vassar College Public Relations; Susan Avery, Maple Grove; Bardavon Opera House; Blue Flower Arts; Inquiring Mind Bookstore; the Memoir Institute; Millbrook Book Festival; Stone Ridge Library; Upstate Films; Woodstock Writers Festival; Shelby Lee Adams; Deborah Askue; Lori Gross; Sarah and Geoffrey Harden; Bri Johnson; David Kermani; Susan Krawitz; Doug Menuez; Austin Metze; John Morstad; and Susan Richards; with an extra helping of gratitude to Chris Metze and Maya Shengold. Most of all, thanks to the writers, for your wonderful words.

EDWARD SANDERS — AMERICA: A History in Verse VOLUME I 1900-1939 — BLACK SPARROW PRESS

DREAMS O

Daniel Pinkwater — Uncle Boris in the Yukon — Harc

WESLEY BROWN — PUSH COMES TO SHOVE

Thinking About Memoir — Thomas — STERLING

DARKTOWN STRUTTERS — BROWN — MASSACHUSETTS

H. THOMAS — REE DOG LIFE

Laura Shaine

brown — Tragic magic — ecco

CLEAR

rb's Pajamas — Abigail Thomas

THE OPUS OF EVERYTHING IN NOTHING FLAT / by Mikhail Horowitz — RED HILL

eeping — Some True Stories From a Life — ABIGAIL THOMAS

MIKHAIL — RAFTING INTO THE AFTERLIFE — Horowitz

ROMEO/JULIET — HOMEST — FINGER FOOD

Sounds of the River — DA CHEN — A Young Man's University Days in Beijing

ARWIN CONSPIRACY — JOHN DARNTON

The HORNED MAN — JAMES LASDUN

be ISLAND of

nisley — French Milk

A MONK SWIMMING — MALACHY McCOURT

M — P

Cinderella CLEANERS — Change of a Dress

JOHN ASHBERY — Where Shall I Wander — NEW POEMS — ecco

JANA

UNNINGHAM — The Midnight Diary of Zoya Blume

SUSAN ORLEAN — THE ORCHID THIEF — A True Story of Beauty and Obsession

PA

E MARTIN — ITALIAN FEVER

MY KIND OF PLACE — SUSAN ORLEAN — RANDOM HOUSE

APPELBAUM

ation — VALERIE MARTIN — ABACUS

carr — crazy sexy CANCER TIPS

Danny Shanahan

n — The Unfinished Novel and Other Stories

THE DEAD BEAT — MARILYN JOHNSON

Gilroy

SET IN MOTION

ANOTHER BULLSHIT NIGHT IN SUCK CITY — nick flynn — NORTON

Plays for Actors — Fran

ARTIN — PROPERTY — VINTAGE

NICK FLYNN — ALICE INVENTS A LITTLE GAME AND ALICE ALWAYS WINS

TALES

The House of Moses All-Stars — HARCOURT BRACE

SOME ETHER — NICK FLYNN — GRAYWOLF

Players and Pretenders

Akiko Busch — NINE WAYS TO CROSS RIVER

EDWARD

l ON THE RIVER — GWENDOLYN BOUNDS — HARPER

HATS & EYEGLASSES — MARTHA FRANKEL

BASH

n — Helen Benedict — Pub Date: Nov. 2009 — SOHO

Robert Kelly · THE BOOK FROM THE SKY — North Atlantic Books

BANG

onely Soldier — THE PRIVATE WAR OF WOMEN SERVING IN IRAQ — BEACON

HARDHEADED WEATHER — CORNELIUS EADY — PUTNAM

PLAYS BY LA — BEAUTIFUL LO

NAME BE SHOUTED OUT? — STEPHEN O'CONNOR

FIRETHORN — Sarah Micklem

HUDSON VALLEY — An Anthology of Hudson Valley Humor — E

Sou

EVERY DAY — CORINNE TRANG — CHRONICLE BOOKS

TRASHED — ALISON GAYLIN

RANG

BLACK & WHITE AND DEAD ALL OVER — JOHN DARNTON — KNOPF

ALPHIE

IALS OF ASIAN CUISINE — S AND FAVORITE RECIPES

Mala

technique is unstoppable — david rees — Riverhead Books

unstoppable — by david rees — Riverhead Books

Bradford Morrow — ARIEL'S CROSSING

the Dragon — My Journey Down the Coast of Vietnam

RIVER of DREAMS — PUTNAM

THE LOST — Daniel Mendelsohn